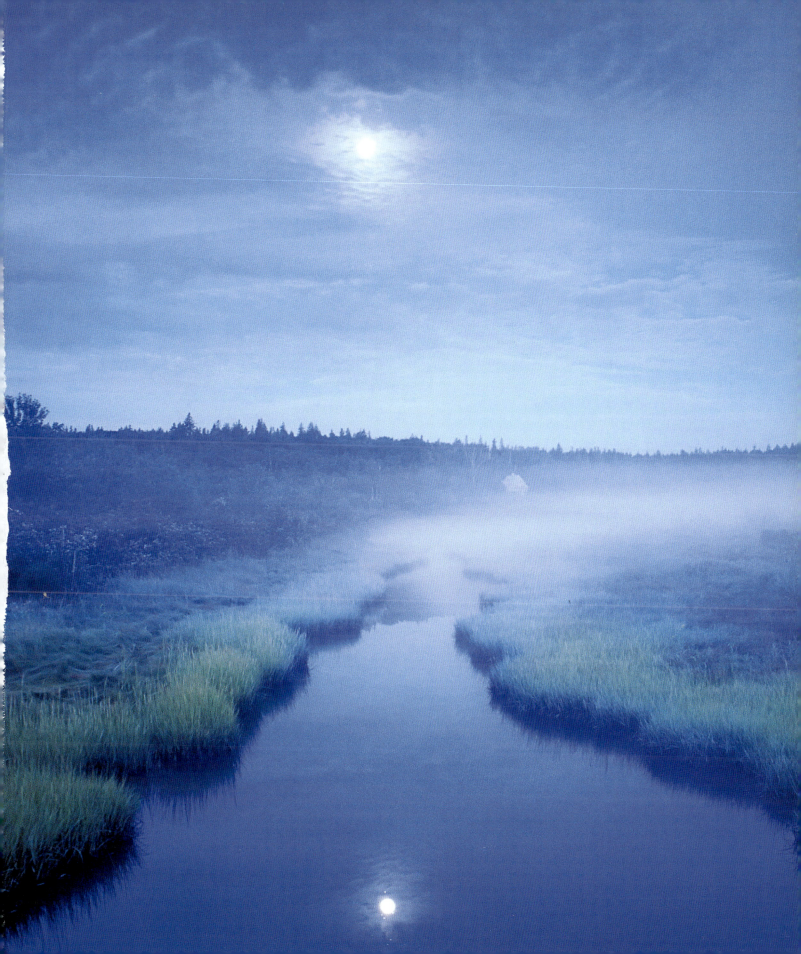

Overleaf: The British Canal, Castine.

nobody's here—
only skunks, that search
in the moonlight for a bite to eat.

—from "Skunk Hour," 1959, Robert Lowell (poet and Castine resident)

The Hidden Coast of Maine

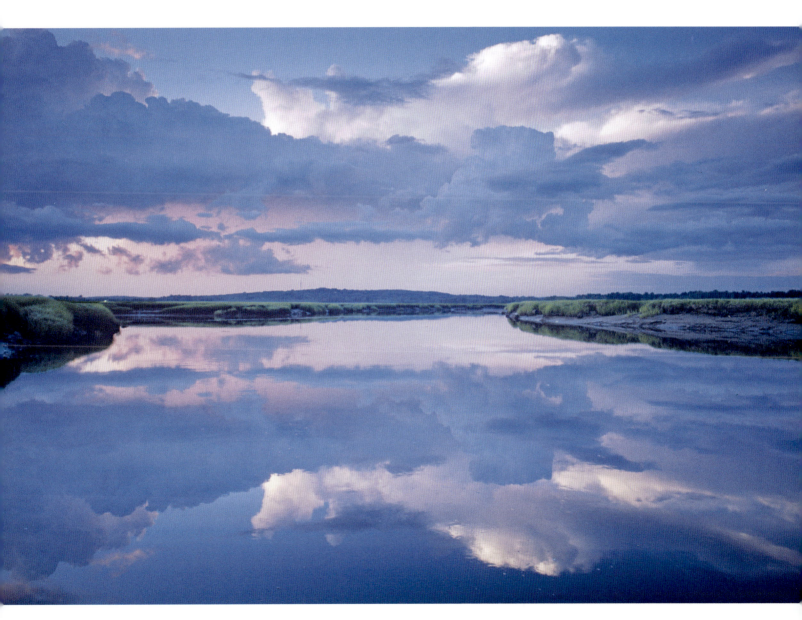

The Scarborough Marsh

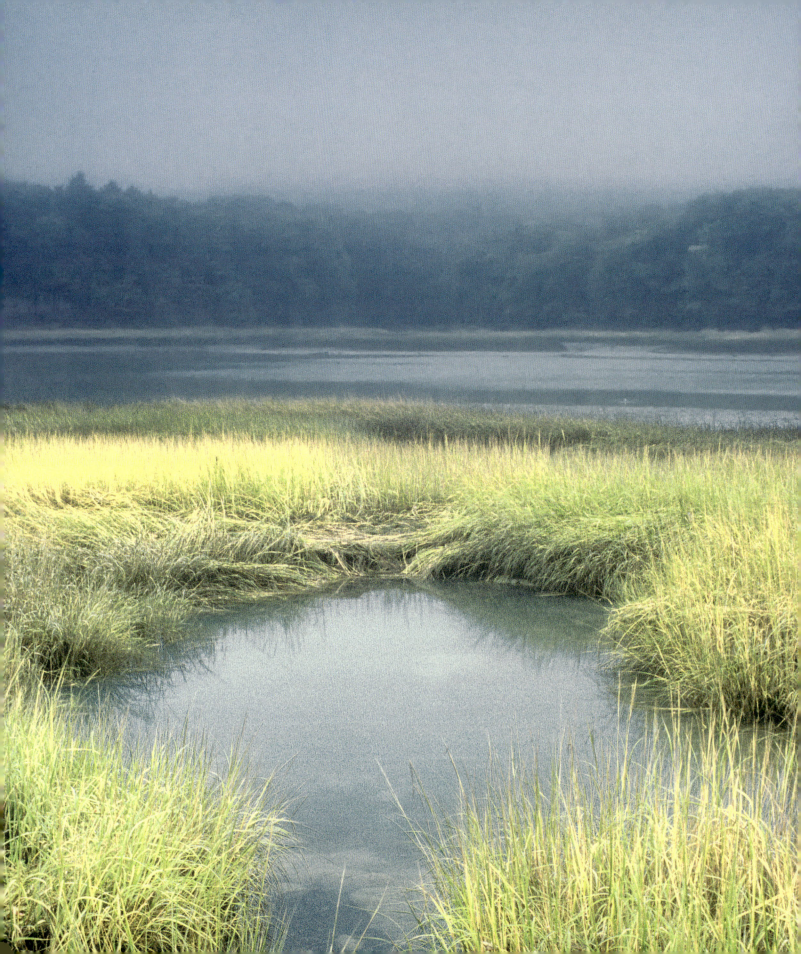

The Hidden Coast of Maine

ISLES OF SHOALS TO WEST QUODDY HEAD

photography by JOE DEVENNEY

essays by KEN TEXTOR

Tilbury House
Thomaston, Maine

Photo on page iv: The Cross River, Boothbay

Tilbury House, Publishers
12 Starr St., Thomaston, Maine 04861
800-582-1899 • www.tilburyhouse.com

First hardcover edition: April 2014 • 10 9 8 7 6 5 4 3 2 1

Library of Congress Cataloging-in-Publication Data
Devenney, Joe, 1947- photographer.
 The hidden coast of Maine : Isles of Shoals to West Quoddy Head / Joe Devenney, photographer ; Ken Textor, author.—First hardcover edition.
 pages cm
 ISBN 978-0-88448-350-2 (hardcover : alk. paper)
 1. Atlantic Coast (Me.)—Pictorial works. 2. Landscapes—Maine—Atlantic Coast—Pictorial works. 3. Maine—Pictorial works. I. Textor, Ken, author. II. Title.
 F27.A75D47 2013
 974.10022'2–dc23
 2013025767

Cover and interior design by North Wind Design & Production
www.nwdpbooks.com
Printed by Versa Press, East Peoria, Illinois

To Mary, Angie, and Nina, who make all creative things happen.

—Joe

To Melissa, who always picks me up.

—Ken

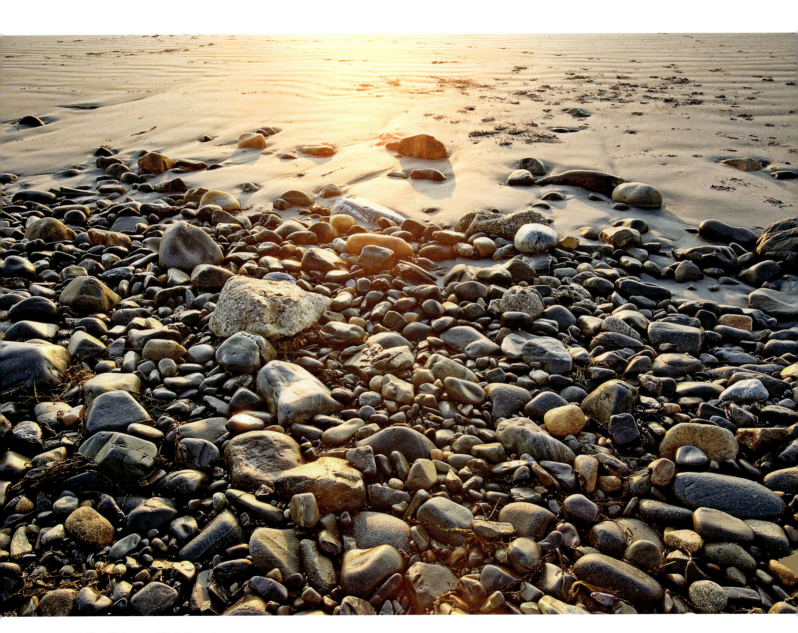

Collectibles on York Beach

Contents

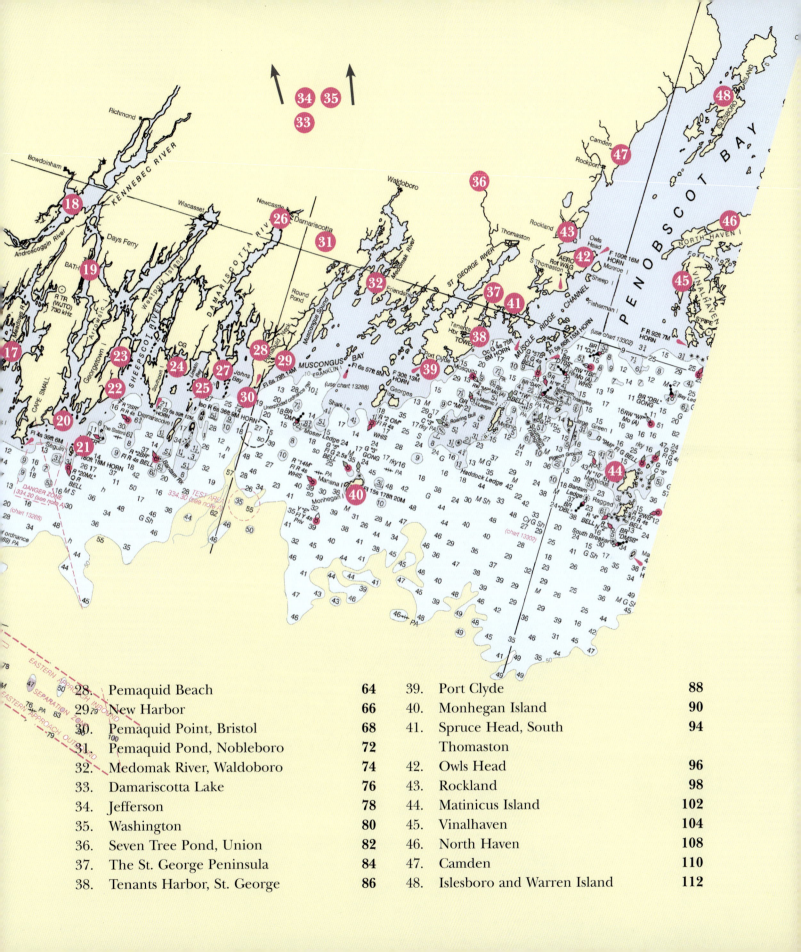

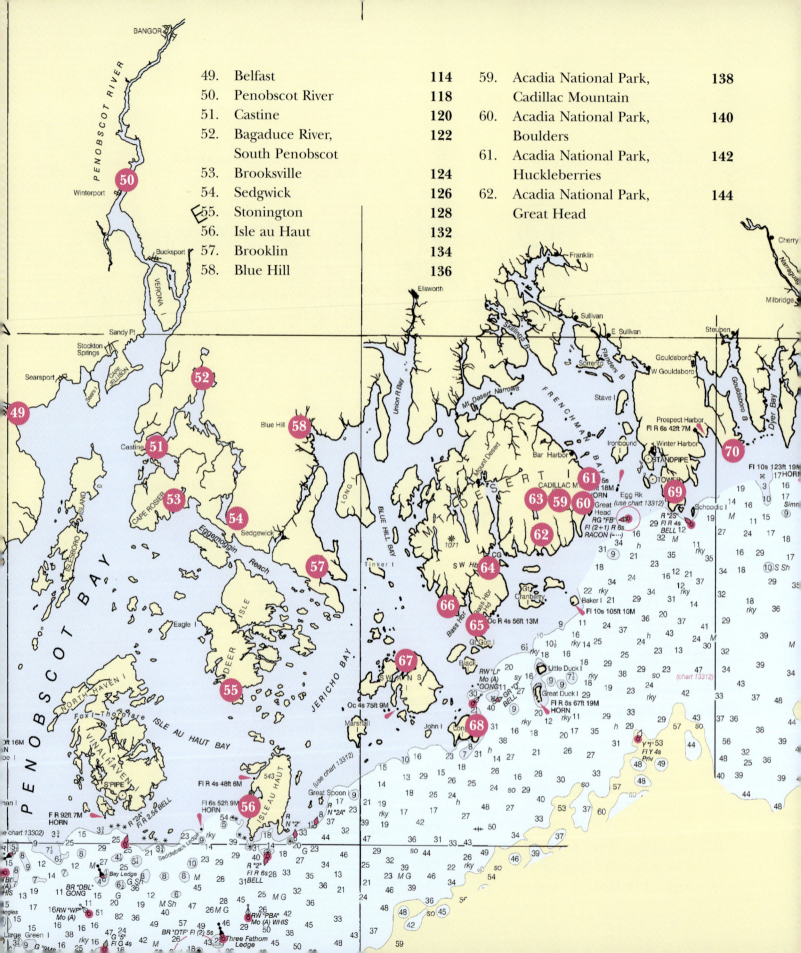

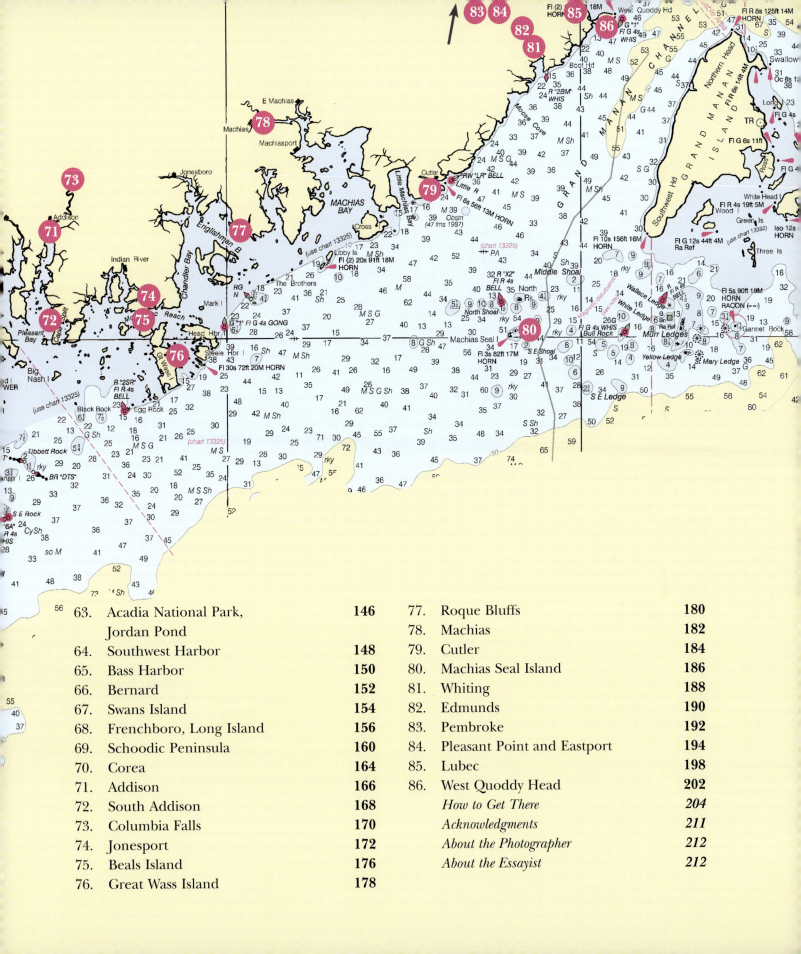

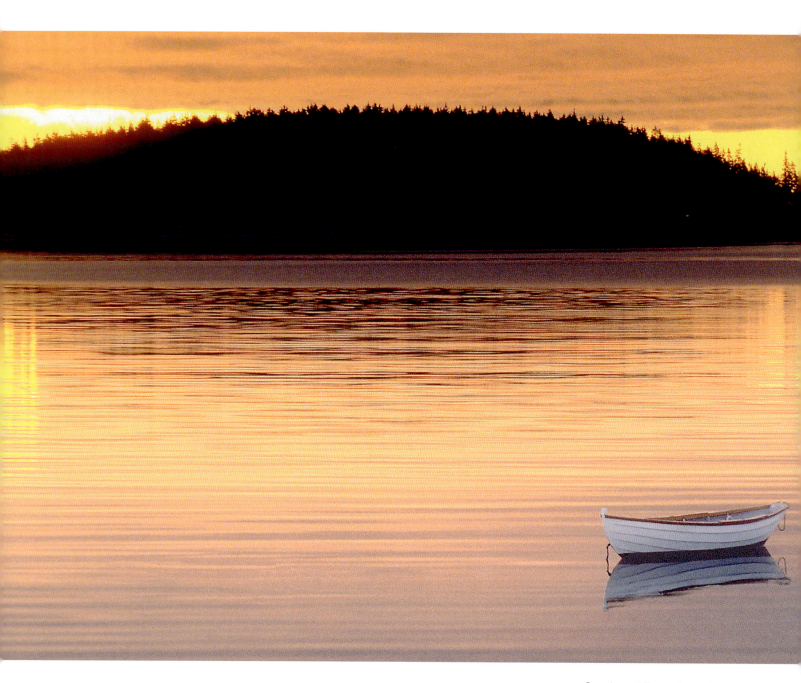

Sunrise at Tenants Harbor

Introduction

Crepuscular rays, lapidarian nirvana, and salubrious swimming may sound like goofy chapter titles in a bad newsstand novel. But when we started poking through the vast collection of Maine coast photographs Joe Devenney has accumulated over the past 36 years, we soon found that they are only the beginning of the unique discoveries one can make in the hidden nooks and crannies between the Piscataqua and St. Croix rivers. In fact, if your sense of fun allows you a broad definition of the word "hidden," the coast from Kittery to Eastport is a veritable cavalcade of adventures, a cornucopia of photography—or any purple phrase our poor thesaurus might lend to the exploration of a previously unseen world.

Consider, for instance, those crepuscular rays. As one of the most heavily marketed destinations in Maine, the Penobscot Bay town of Camden is anything but "hidden" unless you see it as it's never been seen before, decked out in a fog-refracted light show.

And sparkling mornings on the Maine coast can be just as ephemeral and secretive as foggy dawns. From a certain angle, a well-known harbor in East Penobscot Bay can appear indecipherable even to the most frequent visitor. The Maine coast hides its essence behind a veil of spruce and fir, sea wrack and granite, bayberry and beach rose, surf and marsh grass, sun glitter and fog tendril, and we know there are things we're not seeing

The schooner *Adventure*

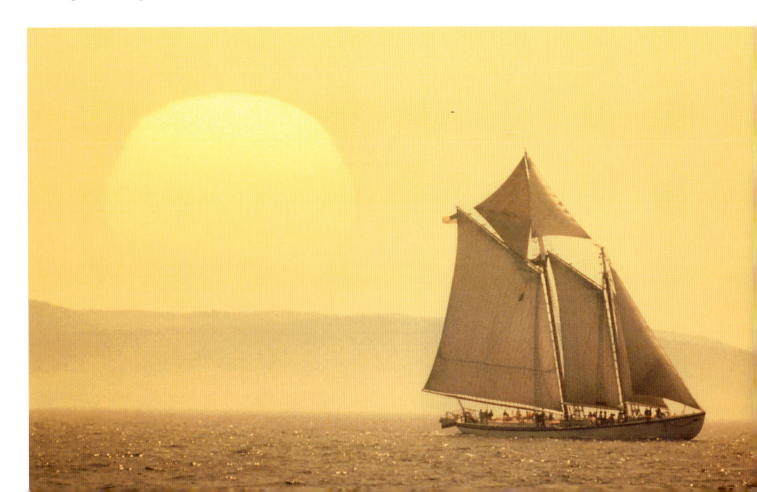

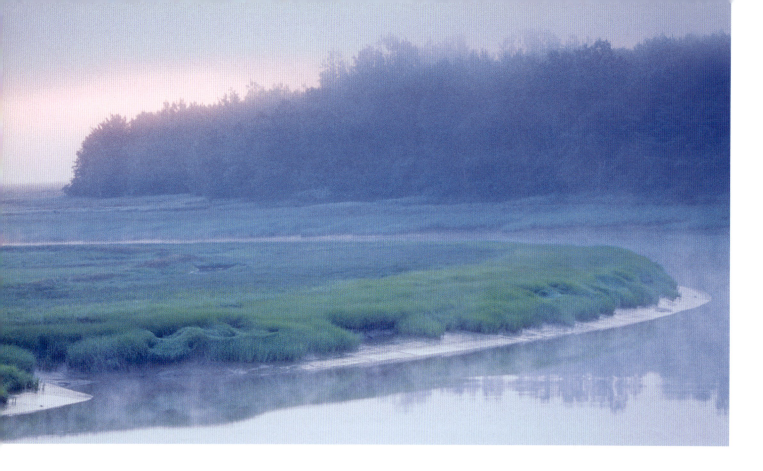

even though they're right in front of us. How can these few basic elements combine in so many ways to induce delight or wistfulness, awe or nostalgia? A Maine coast vista can be so overwhelming that we can scarcely take it in. Joe's camera helps us parse what we see.

Maine is much more than the sum of its geography and beauty. The hardworking people of Maine are the lifeblood of the seen and unseen Pine Tree State. Joe's camera catches them in unguarded moments, in leisure and in work. A ship's pilot using a Jacob's ladder well offshore to board an inbound freighter is one example of the jobs Mainers do to wrest a living from a stern environment. The Jacob's ladder gets its name from the biblical story of angels using a ladder to ascend to Heaven. In Maine waters, visiting ships often need a local "angel" to guide them through stormy, treacherous seas.

The most numerous denizens of the hidden Maine coast wear fur, feathers, or scales and live their hidden lives in, on, or near the water itself, and Joe's camera captures them too. The annual migration of the alewives, or river herring,

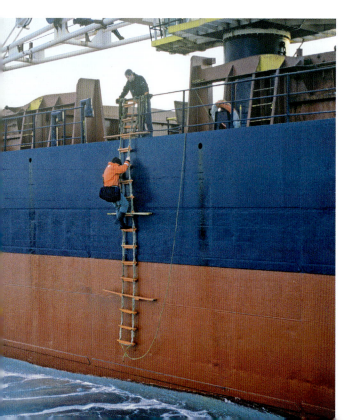

A Penobscot Bay pilot climbing a Jacob's ladder

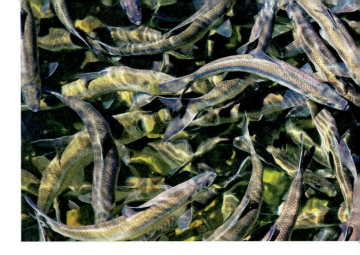

is an iconic Maine coast event that few of us witness. Each May these anadromous fish return unerringly to spawn in the streams and lakes where they were born. Their lives offshore are mysterious, and the urge that propels them on their extraordinary journeys home is not well understood, but the sight of these fish massing in a stream to spawn will not soon be forgotten.

Terns, seals, even clams are likewise revealed by Joe in brief moments of extraordinary light and composition, and he has journeyed to little-known Machias Seal Island to find puffins in their native habitat.

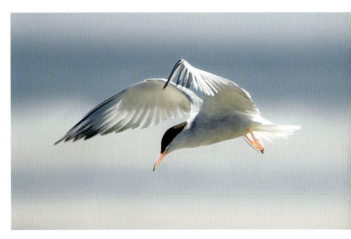

Joe's watchful camera has recorded the architecture of the Maine coast too. Weathered, stoic, stooped, haggard— these adjectives apply to many of the homes, sheds, and churches as well as the people who populate Maine's seaward-facing villages through winter gales and the halcyon days of summer. And yes, we've included a few stalwart Maine lighthouses, revealed here as we've never seen them before. On the Maine coast, things hide in plain sight.

Drive down any Maine peninsula until you reach its tip, and you'll enter an elemental place of stark power and beauty where granite meets sea. Many things hidden there

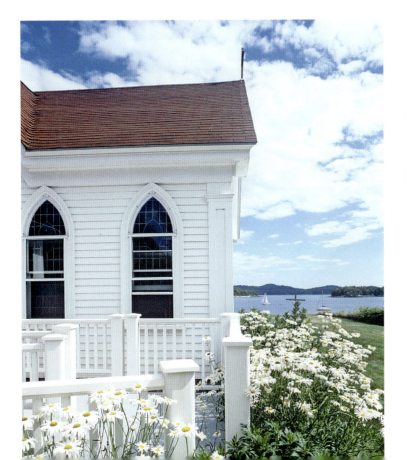

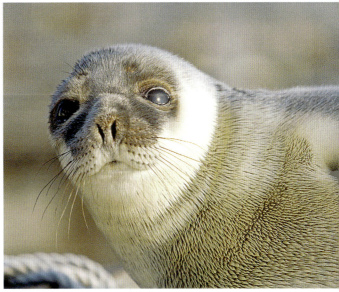

Above, top to bottom: Alewives in Damariscotta Mills; A tern over Popham Beach; Harbor seal.
Left: A Castine church.

3

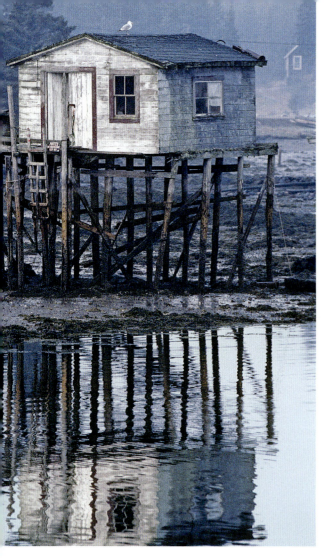

Frenchboro, Long Island

are revealed in these pages. But equally as many discoveries can be made in Maine's upper-estuary salt marshes, beyond the din of surf rote. The Pleasant River, for example, way down east in Washington County, possesses a secret life that is practically unknown except to those who grow up beside it. The hidden loveliness of this river is among the treats in this book.

Lapidaries will make their own discoveries in Joe's photos. If you're a polished-stone enthusiast, take out a magnifying glass to view some of these photos of shorelines, especially those bedecked with rounded stones. You'll see surprisingly beautiful granites, jaspers, feldspars, and rosy quartz. With or

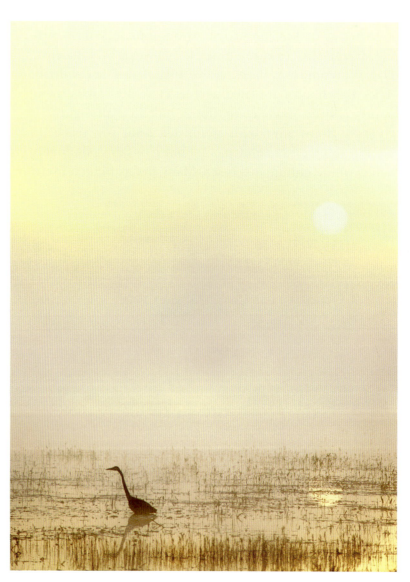

Great blue heron on the Damariscotta River at Newcastle

4

without a magnifying glass, we hope you find your personal "gem" images in the pages that follow. Only a fool would boast of finding all that is hidden along the Maine coast. No doubt we've missed more than we found. But we hope our collective efforts allow you to see and find for yourself some satisfying, smile-inducing hidden pleasures.

–KEN TEXTOR, Arrowsic, Maine, February 2014

Pemaquid
Point

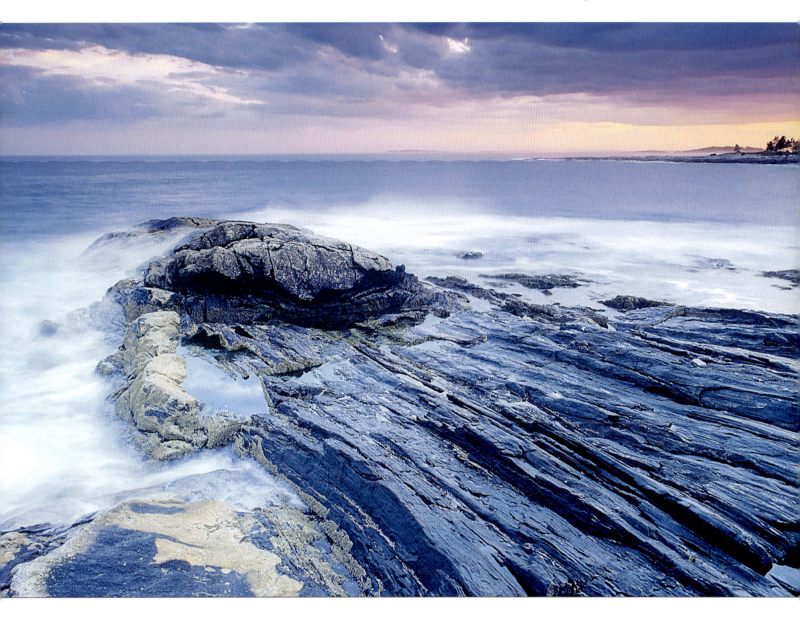

The Isles of Shoals

Is this group of islands some six miles seaward of Kittery really surrounded by shoals? The answer, it turns out, is a matter of interpretation.

The etymological forebear of the modern word "shoal" was bouncing around northern Europe and what would become Great Britain at least six centuries prior to the official European discovery of the islands in the early seventeenth century. Trouble was, and still is, the word was used variously to describe shallow water, a large collection of fish, or, as some have postulated, both. In fact, according to several historians, Captain John Smith named this archipelago the Isles of Shoals because he saw fish cavorting nearby in schools large enough to make the sea appear shallow.

More confusion soon arose between Maine and New Hampshire, both of which made competing claims for the islands for more than 200 years. After much rancor, teeth-gnashing, and litigation, that dispute was finally settled (we hope) in 1976.

Even the number of islands in the group depends on how you define "island." We count seventeen. Others come up with fifteen. And at least one Granite State ferry service doesn't seem to acknowledge the Maine islands, insisting there are only nine in all. But this sunrise captured at Broad Cove on Appledore Island shows unambiguously that the Isles of Shoals are among Maine's best hidden treasures.

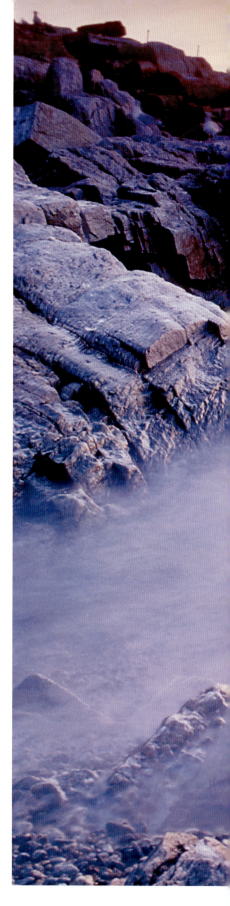

Sunrise at Appledore

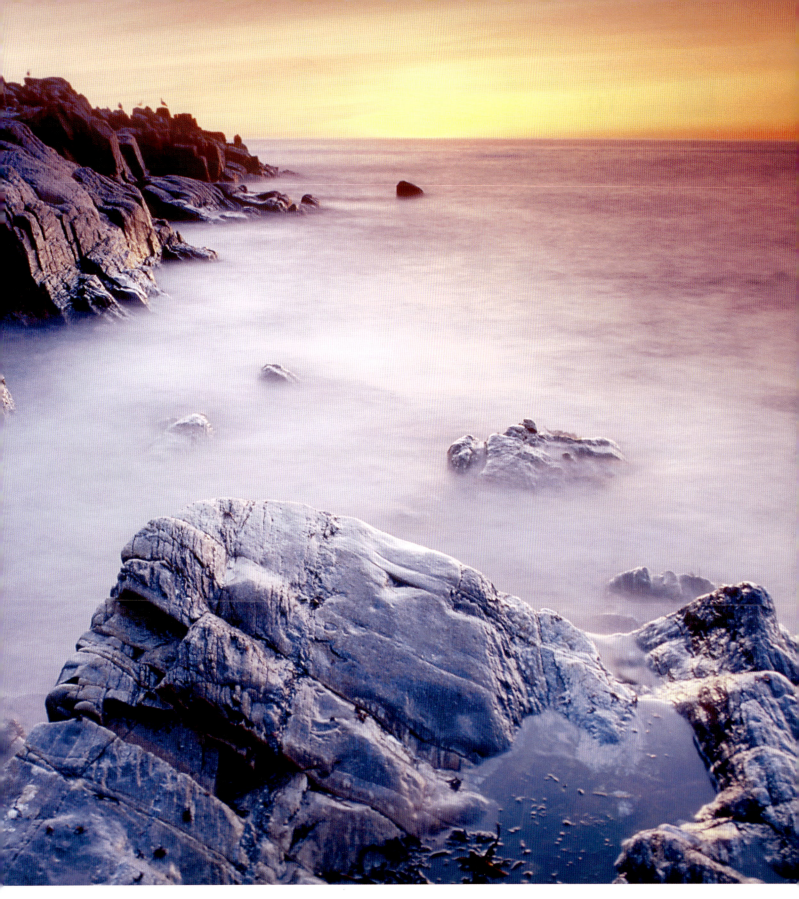

York

York Harbor may look decidedly modern, but a short trip inland will show you the town's antique roots. The best way to get there, if you have the chance, is by riding a shoal-draft skiff on the York River's powerful flood tide.

This little side trip might seem like a fool's errand as you pass under the twin bridges of U.S. Route 1 and Interstate 95. Once the noise and hubbub of those roadways fade, however, the banks of the river become more tranquil. The northern bank, even with the growth of new subdivisions in recent years, still shows the marks of old farm fields and long-forgotten shipbuilding operations, perhaps going back as far as the 1640s when the town was founded.

Soon enough you pass under tiny Scotland Bridge, whose name is a reminder of the blood that runs in many a York native's veins. Then tranquility becomes serenity as bucolic salt marshes take the place of further housing developments. Recent centuries fade, and older times are reasserted.

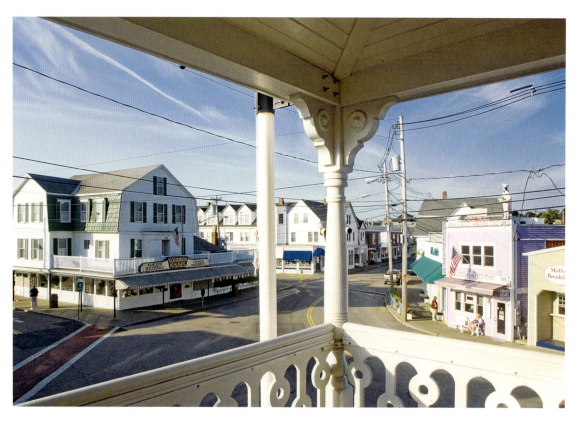

The view from the porch of the Atlantic House, on the corner of Main and Beach streets, York Beach

York Harbor, looking southeast

Cape Neddick

Perspective becomes harder and harder to maintain in the Digital Age. Even this fisheye view of the lighthouse known as the Nubble, at Cape Neddick, reminds us how difficult it is to maintain a sense of proportion in the modern world.

The photo suggests that the lighthouse is at the edge of a rather small, rounded world. We know, of course, that this is not really true, the Earth being nearly 25,000 miles in circumference. Indeed, beyond the Nubble stretches some 3,000 uninterrupted miles of ocean between us—standing on this southern Maine shore—and our counterparts on a beach in Portugal. But what does that mean?

Today, a distance like that can be conquered with a ticket on a jet plane and six hours of reading a bad novel, plus maybe a hassle or two at customs and security. But not long ago, in the Age of Sail, crossing the Atlantic involved weeks of moving at a pace slightly faster than a brisk walk and then searching anxiously for the Nubble's counterpart on the other side. Bad food, bad weather, and bad company had to be endured throughout. And when the Nubble's counterpart was finally sighted, a surge of joy in excess of winning a Super Bowl washed over the ship.

Looked at this way, our innate love for coastline sentinels like the Nubble becomes understandable. Even if you never have and never will travel a single mile in a vessel of any description, a little perspective can give you a great deal of appreciation for a lighthouse on any shore.

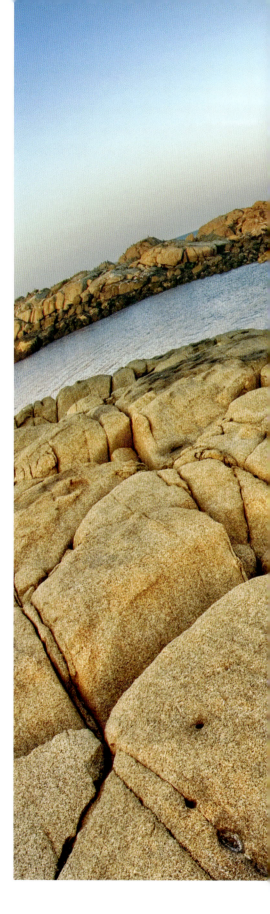

The Nubble

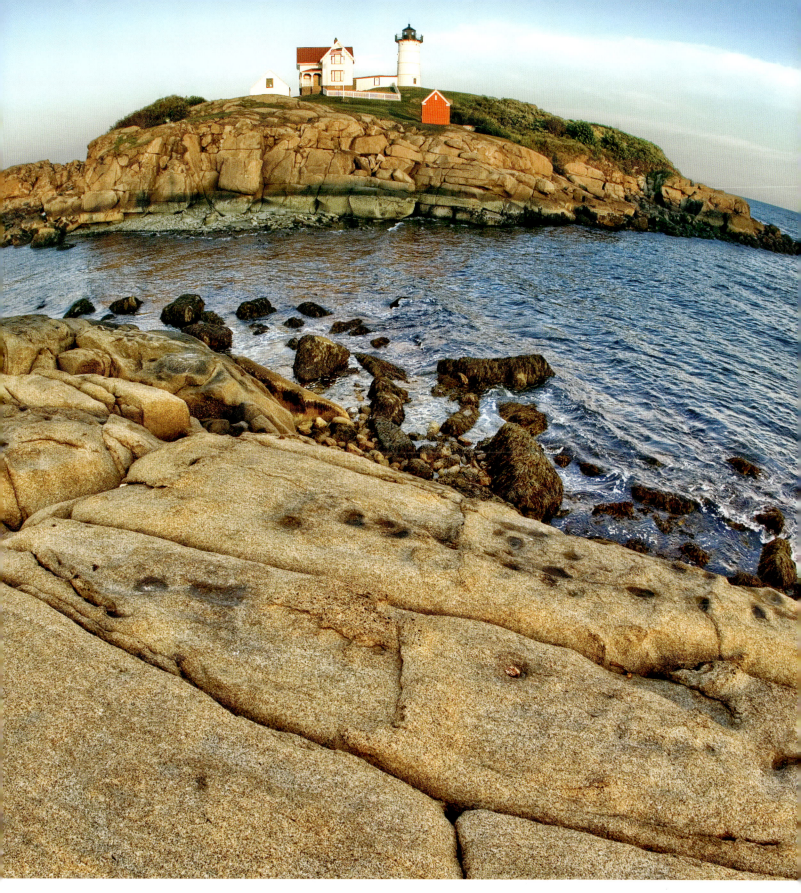

4 Ogunquit

Looking as if they might be moored in heaven, the boats in Perkins Cove in Ogunquit are indeed in a nautical utopia. Perfectly protected from just about any storm imaginable, this enviable anchorage required more than just a wave of Neptune's trident for its creation.

Settled in the late seventeenth century, Ogunquit attracted large numbers of fishermen among its earliest residents, but the shoreline lacked a good natural harbor. Boats could be launched and retrieved from local beaches when the weather was good, but major storms turned too many boats into kindling.

So the fishermen started digging. By sheer grit, and without any engineering studies or environmental impact statements, they created a trench from what was then called Fish Cove to the Josias River and what is now Perkins Cove. By a stroke of luck, the ensuing tidal currents rapidly increased the depth and breadth of their efforts.

Since then, boats moored in Perkins Cove have been quite safe from storms. With so little room, rights to the limited number of mooring spaces are tightly held family treasures—as they should be. If your grandparents bequeathed you a one-of-a-kind home by the sea, would you sell it?

The beach at Ogunquit is made for bare feet, leaving prints that the next tide washes away.

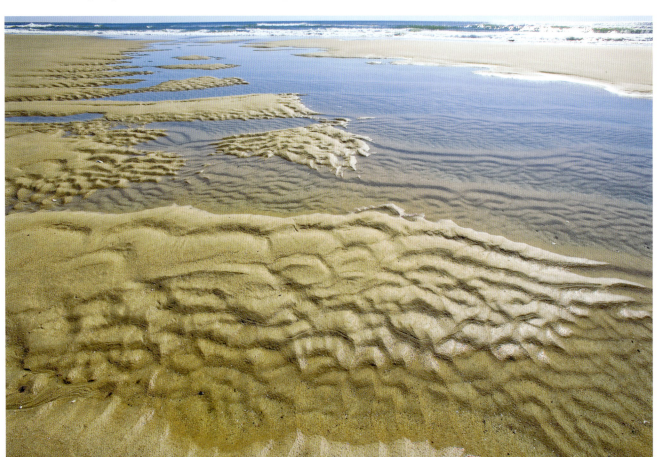

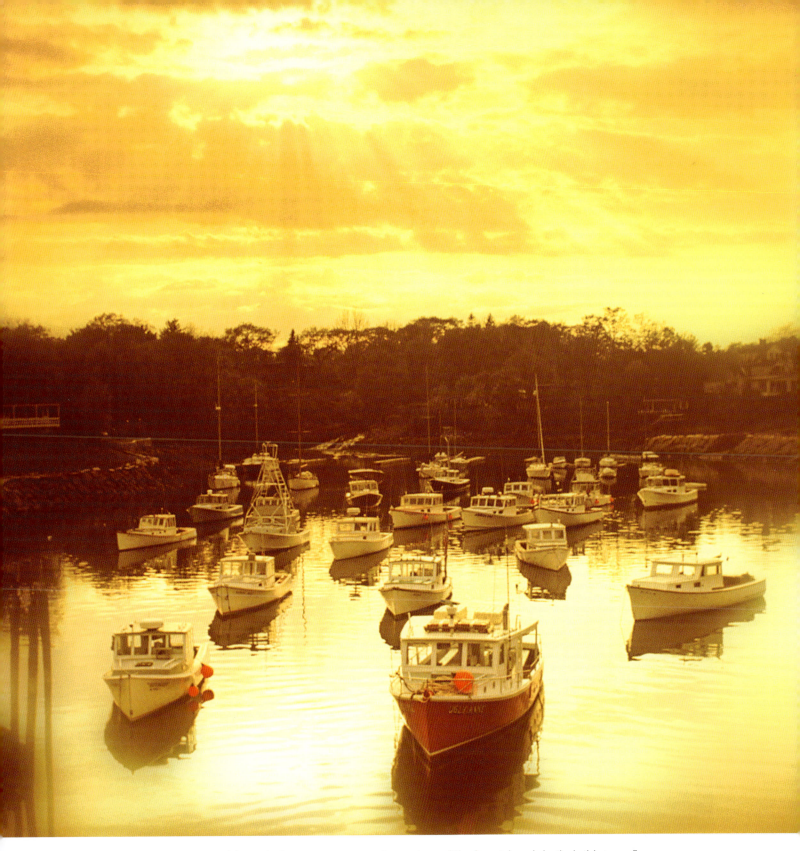

"Light breaks where no sun shines; / where no sea runs, the waters of the heart / push in their tides. . . ."
—Dylan Thomas

5 Wells

Sculpture is apparently one of Neptune's hobbies. With gentle wave action and subtle tidal changes, he carves and shapes beach sand along the Little River at the Wells National Estuarine Research Reserve into eye-popping masterpieces that he reworks twice a day.

While vacationers frolic at nearby beaches and roadside attractions, research scientists frequent the 2,250-acre reserve to study the life cycles of eels, alewives, smelts, and a host of other critters. The vagaries of natural sand sculpture are measured by scientists tracking rising sea levels and barrier beach formation and destruction. The rest of us are free merely to enjoy the ephemeral beauty as it comes and goes on a weekly, daily, even hourly basis.

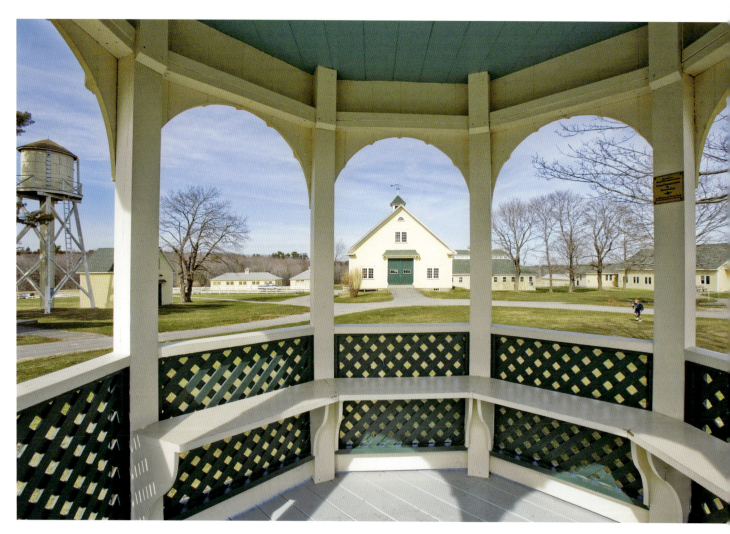

Gazebo at Laudholm Farm

Little River, Wells National Estuarine Research Reserve

6 The Rachel Carson Wildlife Refuge

She looked like anyone's mother in the 1950s, sweet and unadorned, smiling shyly. But Rachel Carson is credited with founding modern-day environmentalism, largely as a result of the publication of her controversial book *Silent Spring* in 1962. The photo opposite was taken near the Rachel Carson Wildlife Refuge headquarters in Wells, but she and the refuge are woven into the fabric of the entire southwest coast of Maine.

A native of Pennsylvania, Carson frequently visited a part of the coast of Maine far from the salt marshes with which she is now associated. The rocky shores of Southport Island, connected to the mainland at Boothbay Harbor, were a favorite summer haunt of hers. She often said that the Maine coast continually inspired her work and writings, and when she died in 1964, she chose to have her ashes scattered on Sheepscot Bay, near Cape Newagen at the tip of Southport Island. Carson remains an icon to many on the Maine coast. Her books *The Edge of the Sea* and *The Sea Around Us* are still standard texts in many Maine schools.

Left: Sunrise at the Rachel Carson Wildlife Refuge. Opposite: Refuge salt marsh.

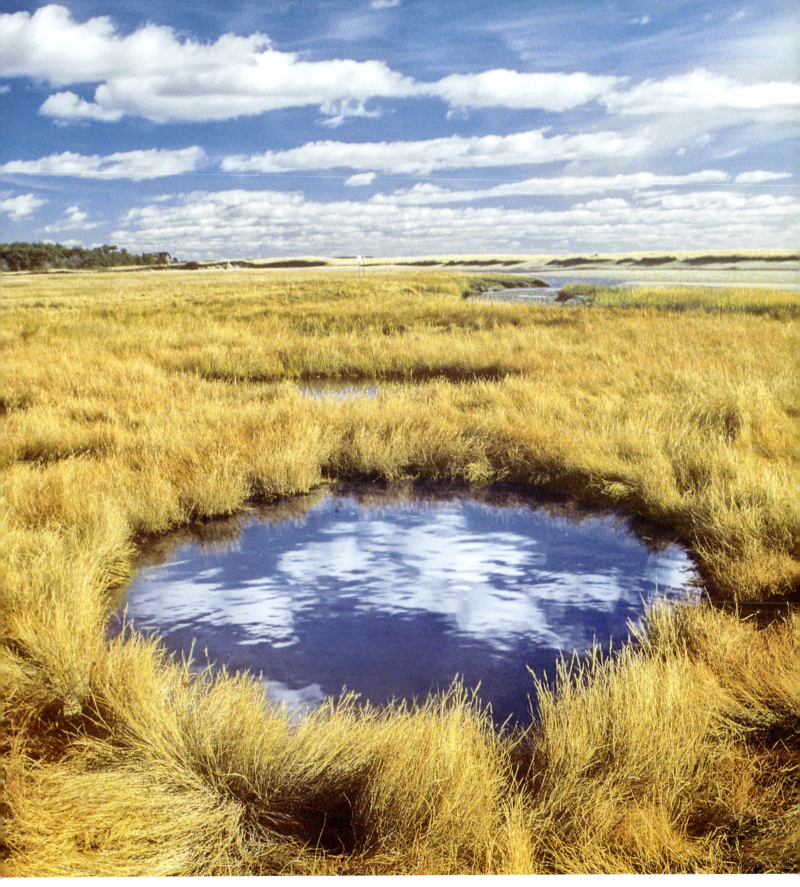

Kennebunk & Kennebunkport

Amazingly, a gentleman or gentle woman sporting a surfboard is an increasingly common sight at Gooch's Beach in Kennebunkport. In fact, many Maine beaches report increasing numbers of surfers, forcing one to wonder whether it's true that you can "catch a wave and you're sittin' on top of the world."

Overplayed Beach Boy tunes notwithstanding, there are perfectly logical reasons why Maine is attracting wave riders. Our notoriously cold waters (rarely out of the 60s even in midsummer) put a lid on the number of competing surfers. The tubular folks south of Cape Cod always complain of too many nearby surfers making maneuvering on a wave more difficult. In Maine, not so much. And that's especially true in winter, when storms on the Gulf of Maine whip up big surf for those crazy enough to tackle it.

Still, in hidden nooks at hidden times of day, Kennebunkport is what it has always been, a place of sand, rock, dune grass, and plaintive cries of gulls.

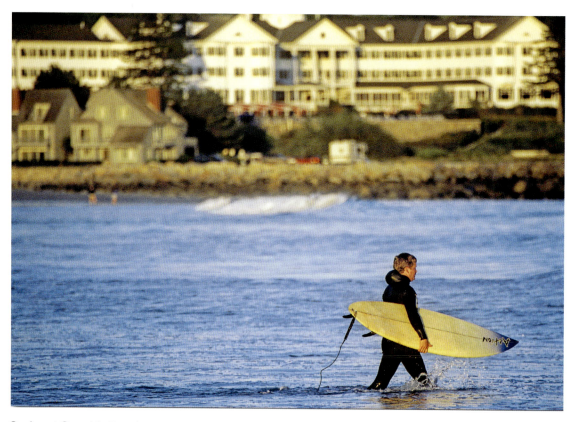

Surfer at Gooch's Beach

Gooch's Beach, Kennebunk

8 Ferry Beach, Saco

Exactly what is it that imprints memories of a day at the beach so indelibly in our minds? Whatever it is, surely this youngster headed down a boardwalk at Ferry Beach near Camp Ellis, Saco, will have an unforgettable day. After all, a damp day at the beach is all about odors.

Neuroscientists are rapidly coming to the conclusion that Marcel Proust reached years ago: The areas of the brain concerned with memory are in close proximity to the areas that process smells. Moreover, biological oceanographers have concluded that one of the most compelling scents of the sea appeals to our most primal instinct: the urge to eat.

When our raincoat-clad youngster on the boardwalk "smells the salt water," she is actually inhaling a gas called dimethyl sulfide, which is given off by the ongoing deaths of trillions of plant-like critters in the water known as phytoplankton. And that's the same gas given off by such items as ripening fruit, baking bread, brewing beer, and many other scrumptious temptations. (For what it's worth, pure salt dissolved in pure water has no discernible smell at all.) With dimethyl sulfide in the air, it's no surprise that young and old alike experience a heightened sense of hunger at the beach. And perhaps the satisfaction of that appetite with some of our favorite foods is one strong basis for fond memories of a trip to the beach, whether at age five or seventy-five.

In any case, we can only envy our young stroller and the memories of Maine's coast to be stored away for reference at some time in the uncertain future. On rainy days or dry, there is always some secret to bring home with you, one you may not even know of for many years and until you smell it again.

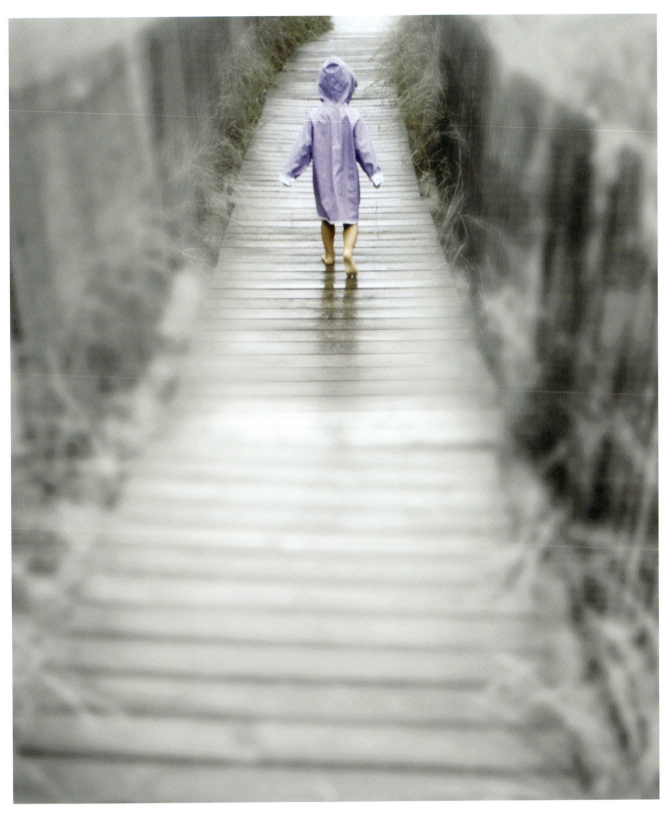

A damp day at Ferry Beach

Old Orchard Beach

Quiet reflection and secluded strolls are rarely in abundant supply at busy Old Orchard Beach, the venerable summer resort that has become Maine's Capital of Kitsch. But at sunrise on a weekday morning in August, they are still possible.

At such a time you might consider yesterday's sunbathers and last night's revelers with awe and a touch of wonder. You might ponder how many gallons of suntan oil are washed into local waters, or a wandering mind could estimate the decibel level of an oldies band from the night before and guess at its impact on tympanic aging.

Then there is the name of the beach itself: Old Orchard.

Today, of course, there is no orchard in this Maine garden of earthly delights, but historians say one was planted and cultivated in the late 1600s somewhere near the edge of the sandy strand, only to be abandoned when violent disagreements with Native Americans made further farming untenable. But the orchard, we are told, survived, thrived, and was readily visible from just offshore. Sailors used this visible landmark for another hundred years or so, referring to it as "the old orchard beach," as distinct from other nearby beaches.

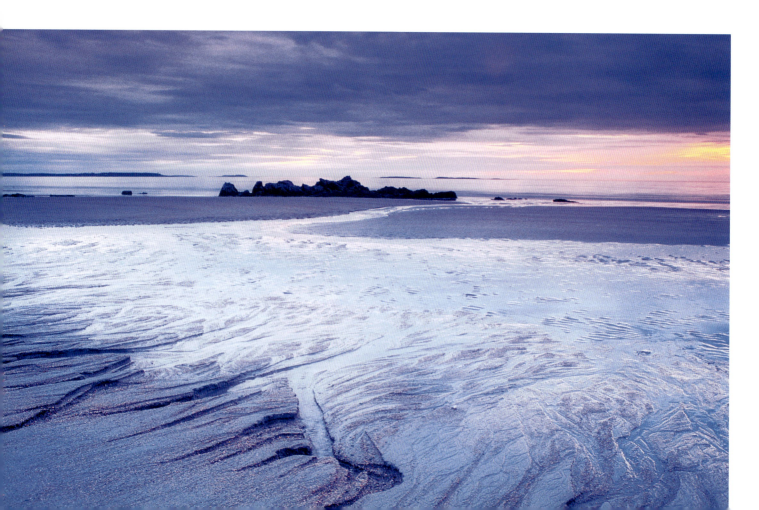

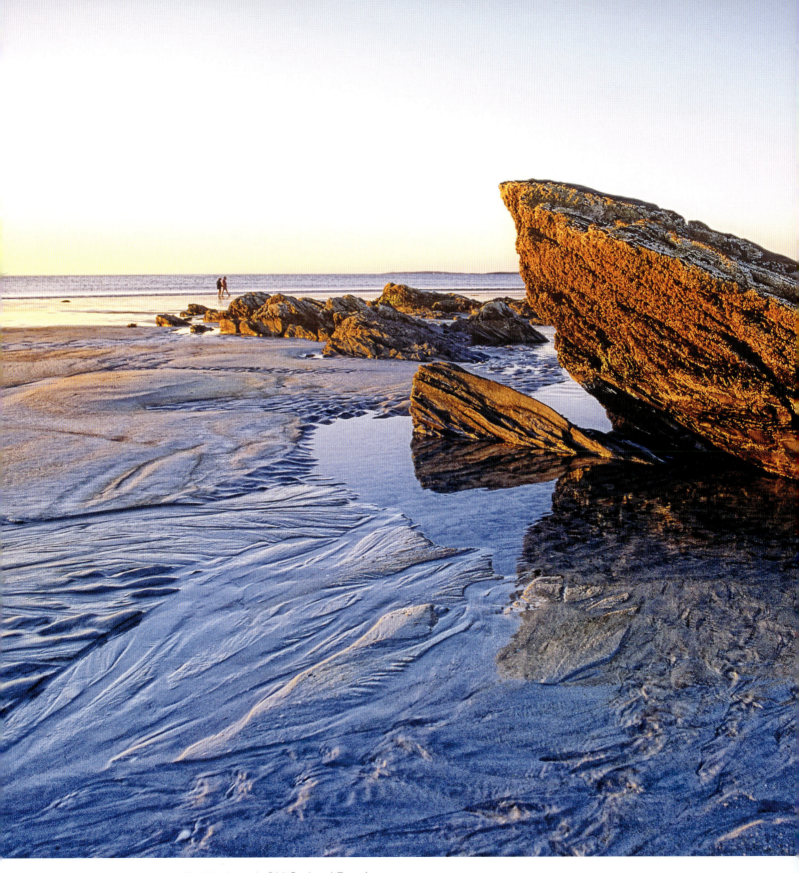

Opposite and above: Braided sand, Old Orchard Beach

Prouts Neck

This high-end enclave could not be more different from Old Orchard Beach, which its west shore faces across Saco Bay. There are folks on Prouts Neck who make it plain that impromptu visitors are at the bottom of their list. Although similar in that respect to a half dozen other rocky points sticking out into the Gulf of Maine, Prouts Neck is notable as the summer home of famous artist Winslow Homer. In fact, his studio, a National Historic Landmark, is now open to the public—sort of. Even better, there is the Cliff Walk trail near his home, and it's open to the public. Better still, the 250-acre Prouts Neck Bird Sanctuary is popular with avian enthusiasts from all over the world. And best of all, the crowds are much thinner than Old Orchard Beach.

Winslow Homer's studio

The seaward shore of Prouts Neck

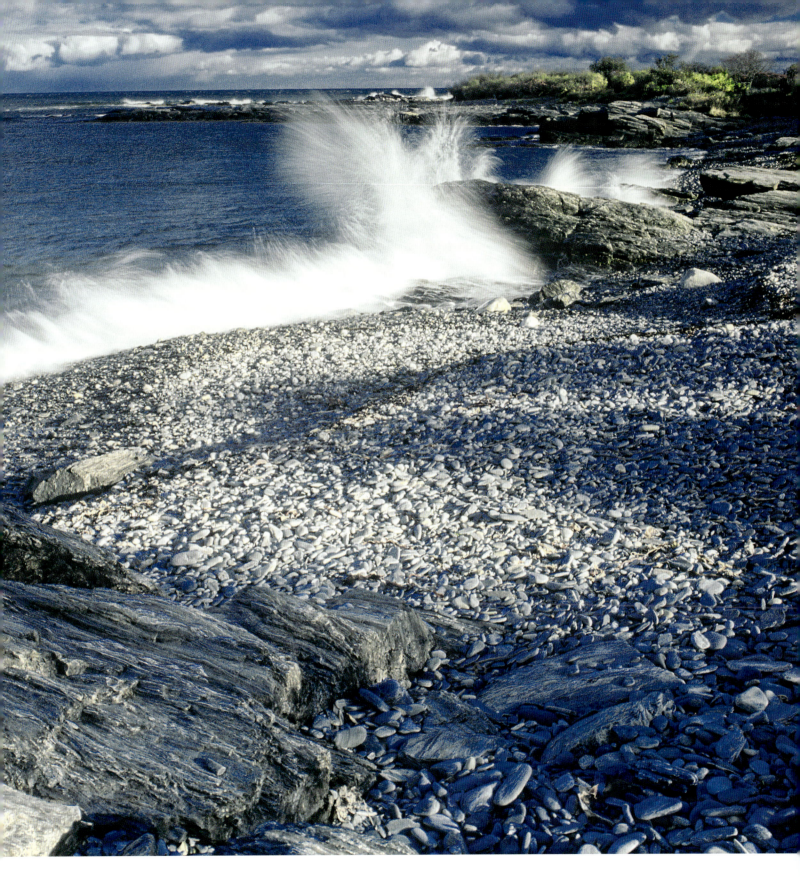

11 Scarborough Marsh

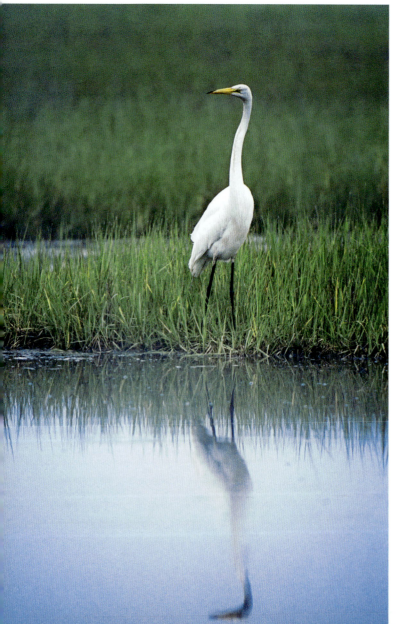

Stench to some is sublime fragrance to others, as magnificent Scarborough Marsh makes clear even to the most casual visitor. Even better, that "stench" means this 3,000-acre salt marsh is doing exactly what Mother Nature intended, despite human interference past and present.

Simply put, a salt marsh is a natural septic system protecting the ocean. The smell it generates derives from chemical reactions that absorb an overabundance of runoff nutrients from the land, creating an incredibly fecund nursery environment for shellfish, finfish, and waterfowl and at the same time preventing coastal waters from turning eutrophic and thus unfit for lobsters and other sea life. Further, salt marshes dissipate storm seas, protecting the upland areas behind them.

Alas, the presence of too many people can overwhelm delicately tuned systems like the Scarborough Marsh. Since Colonial times, marshes have often been looked upon not as Nature's solution, but as problems in need of "correction." Even today, filling, altering, and developing these wetlands, along with the fertilization of nearby suburban lawns and putting greens, make a marsh's job tougher and tougher. Environmental scientists urge us to think about the value of the "ecosystem services"—both economic and spiritual—we lose when we diminish natural habitat. In the case of a salt marsh, that value is dear indeed.

So when you visit a salt marsh and inhale its signature smell, count it among life's natural perfumes. Most of the planet's living organisms already do.

Left: An egret fishing in the marsh.
Opposite: The Scarborough Marsh on a still afternoon with thunderhead building in the distance.

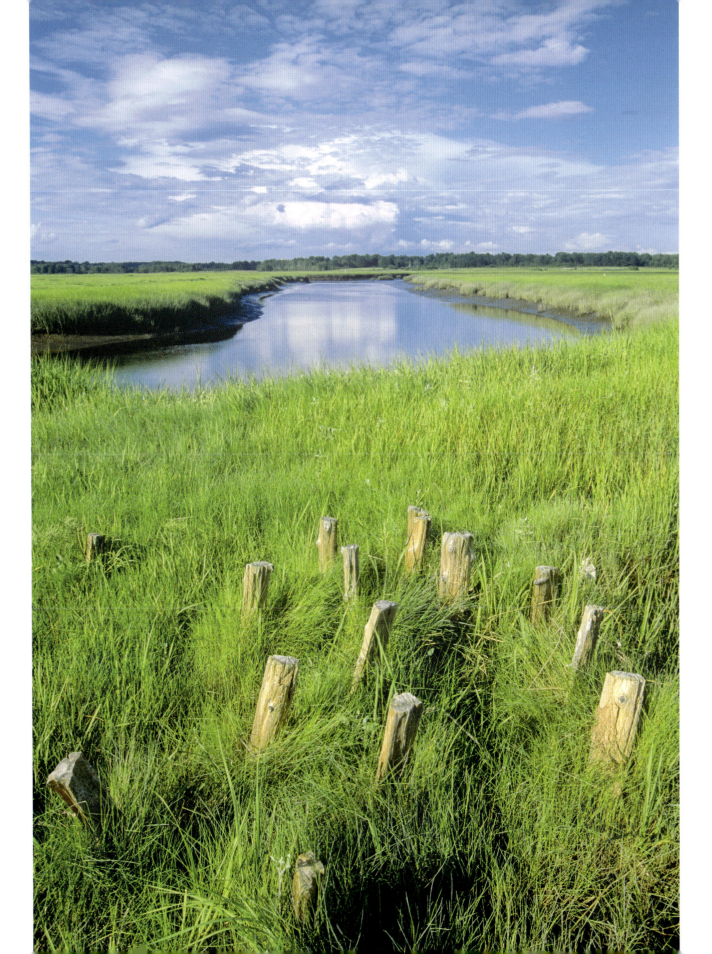

12 Portland Harbor

Forlorn and nearly forgotten, Ram Island Ledge Light was never quite in the right place at the right time. Despite being near the entrance of Portland Harbor, its location required a special type of lightkeeper and hardly attracts the romantics of today who preserve and protect such structures.

The ledges it marks are submerged most of the time, which made the construction of a lightkeeper's home impossible. That meant living in the tower itself, which often led to what today are called "mental health issues" for the lightkeeper. Only the toughest survived.

And it's rough out there. Two attempts to put a light on the ledges failed prior to 1902, when an unadorned granite edifice was put in place and became home for a light and foghorn that are still in use today. Lightkeepers were taken off for good in 1959.

Even today, no one seems to want much to do with Ram. No charity or government organization bid on it when it was put up for sale in 2010, and the winning private bidder appears in no hurry to spruce things up. Only the gulls and the occasional soft-hearted lobsterman seem to appreciate it now.

Ram Island Ledge Lighthouse

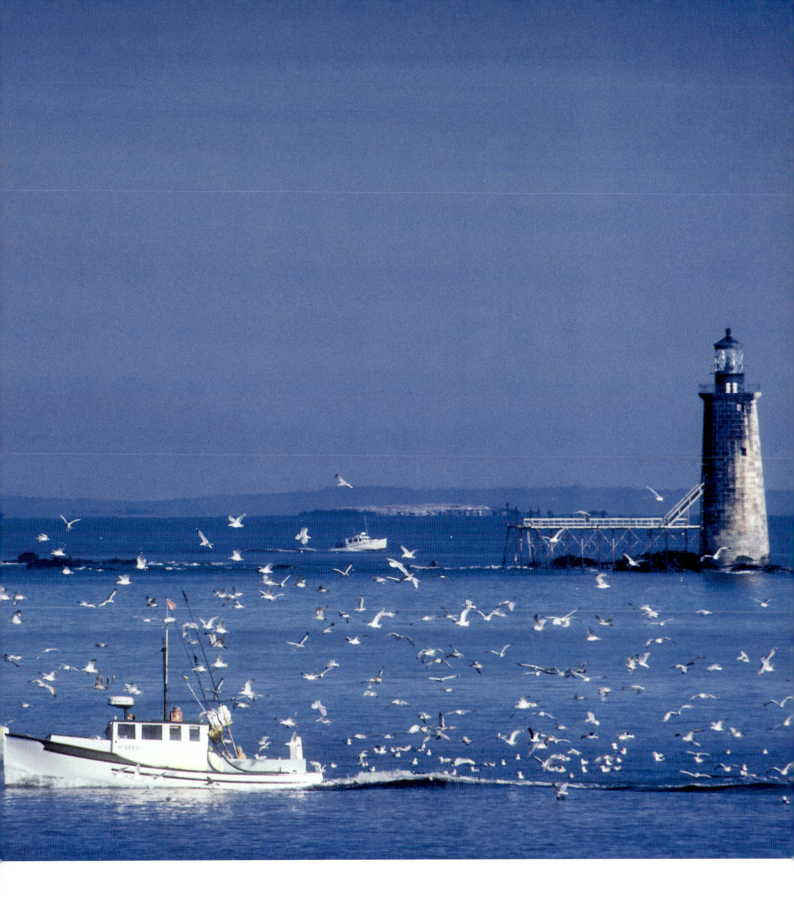

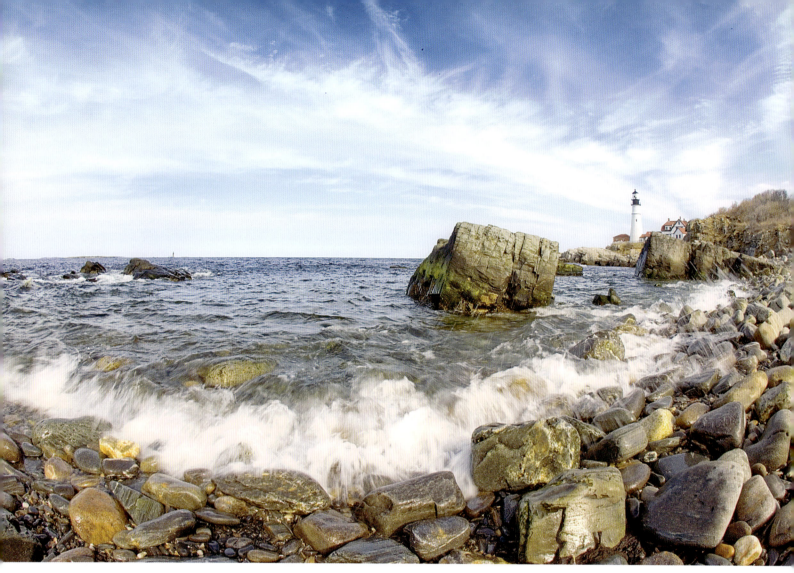

Portland Head Light in
Cape Elizabeth

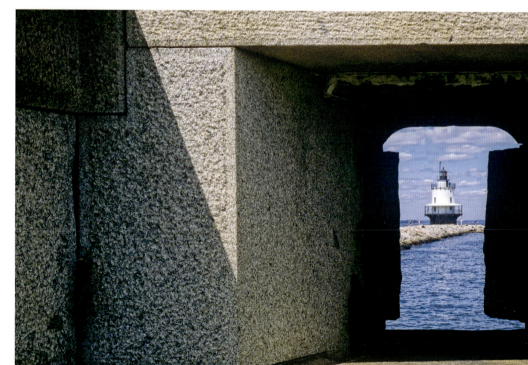

Spring Point Ledge Lighthouse,
South Portland

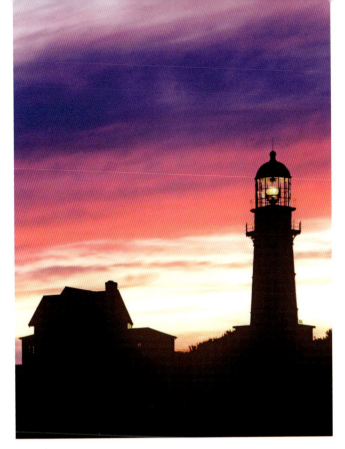

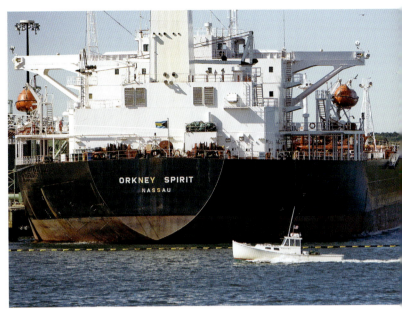

Commercial traffic big and little

Two Lights State Park, Cape Elizabeth

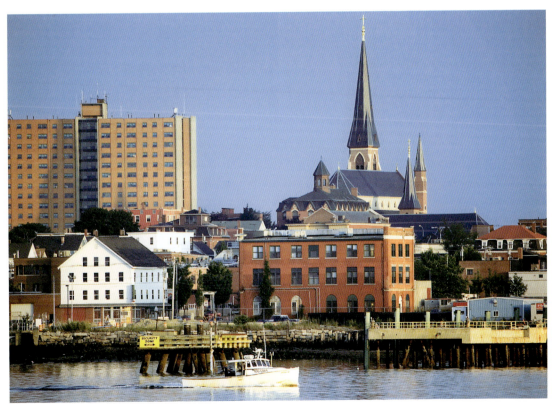

A portion of the
Portland skyline
seen from the South
Portland shore

13 Sebago Lake

Clanging along with a sun-filled symphony of metallic splinks, clunks, and bah-wangs, aluminum boats like these transported a generation of young boys and girls into their formative boating experiences. Dad could buy one cheap at Sears or from a Montgomery-Ward catalog store, and then away we all went. Or you could just rent one for the day, as you still can at Sebago Lake along the west shore near East Sebago. They were the Everyman Boat from the 1960s onward, a bare-essentials VW bug-on-the-water designed solely to get you from point A to point B with the potential for adventure every inch of the way.

The first "adventure" was tipping. Excited kids always managed to scramble around an aluminum boat in a way that was bound to make Dad lose his balance and fall—preferably overboard if you enjoyed a true ruckus. Or the boat would tip and take on water. Or we'd all just fall to the boat's bottom. Mom, of course, wisely waited until the hubbub settled down before stepping aboard—if she was unwise enough to attend this party at all. And then there was the rowing.

Yes, yes, we know all such boats are propelled these days with an outboard. But once upon a time they were rented with just oars. An outboard was a luxury that the five-dollar daily rental didn't include—unless you wanted to pay two more bucks. Not our dad! So we learned to row, sort of, with brother on one oar and sister on the other. When the boat described endless circles, as it always did, it was Sis's fault. She can't row. But Brud, you don't listen. And so on. Eventually, Dad ended up rowing.

At some point fishing would be undertaken, with mixed results. If nothing was biting and the sun oppressive, beaching the boat and going for a swim was the best option. And in Sebago's crystal clear waters—pure enough to supply the entire city of Portland with drinking water—the dip always refreshed. Then more clanging and banging, punctuating a day to be remembered as much for sounds as sights.

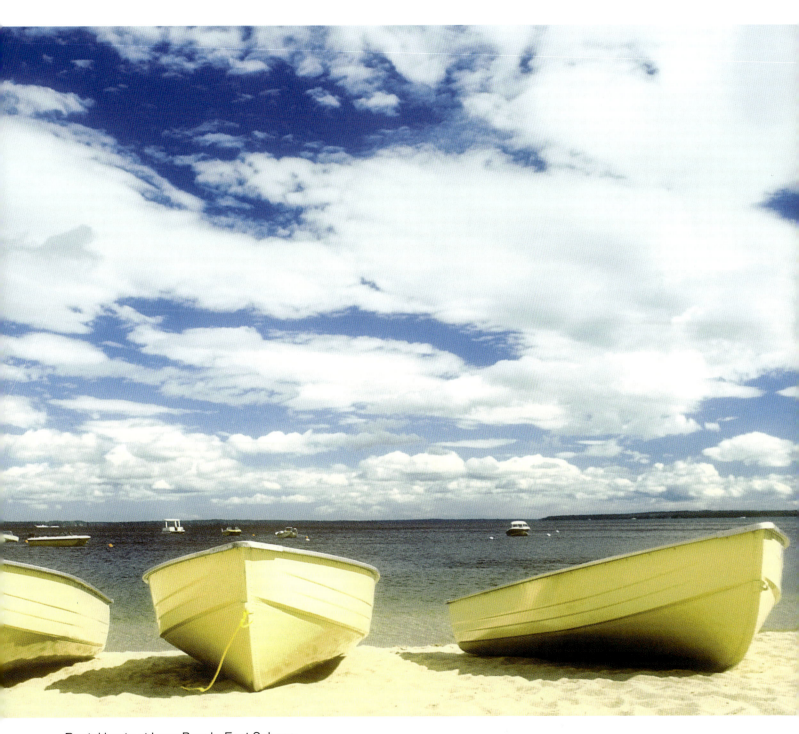

Rental boats at Long Beach, East Sebago

South Freeport

Harkening back to South Freeport's more down-to-earth past, an aging fishing dragger was "parked" this summer day in one of the toniest neighborhoods on Casco Bay. Exactly what the inhabitants of the Porters Landing district thought of this temporary visitor has gone unrecorded, but we suspect that at least some longtime residents of this branch of the Harraseeket River smiled upon its presence.

In fact, Porters Landing is just one of several branches of the Harraseeket that became very busy in the eighteenth century with down-and-dirty vessels of various descriptions. Shipbuilding and shipping were big business in South Freeport for nearly two centuries thanks to its sheltered location and waters that stayed relatively free of ice during the winter.

A riverside general store, post office, and various boatbuilders survived well into the middle of the twentieth century, surrendering only in the latter part of the century to Portland-driven suburban real estate booms and L.L. Bean's dominance.

Still, many residents within sight and hearing of the Harraseeket will correct you if you suggest that they are from Freeport. To be from South Freeport is to be from a different place entirely, one that is removed from mercantilism twenty- four hours a day, seven days a week.

Ready to fish

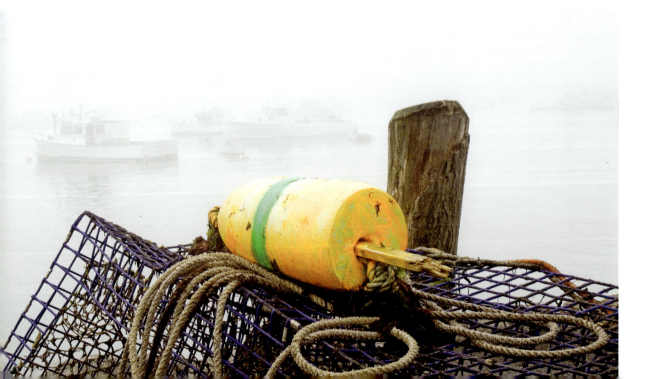

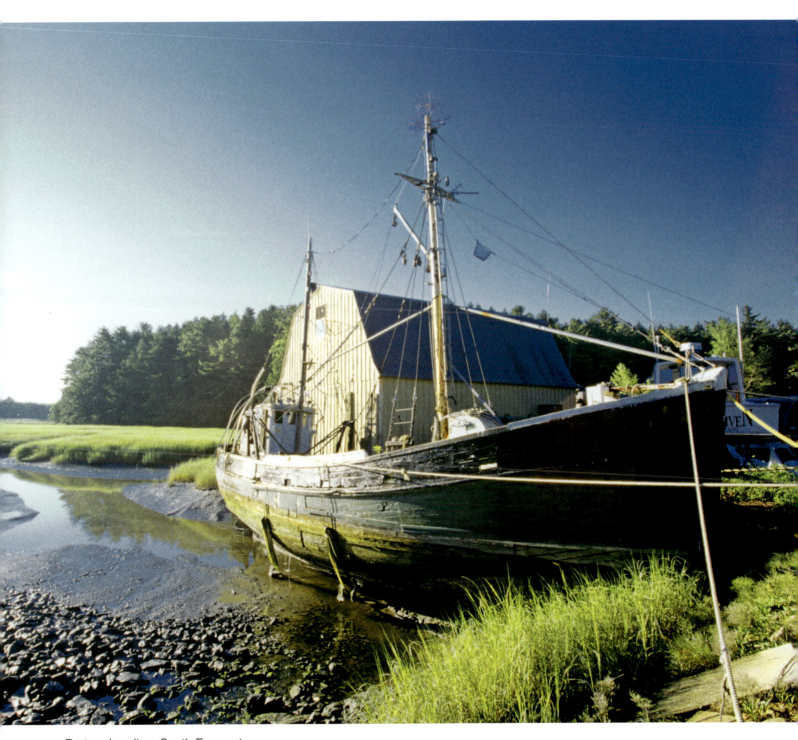

Porters Landing, South Freeport

Wolf's Neck Woods State Park, Freeport

Unknown to many longtime sailors of Casco Bay, there is yet another body of water on the Maine coast called Little River, though it's really just a cove that dries out at low tide with a trickle of a creek entering its upper end. Still, when the tide returns, a person in a shallow-draft boat can follow that creek some two miles through Freeport countryside that looks as the town did fifty or a hundred years ago. In fact, we have often wondered if larger vessels in centuries past went up this tidal stream, giving cartographers good reason to put Little River on the chart.

As visitors to Wolf's Neck Woods State Park will attest, the shoreline near the Googins Island Osprey Sanctuary is impressive, especially at high tide. And this serene and uncluttered strand is only a few miles from Maine's ground zero of exuberant shopping and effervescent consumerism in downtown Freeport. What better place to try out the kayak you just bought at L.L. Bean?

Right: A Freeport church. Opposite: Wolf's Neck in fog.

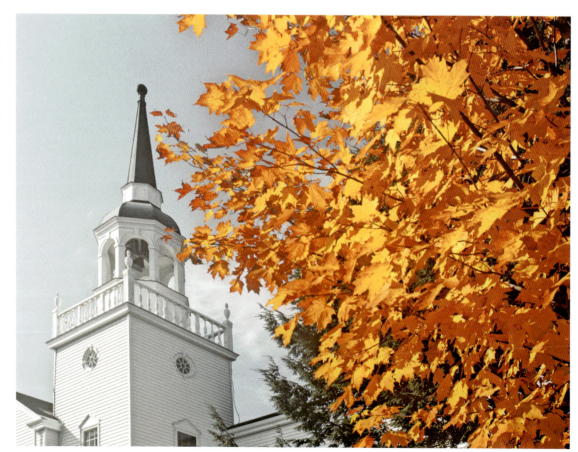

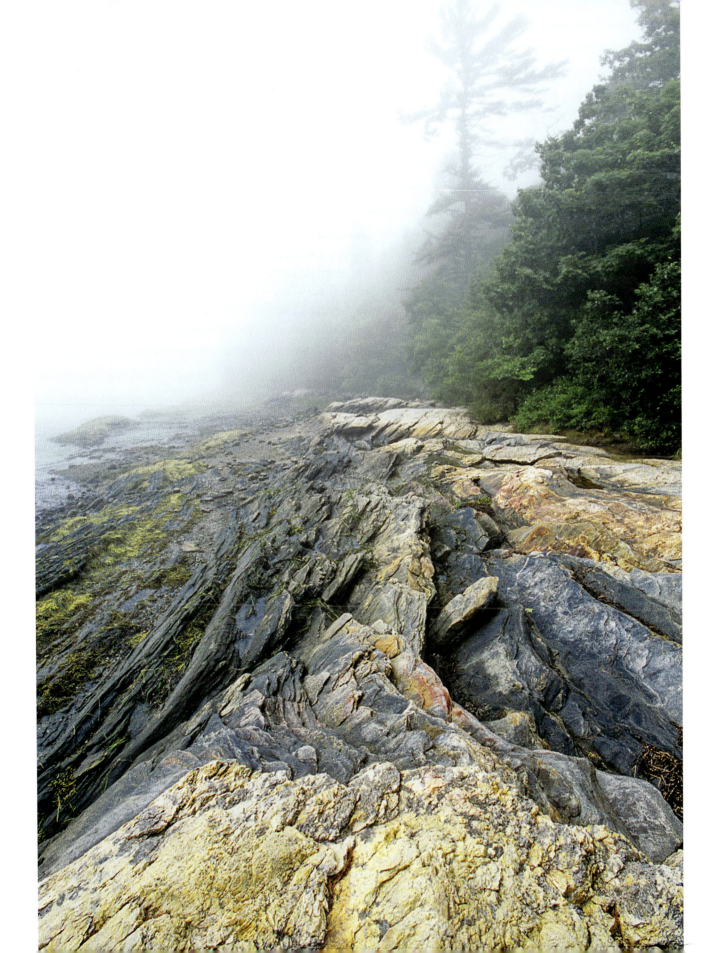

16 Harpswell

Seemingly tucked away in a forgotten cove near Nowheresville, these two fishermen are after Maine's most prized saltwater fish: striped bass. But they are, in reality, at about ground zero of Maine's busiest body of coastal water, Casco Bay.

Indeed, these fishermen are somewhere in the municipality of Harpswell, great stretches of whose shores are jam-packed with side-by-each bungalows, with hardly a space to swing a fishing rod. But even in Harpswell you can find forgotten coves in which to cast a fly, lure, or bait for schoolies, which is the name for the small striped bass that generally haunt hideaway waters like this bit of nirvana.

We could pinpoint where these fishermen are casting their lines, but in deference to the time-honored unwritten rule of not revealing a "honey hole" fishing spot, we won't. Suffice it to say there are scads of places in Casco Bay and elsewhere to search for stripers, which are also known to some visitors as rockfish, linesiders, greenheads, old pajamas, rollers, squidheads, squidhounds, bunkerchunkers, or herringhogs.

If you want to start an impassioned discussion, just bring up the idea of the "perfect" bait for striper fishing. These gentlemen look at peace with fly fishing, but exactly which fly we won't venture to guess—again, to avoid one of those impassioned discussions related to fishing.

A Harpswell dock

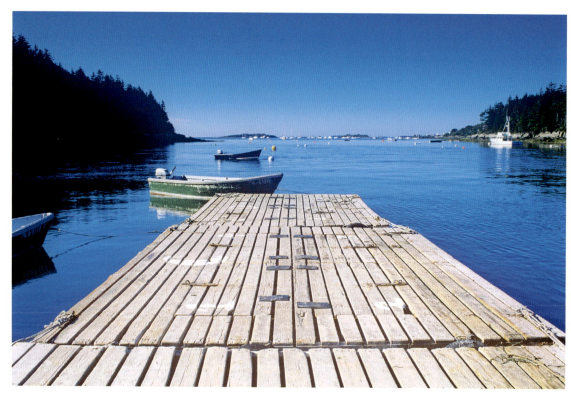

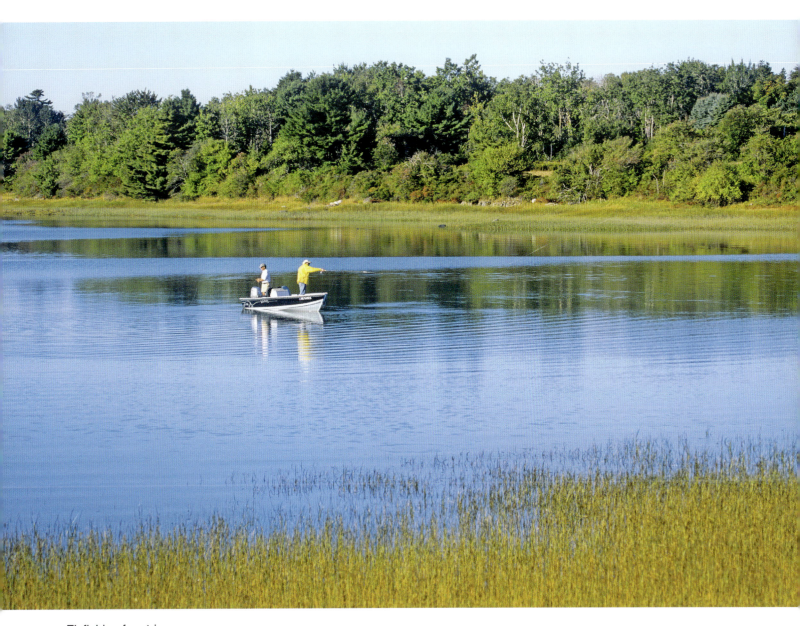

Flyfishing for stripers

17 Cundys Harbor

Tide's going out, the sun's about to rise, and the wind's only a word this morning. All's right with the world, right? Well, maybe.

Depending on how persnickety you are, the lovely port of Cundys Harbor in eastern Casco Bay has: (1) no problems; (2) a small problem; or (3) a problem of national importance. And the issue is: the apostrophe.

Yes, some Maine folks get up in arms over the lack of an apostrophe in the names of harbors like Cundys. Most people who live on land will give Cundy's Harbor its apostrophe wherever and however they write it, but the makers of nautical charts in Washington, D.C., generally refrain from using the punctuation mark except in extreme cases like, say, Martha's Vineyard.

Some years ago, a Maine lawyer even started a campaign to get Washington to change its ways—to no avail of course. The reason eventually offered to one fellow who tried for two years to get NOAA to insert an apostrophe into Bucks Harbor in Penobscot Bay was that some boater might mistake the punctuation for a rock. Really? Still, we're quite happy with Cundys Harbor however you write it, and we suspect most of those who live there are too. Who wouldn't be?

Cundys Harbor, Sebascodegan Island, New Meadows River

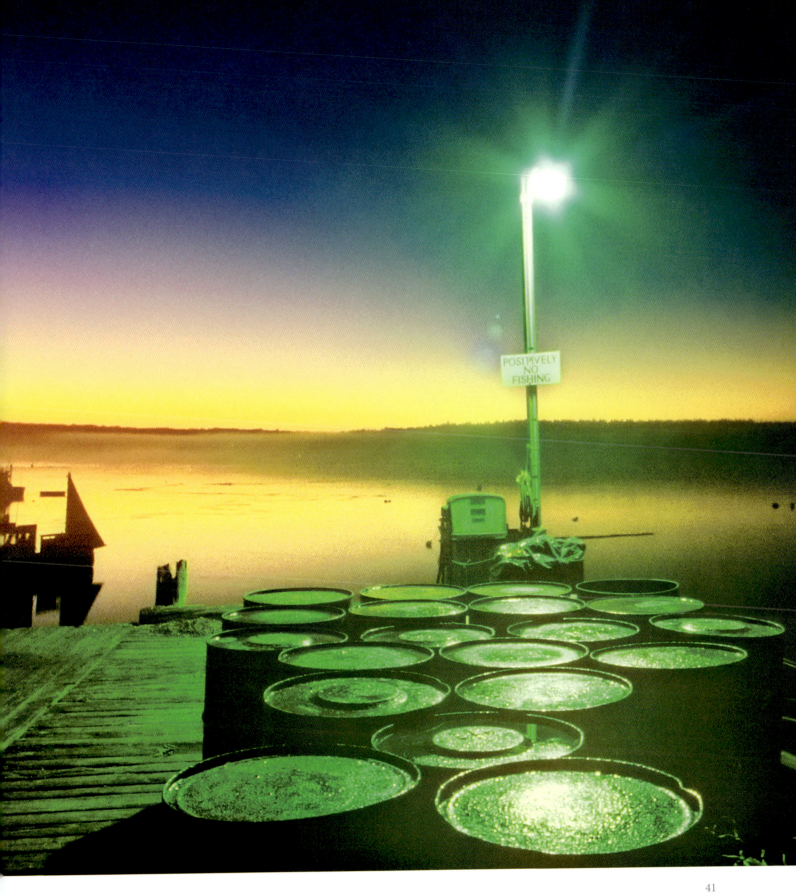

Merrymeeting Bay

Inexplicable and unpredictable, Merrymeeting Bay, just north of the city of Bath, defies even the so-called experts in fields as divergent as hydrology, meteorology, geography, and biogeography. It's not really a bay, given that the 17-mile-long Lower Kennebec River intervenes between Merrymeeting and the sea. Fed by six rivers, including the mighty Androscoggin and Upper Kennebec, but drained by only one, the Merrymeeting is a rare example of an inland delta. It experiences five-foot tides, yet salt water from the Lower Kennebec is prevented from entering the bottleneck lower opening called The Chops by the combined freshwater flowage of the six feeder rivers. Thus the Merrymeeting is deemed a freshwater basin, although distinctly salty currents have been discovered well beneath the bay's surface, especially during dry summers, and saltwater fauna follow those subsurface currents upriver, resulting in regular sightings of harbor seals chasing stripers all over the bay.

Underwater topography changes are frequent. Sandbars appear and disappear annually or by the decade, or even generationally. Strong thunderstorms often generate torrential downpours on Merrymeeting when just a few miles south or north of the bay, it's sunny and dry.

Merrymeeting Bay hosts a large bald eagle population and is second only to the Chesapeake Bay in concentrations of waterfowl on the East Coast. It is also a stopover for great numbers of migratory birds. In short, Merrymeeting Bay is a hidden Maine treasure.

Left: The bay from Bowdoinham.
Opposite: East side of the bay between Butler Head and West Chops.

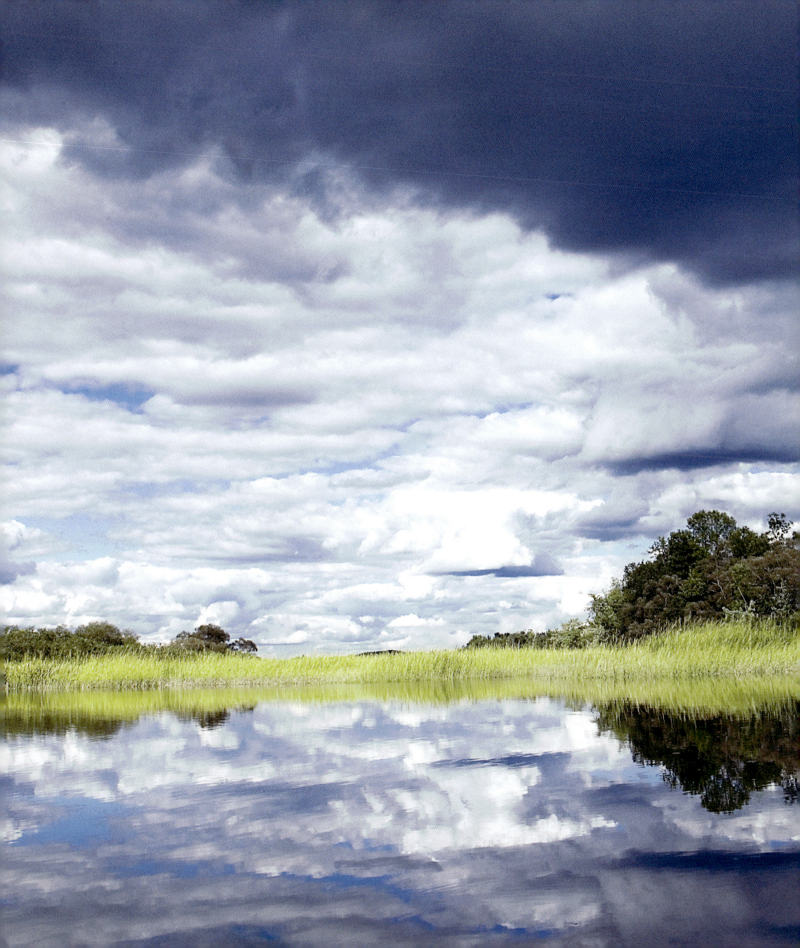

19 Bath

A rock in the tide comes to mind, both literally and figuratively, when considering Bath and the Kennebec River. As the cradle of American shipbuilding, Bath has long stood as a nautical construction stalwart while the currents of history swirled around it. But Bath owes most of its success to that quixotic tidal river on its doorstep.

Those familiar with the Lower Kennebec know that its moods run from benign to downright homicidal. The tidal currents themselves are considerable. But the river also drains an upcountry area larger than the state of Connecticut, adding considerably to the outgoing tide, especially after heavy rains.

When all that water heading out of the Kennebec meets a wind blowing strongly from the opposite direction, mayhem ensues. Perfectly seaworthy boats have been swamped and sunk in these conditions in recent years, and even grimmer statistics are available.

Still, a sense of pride and accomplishment can overtake the humble waterborne visitor who ascends the Kennebec and reaches Doubling Point Lighthouse on a nice day. Around a bend in the river and beyond the lighthouse are the shores on which many in the U.S. Navy say the best ships are still built, tides of any kind notwithstanding. The sight is pretty impressive.

The Bath Iron Works naval shipyard

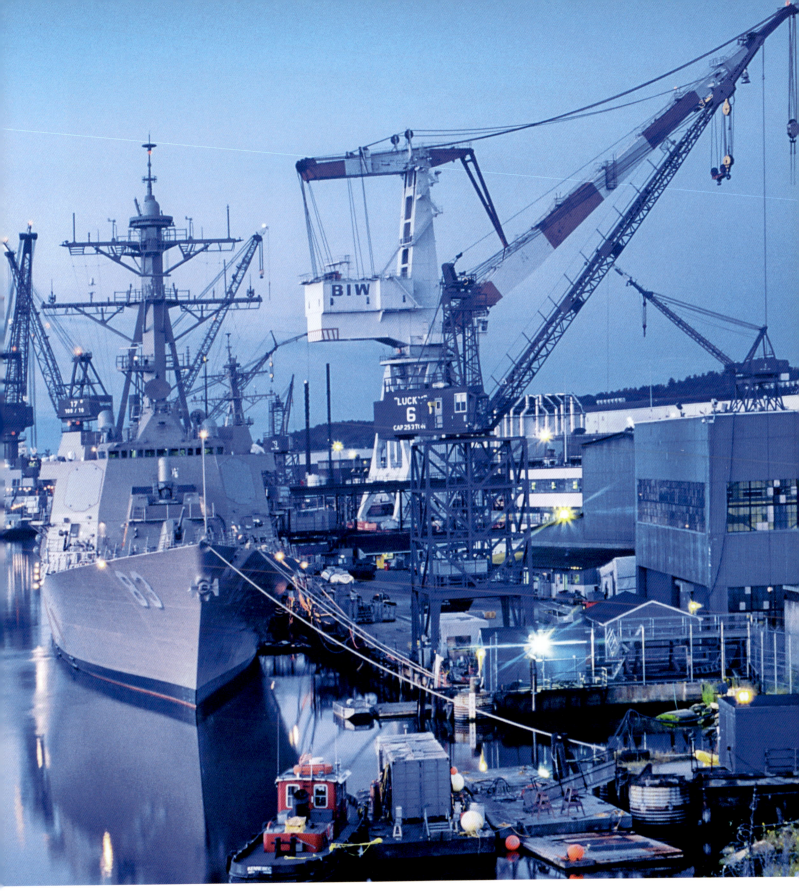

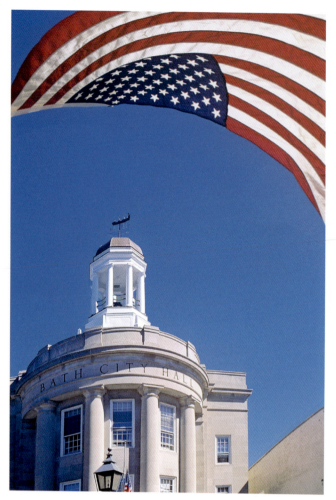

The Bath City Hall

At the Maine Maritime Museum in Bath

If you launch a boat at either of Bath's two public launch ramps and head east through the passage between Sasanoa Point and Arrowsic Island, you'll enter Hanson Bay, in the town of Woolwich, where these geese are swimming. Thirty years ago, no bird of any description could have overwintered on Hanson Bay, because the tiny, marsh-fringed bay iced over every year, providing a good platform for smelt-fishing shacks but not for birds needing open water. In recent years, though, the bay has stayed open, and Canada geese have used it, nearby Hockomock Bay, and parts of the Upper Kennebec River for winter havens instead of decamping for points south as geese used to do.

Doubling Point Lighthouse on the Kennebec, just downriver from Bath

Looking up the Kennebec River from the Bath waterfront at sunrise

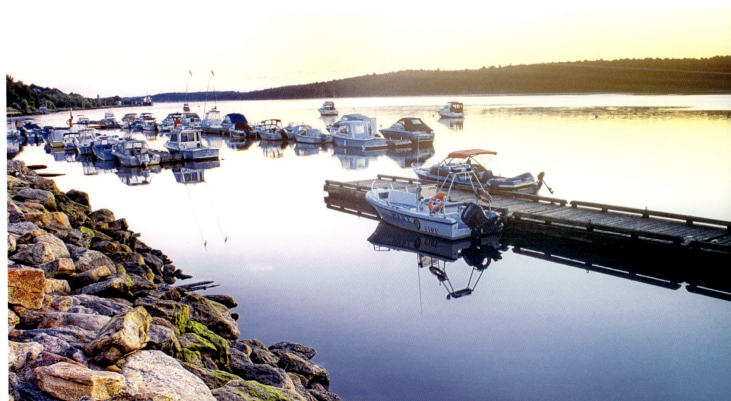

Popham Beach, Phippsburg

Man and Nature appear to be doing the same thing when we see a shoreside xeriscape of dune grass and old-fashioned wind fencing. But are they?

Sand dunes, we have learned, are Nature's way of protecting inland stretches of forested uplands. Over time, wave action builds these ramparts of sand, and then dune grasses move in to stabilize this loose structure. Eventually, to leeward of the dunes, more complex soils can build up and, over millennia, establish ecosystems of greater complexity and stability. This is a theory naturalists have held since the eighteenth century.

But alas, dune grasses are fragile. They can survive the arid sediment, salty air, and storm-tide encroachments of riparian life here at Popham Beach State Park in Phippsburg. Human traffic, however, tends to shorten the lives of dune grasses. These golden blades just haven't had time to develop a natural, genetically encoded response to being stomped on. So fences help keep humans off the dune grass and away from shorebird nests as well as becoming further stabilizers for the sand.

Lately, however, some biologists have been questioning this approach to dune protection. Many dune grasses have been planted by humans intent on beach stabilization, and too often a single species is used, leaving the dunes open to something called "monocultural collapse." If some disease or bug attacks the single species of grass, there's nothing left to hold the dunes together. And wooden slats wired together as fences certainly won't do the job.

On a late summer's day, however, it is easy to forget these concerns and just concentrate on the view of the misty Atlantic waters. They seem eternal, and Man's visitations, temporary. And that's somehow comforting, when you think of it.

The view from the corner of Popham and Hunnewell beaches, with Whaleback Rock in the distance

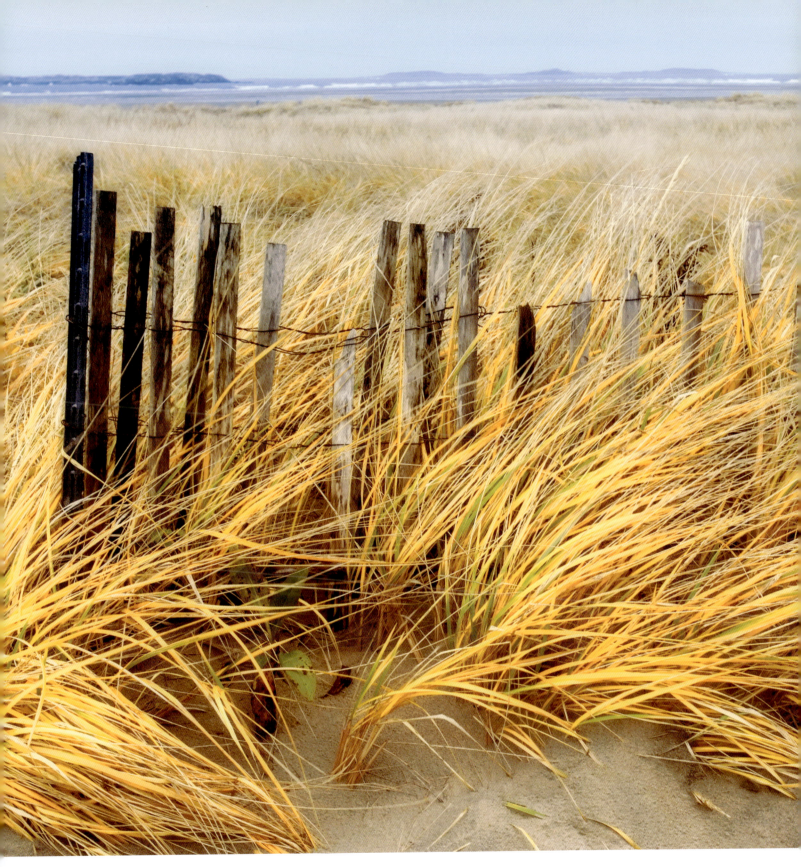

Dune grass at Popham Beach

Seguin Island

High and mighty, the light atop Seguin Island has been leading mariners to safe havens for more than two hundred years. And because of its age and location well offshore from the mouth of the Kennebec River, it has been among the most searched-for lights on the entire Maine coast.

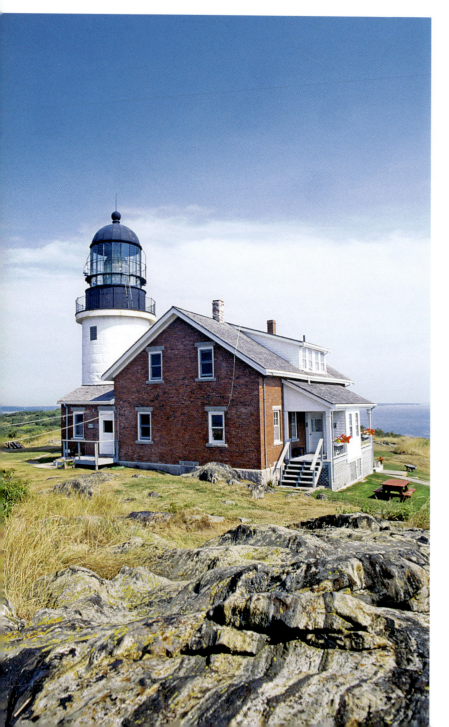

Before the advent of electronic gizmos, a visiting mariner approached the Maine coast cautiously—very cautiously. It was prudent to first find a lighthouse with a beam that would be visible well offshore, such as Seguin's bright white twinkle, which is visible some 18 nautical miles at sea.

Upon finding Seguin's light, the mariner has access to at least five safe ports via the New Meadows, Kennebec, Sheepscot, and Damariscotta rivers, with Boothbay Harbor nestled among them. Thus, although Portland Head Light might see a great deal of Portland-bound traffic, Seguin has attracted traffic for numerous ports, much like Monhegan and Matinicus lights farther east.

Mariners still use these handsomely made lights to verify what the electronic gadgets are saying. They remain highly functional and essential in addition to being historic and architectural treasures.

Left: Seguin Island Lighthouse. Opposite: The light with Fresnel lens is 180 feet above high water.

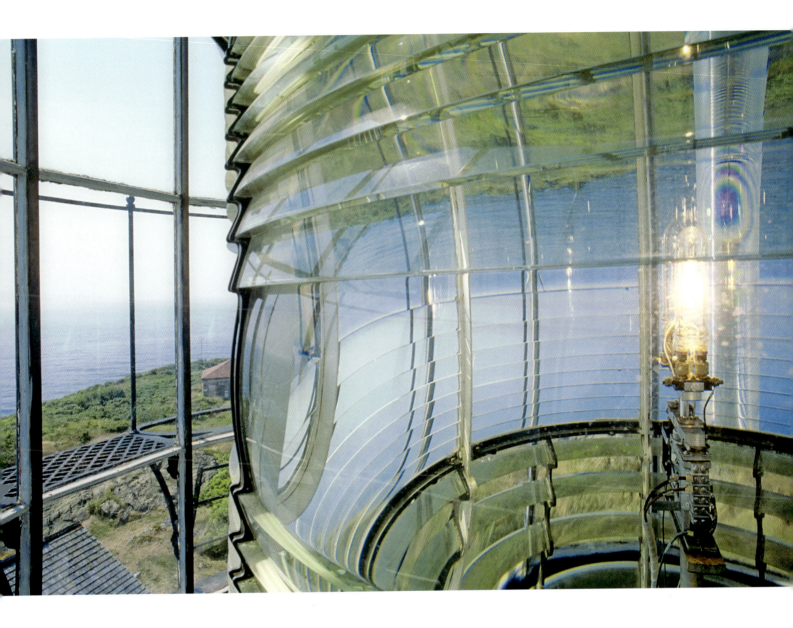

Reid State Park, Georgetown

Rags to riches is a familiar storyline. But what's rare is when the ragamuffin so consistently operates offstage and the riches end up in the hands of so many. In a nutshell, that's the story behind Reid State Park in Georgetown.

Walter E. Reid was born dirt poor in 1868 along the shores of Sheepscot Bay. One of six children, his seafaring father was lost at sea when he was eight, and he had to leave school to go to work when he turned eleven. But by golly, he knew how to work.

Among the trades he acquired before his mother's death ten years later were butcher, carpenter, seaman, and factory manager. He parlayed them all into top jobs at giant national companies in food processing, shipping, and tobacco.

Not content with merely managing these companies, he began owning them, mostly through stock purchases over the phone—Georgetown's first—from his home on the Sheepscot. The New York press never quite tracked him down, usually referring to him only as "The Mystery Man of Wall Street."

But he never forgot his roots. Toward the end of his life, he acquired the shorefront land that he gave in 1946 to the State of Maine, including all the beaches, dunes, ledges, and backwaters of stunning Reid State Park. His rags, our riches.

Sand and stone at Reid State Park

Looking across Sheepscot Bay toward Southport Island and Cape Newagen

Five Islands, Georgetown

The back door is a special way to enter a house or a harbor, fraught with more hazards than the conventional front door. Use of a back door tells the world that you're familiar hereabouts.

The harbor of Five Islands on Sheepscot Bay is just one of dozens of Maine havens with a "secret" backdoor entrance. Across the bay, the back door is The Arch at Newagen Harbor. Back in Casco Bay, there is Jaquish Gut near Land's End on Bailey Island. And so on all along the coast.

Five Islands, however, boasts two alternatives to its obvious "front door," which is located directly east of the town wharf. The northern entrance is narrow but straight and marked, but as the picture opposite shows, the southern entrance is jammed with ledges and islets, not all of which appear in detail on nautical charts. What to do then?

As with any back door, it's best to equip yourself with a little "local knowledge" before using it. Fishermen are usually generous with navigation advice. It might be brief: "Just stay among the trap buoys and you'll be fine." Or possibly: "Favor the shore first, then the island." Or maybe: "Don't even try it." Like any good homeowner, they really don't want you to trip on their doorstep, back or front.

Left: A skiff at Five Islands. Opposite: Five Islands harbor.

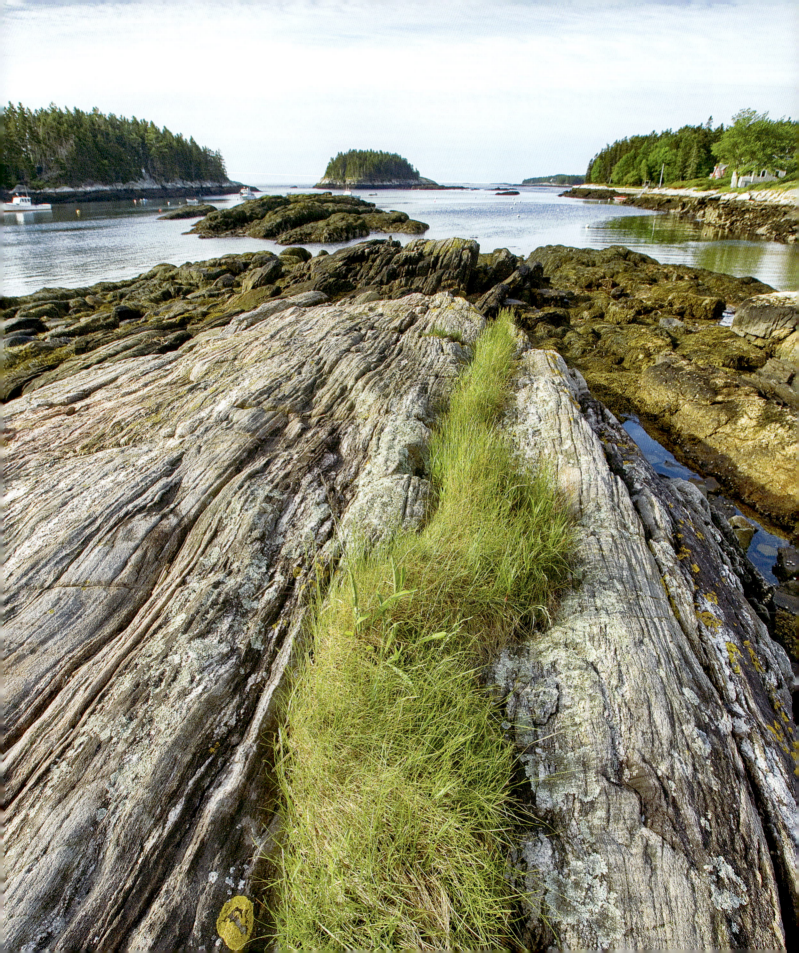

24 Boothbay Harbor

Powered initially by baby boomers with spare time and cash, the kayaking craze has entered its third decade with enthusiasts just about everywhere. Even this shallow, normally boatless cove in Boothbay Harbor sports a colorful array of these sometimes-controversial vessels, which are now inspiring a second and third generation of devotees.

What could be controversial about such a simple, nonpolluting means of getting around in just about any waters deeper than ten inches?

The boat itself is not so much an issue as its user. Because kayaks are so cheap and easy to own, many stone-cold novices get on waters they misunderstand. Foggy, rough, and cold waters can stir up within minutes in Maine, leaving some operators lost or worse.

Additionally, with a shallow draft and a tendency to travel in flotillas, some kayaking expeditions end up on tucked-away shores whose owners feel their privacy is being invaded. And recreational fishermen complain that launching ramps get overrun with kayak-delivering vehicles, not to mention kayak convoys that scare away fish from areas long seen as hidden angler meccas.

Fortunately, plenty of kayaking pros know all about the sport's tendentious side and are working hard to correct miscues. A vessel with so many positive attributes deserves all the support it can win.

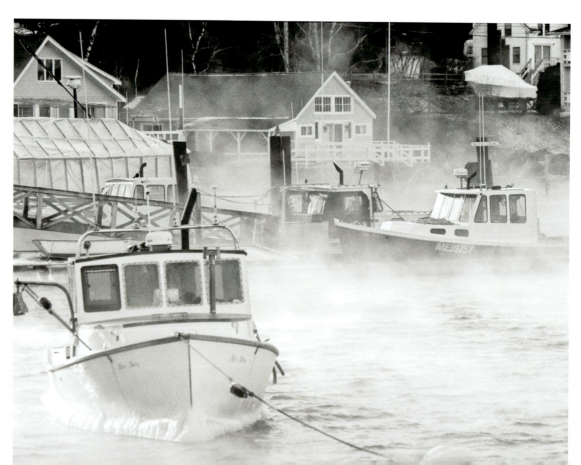

Sea smoke on a January day with the air temperature at −10° F, east side of the harbor near the lobstermen's co-op on Atlantic Avenue.

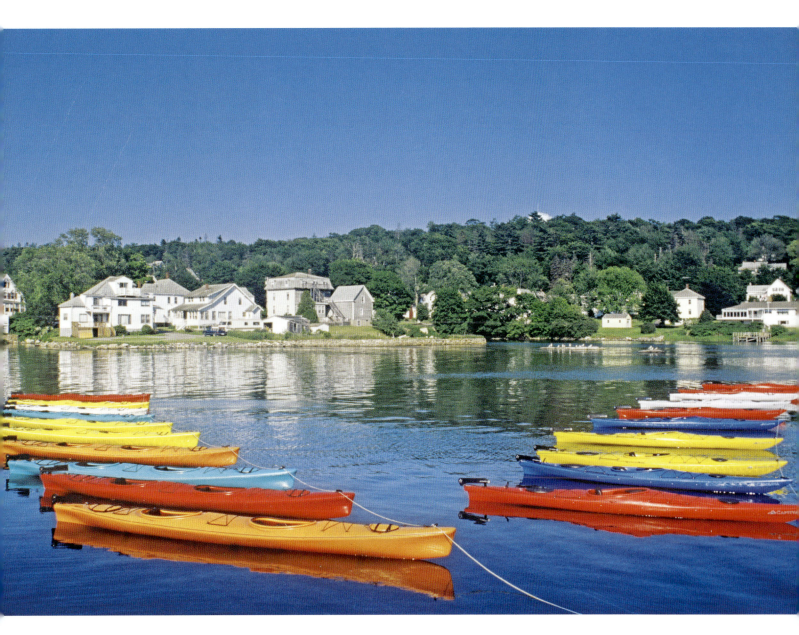

Rental sea kayaks

Ocean Point, East Boothbay

Fisherman's Island Passage is one of the Maine coast's more heavily traveled thoroughfares. It is a rare summer day when this east-west passage off Ocean Point, at the southern tip of Linekin Neck in East Boothbay, isn't jammed with boat traffic.

The traffic stems to a large degree from the proximity of the passage to Boothbay Harbor, which is as popular with waterborne visitors as it is with the tens of thousands who arrive overland. Happily, the boat traffic is, for the most part, neither as frenetic nor as dangerous as its counterpart on an interstate highway. In fact, if you can find a spot to view the activity from land, you'll see that the passing stream of boats emanates its own sense of peace.

"The sea is the land's edge also, the granite
Into which it reaches, the beaches where it tosses
Its hints of earlier and other creation…."
—T.S. Eliot, "Dry Salvages," *Four Quartets*

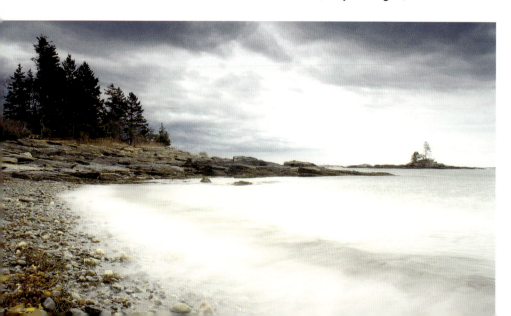

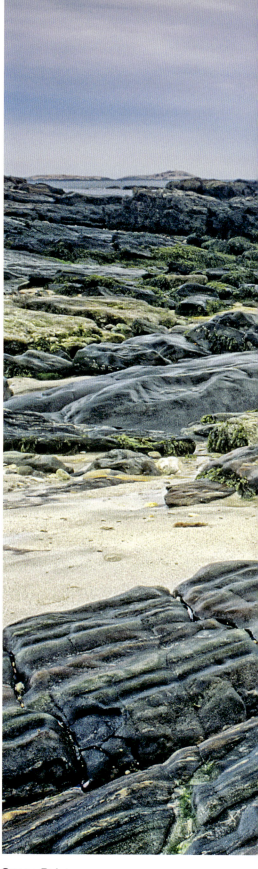

Ocean Point

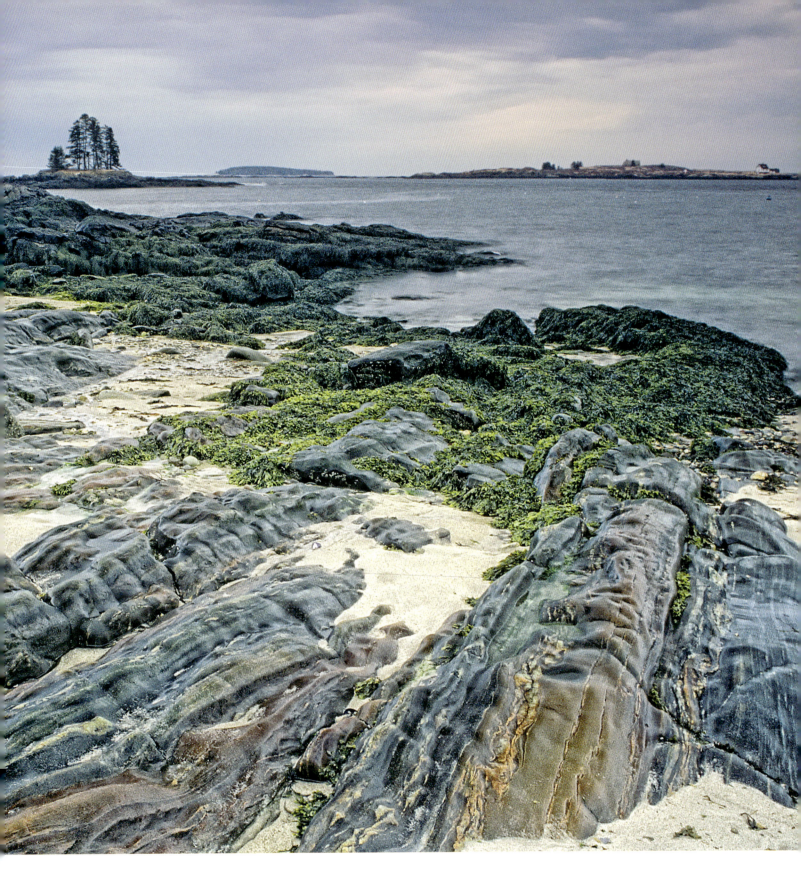

Newcastle

Traditions in the nautical world rarely change, even when the origins of the tradition no longer apply. At the head of navigation on the Damariscotta River, the morning fog reveals the spire of the Second Congregational Church in Newcastle, on the west shore of the river. All is calm and peaceful—or is it?

In the nineteenth century, cartographers regularly put church spires on nautical charts, their object being not to promote religion but to offer a landmark that would help a mariner deduce exactly where he was on nearby waters. Today's charts still include many of those nineteenth-century spires.

With the advent of highly accurate, inexpensive electronic navigation equipment, few mariners use church spire landmarks any more. And given the governmental zeal for political correctness, one can wonder how long it will be before spires are removed from nautical charts.

Until that day comes, however, a "spire" is a tradition for the eyes and heart. And in the interests of equal opportunity, the charted spire on the east side of the river in Damariscotta belongs to the Damariscotta Baptist Church—also a fine-looking architectural detail to greet the new day and the returning mariner.

Right: A house on the river in Newcastle. Opposite: Boats on the Damariscotta River.

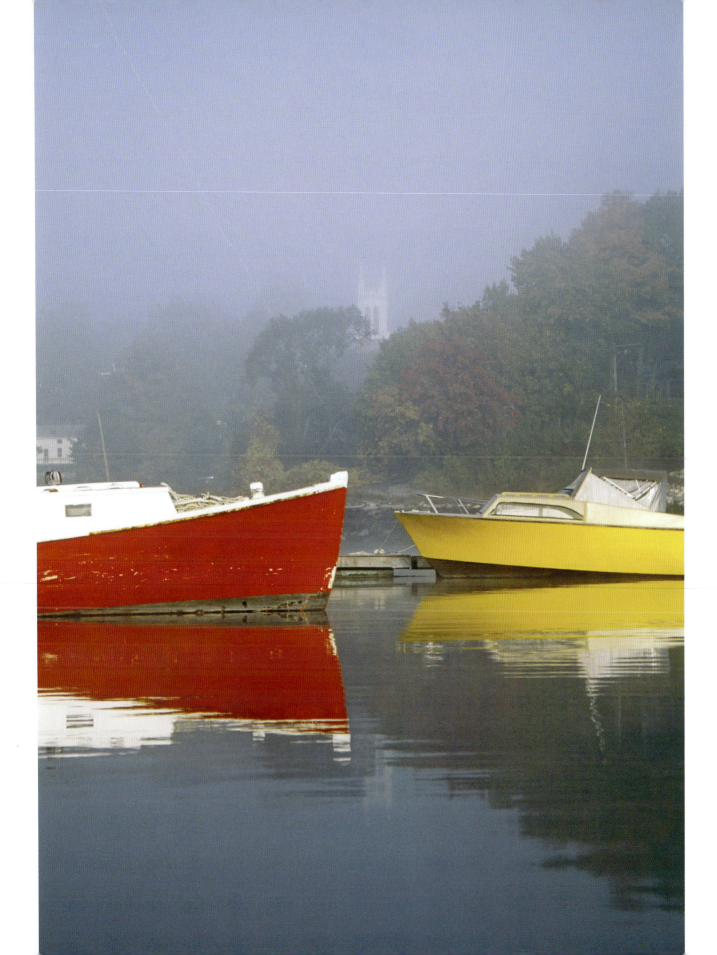

South Bristol

Symbolism is rarely a topic of discussion in tucked-away harbors between Kittery and East-port. But in The Gut, which separates South Bristol from Rutherford Island, the images are too compelling for many longtime Mainers to ignore.

The pretty fiberglass sailboat in this photo might be from the 1970s or '80s. Behind it are the abandoned buildings of a shipyard that had been constructing wooden vessels for a hundred years before fiberglass showed up. Although wooden boats are still built here and there in Maine, the industry nationwide essentially collapsed when fiberglass took over. Because multiple copies of a fiberglass hull or deck can be produced from a single mold, these new boats were, from the beginning, cheaper to build or buy. They were boats for everyman, not just the wealthy few, and they were perfectly in tune with the postwar boom that swept America in the 1950s and '60s. And as it turned out, they were also durable.

Indeed, fiberglass boats have proved so durable that many built in the 1960s are still around today. Unfortunately, with so many boats being pursued by not-so-many potential boat owners, used fiberglass boat prices have been depressed lately, and many have simply been abandoned.

Happily, though, waterfront real estate is always in short supply, and even abandoned shipyards are eventually turned into thriving marinas. Moreover, even fiberglass boats are recyclable in a crunched-up, chopped-up form. So maybe this is a case of something that goes around coming around.

Tools of the trade

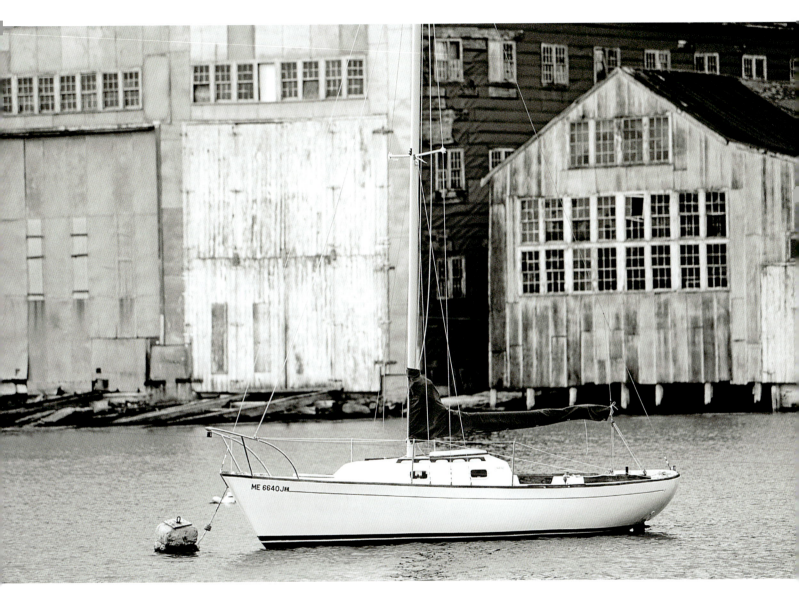

The Gut, South Bristol

Pemaquid Beach

The 1981 movie *On Golden Pond* still has a generation believing that loons are freshwater birds, but the truth is more complicated. Exactly where these loons on Johns Bay, west of Pemaquid Point, spent their summer is debatable. Just inland of Johns Bay is Damariscotta Lake, which is known to harbor a sizable loon population during the warm months. But they also could have come from Sheepscot Pond, China Lake, or Lake St. George. The point is, they breed in fresh water during the summer, then move in late September to sheltered coastal waters.

Whether these loons move on to saltwater coves farther south or remain most of the winter along Maine shores is uncertain. Loons can and do migrate hundreds, even thousands of miles every autumn, particularly if their summer home is a lake in the Upper Midwest.

Do they return to the same lake year after year? Scientists are still debating this one. But loons are along the Maine coast from late September to at least Christmas, possibly longer. And yes, some nights you can hear them calling.

Pemaquid
Harbor

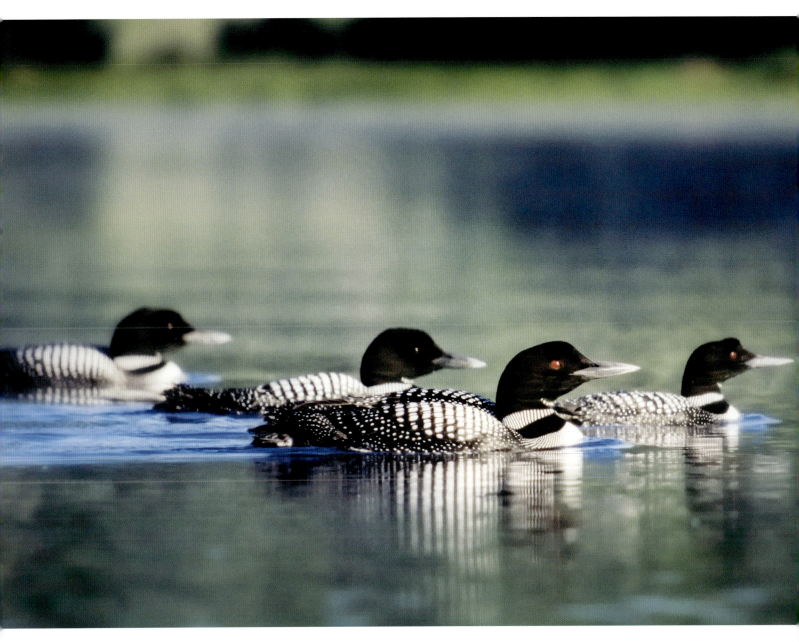

Loons on Johns Bay

New Harbor

A casual passerby might look at this overturned boat in the weeds at New Harbor and conclude that it is washed up and forgotten. But a closer looks reveals a lot more life left in it and a fair degree of respect, too.

Known as a dory, this boat is as New England as any vessel can get. Various forms of dories have been around for nearly three hundred years, probably longer, and this flat-bottomed, slab-sided variation has been a favorite among Maine fishermen since before there even was a state of Maine.

Like vans, pickups, and SUVs today, the dory's practicality was paramount. Loaded with fish, gear, bait, men, and what-all, they could go anywhere and serve most any function. Those qualities are what make this boat type still useful today—mostly as an auxiliary vessel used in conjunction with other dories or a larger, mother vessel.

Back Cove, New Harbor

This dory, therefore, is not in the autumn of its years, as are the sumac and maples behind it. Instead, it shows every sign of being cared for by a no-frills fisherman who expects it to stay put for the winter and be ready for another year of fishing next spring. He'll probably get exactly that.

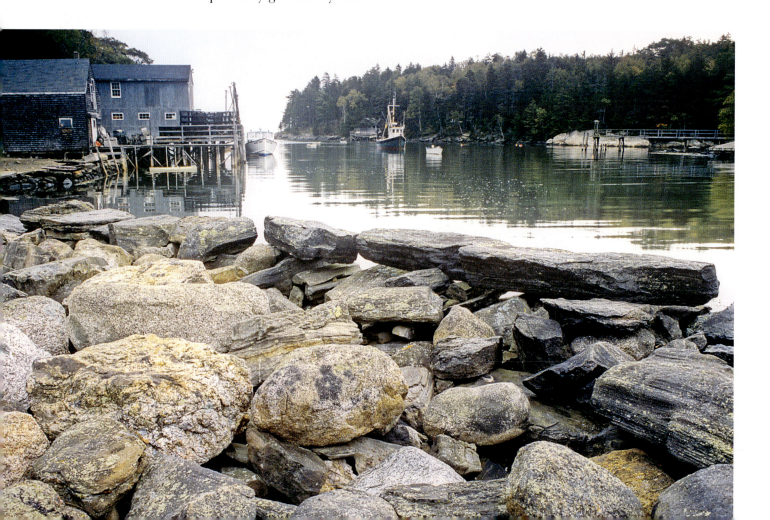

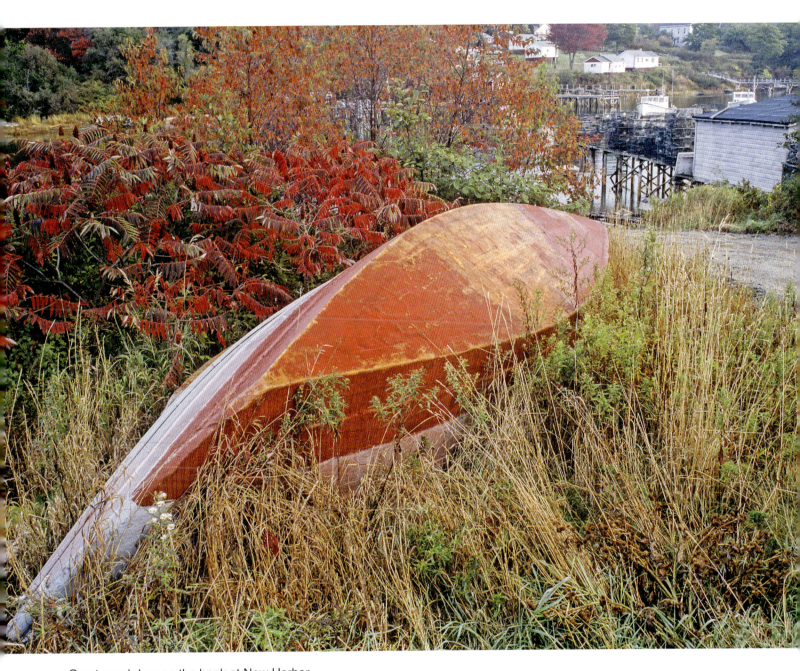

Overturned dory on the bank at New Harbor

Pemaquid Point, Bristol

Lighthouses visited in the summertime present a false impression of safety and impregnability. During the winter, Pemaquid Point, which may be Maine's most-visited lighthouse, can be a precarious place.

Even lighthouses that are fifty or more feet above high tide have been swept by heavy rollers generated by snow-filled easterly storms. So the construction of a lighthouse must be robust to say the least. In fact, Pemaquid Light had to be built twice, because the first attempt in 1827 couldn't stand up to storm winds and seas. The 1835 version has worked out better.

These days, lighthouses are in danger from neglect. Since the federal government has abandoned most lighthouse maintenance, local charitable groups have had to take up the slack, with mixed results. Like many others, Pemaquid Light carries on by a shoestring and hard work—not unlike the storm-pummeled lightkeepers of old.

Even in clement weather, the surf at Pemaquid Point can be impressive. In a storm it can sweep the unwary off the rocks.

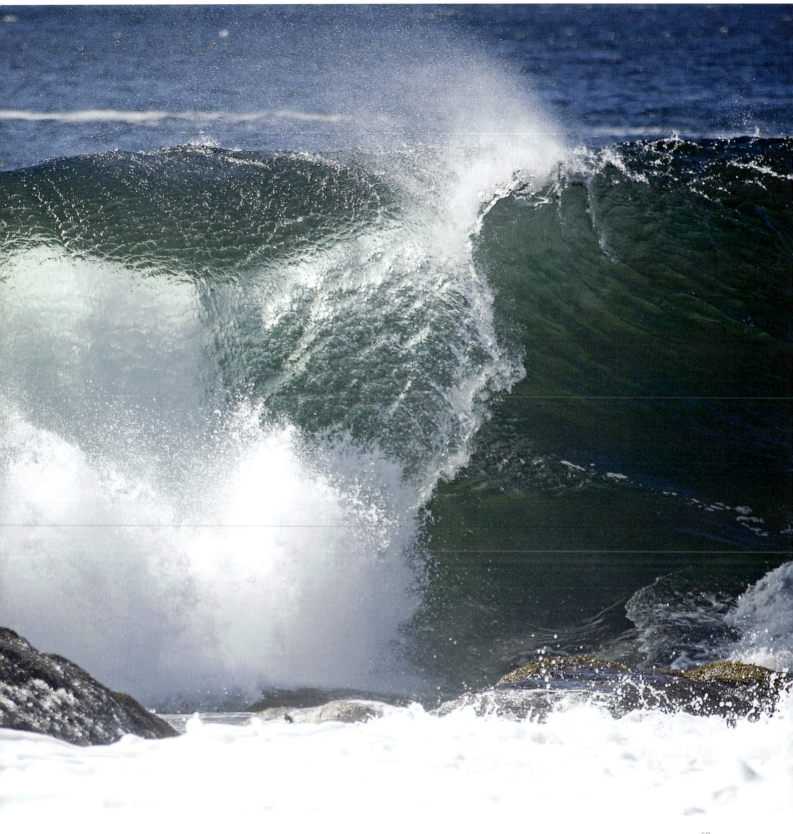

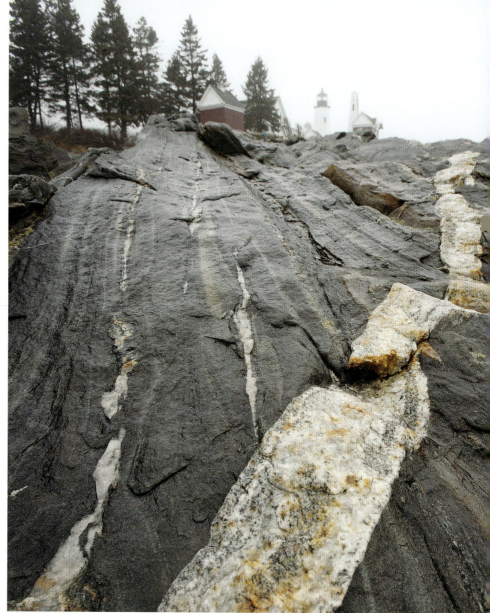

Clockwise from top right: The lighthouse in fog; Pemaquid Point at dawn; Looking out to sea.

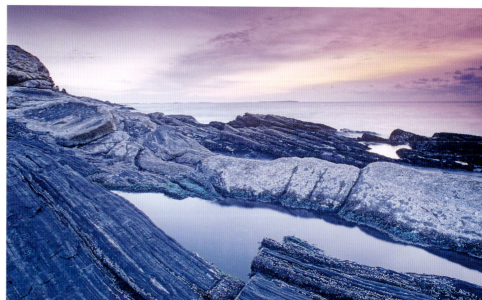

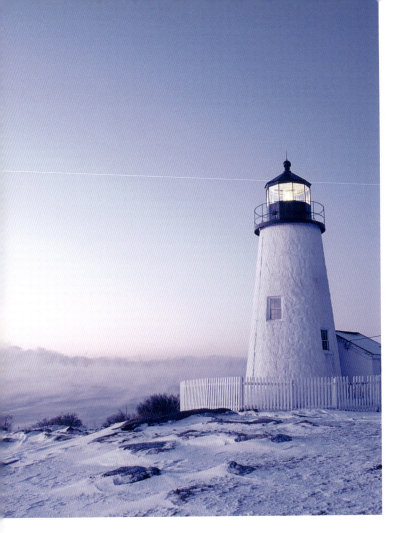

The Bradley Inn is near the lighthouse.

Left and below: Pemaquid Point in winter

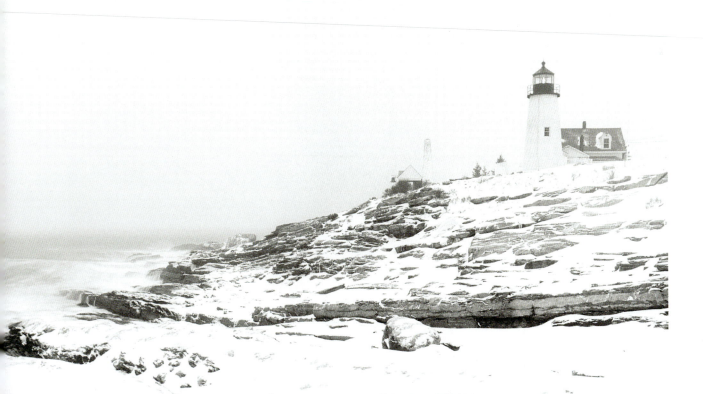

Pemaquid Pond, Nobleboro

Four different fogs haunt Maine waters from one end of the coast to the other, and often pretty far inland. This particular fog is within the smell of salt water and was caused by the waters of Pemaquid Pond in Nobleboro. But it's sort of an upside-down version of the fog with which Maine coast denizens are most familiar.

As the weather people on television never tire of telling us, when warm, moist air from somewhere south of Maine passes over our cold Gulf of Maine waters, fog forms. But in Pemaquid Pond on this late September morning, the reverse is true; cool air in contact with the summer-warmed lake is forming what is called "steam fog." The explanation is easy.

On all bodies of water, evaporation takes place all the time, and the warmer the water is, the faster it evaporates. With a maximum depth of only about sixty feet, Pemaquid Pond warms up quickly in the summer, usually stabilizing at around 75° F. But until the air over the water reaches 40° or so, you can't see all that water evaporating. Once it does hit the condensation temperature, evaporating water becomes as visible as steam over a hot tub on a cool summer's night.

Less visible in Pemaquid Pond's waters in September, but no less a part of the seasonal rhythm, is the departure of the last of the season's alewife fingerlings. Somewhere under that steamy, foggy blanket, the six-inch juvenile offspring of the anadromous adults that arrived here in the spring are returning to the sea. The steam fog will help cover their retreat, which is often watched by hungry aerial predators, who are ready to dive on these fascinating little couriers from the deep. Go alewives!

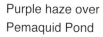

Purple haze over
Pemaquid Pond

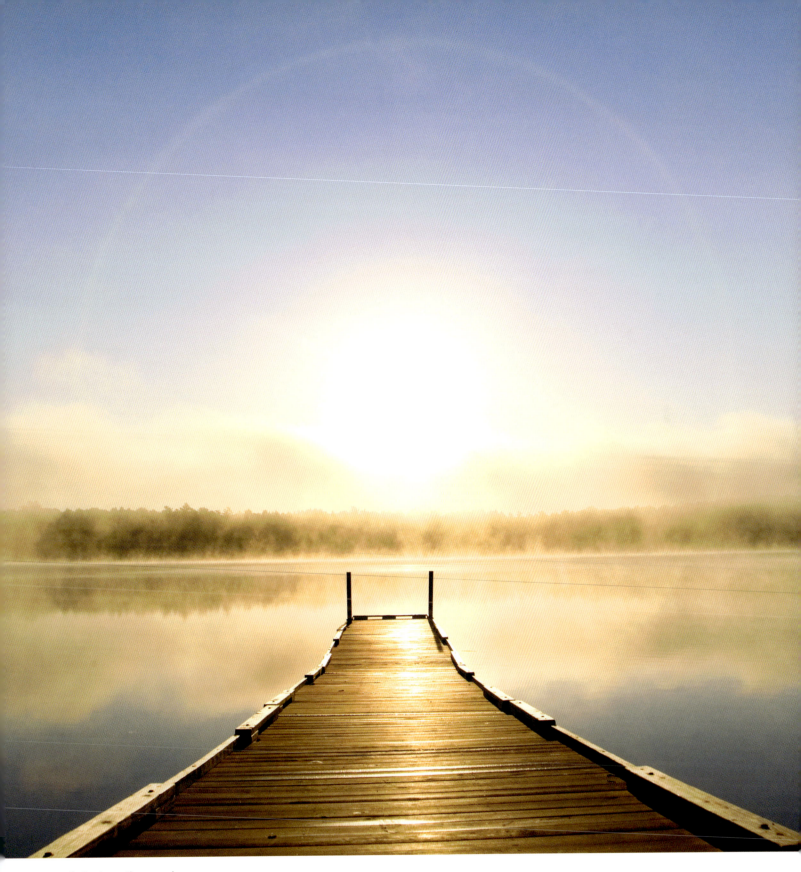

A dock on the pond

32 Medomak River, Waldoboro

Swimming in salt water is often the last attraction on the mind of a visitor to the Maine coast east of Casco Bay. And with seawater temperatures averaging well under 60° F even in midsummer, we understand the reluctance. But sometimes, if you know the right places and times, salt-water swimming in Maine can be downright salubrious.

A good place to start might well be in the Medomak River estuary in Waldoboro. It has all the right ingredients for warming the water to 70° or better as early as June. Oddly enough, what you need is a lot of mud. Here's how it works:

Choose a bright sunny day with a late-morning low tide. The intense midsummer sun will have plenty of time to warm up the mudflats starting early in the morning, and mudflats are plentiful and extensive in the Medomak, as in numerous other backwaters along the Maine coast.

Ideally, the day should also include a below-normal, smaller tide. Above-normal tides stir up the incoming water, bringing deep colder waters from the outer bay inshore. With small tides the opposite is true, and that bright sun has plenty of time to warm up the lazy inflow of salt water.

By mid-tide or so on the flood, the sun has warmed those shallow, slow waters flowing across the top of sun-warmed mudflats to something resembling tepid bath-water, and you're ready for a refreshing dip—instead of the bone-numbing splash that makes your brain ask, "What were you thinking?"

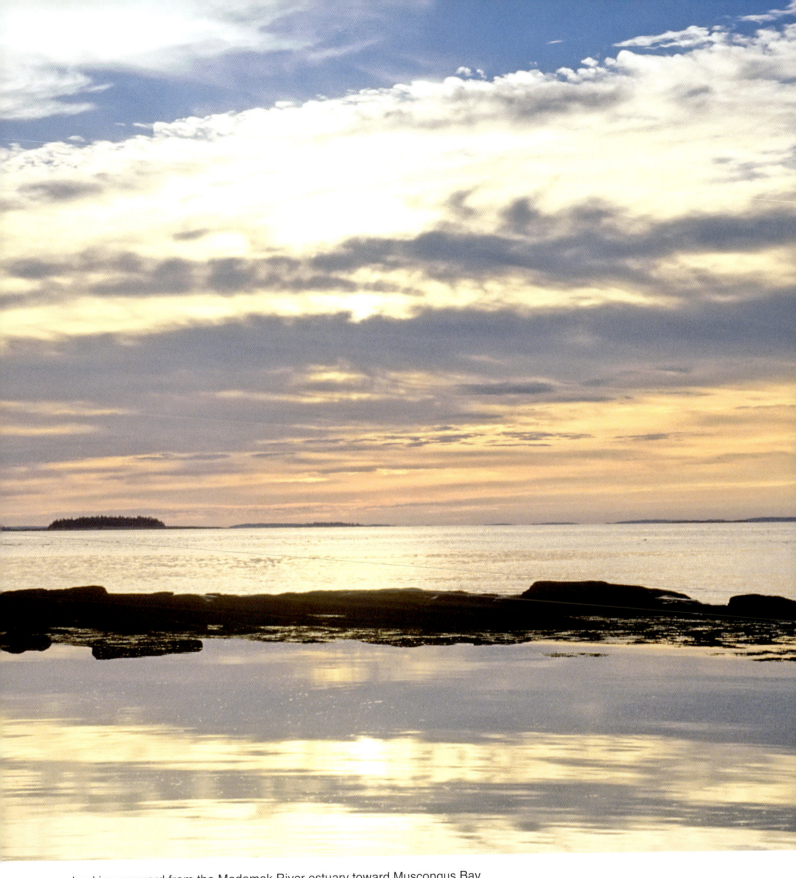

Looking seaward from the Medomak River estuary toward Muscongus Bay

33 Damariscotta Lake

Water is quirky. When most substances transition from liquid to solid form, they contract and become denser. Not so with water. Although water does become denser as its temperature drops, it stops condensing when it hits approximately 39° Fahrenheit (4° Celsius) and thereafter expands slightly with further cooling. Upon freezing into its crystalline form at 32°, it expands still more. As a result, ice is 9 percent less dense than water and thus floats. Lakes freeze with ice on top, not sinking to the bottom.

When ice-out time arrives in spring, as in this photo taken in the town of Jefferson, weird things can happen. For one thing, money changes hands due to the non-physics phenomenon known as betting. As most year-round lake residents know, betting on the exact date the ice will disappear is a traditional source of amusement and a fair amount of good-natured quarreling.

Immediately after ice-out, as the surface water warms toward 39°, it becomes denser and sinks, causing deep water to well up and replace it. And there is a second, stronger turnover of lake water in the fall, when cooling surface water sinks and forces warmer water to the surface. A similar though less pronounced breakdown of thermal stratification occurs in the fall and winter in coastal waters like those just a few miles from Damariscotta Lake, and the resultant upwelling of deep water carries nutrients to the surface to fuel a phytoplankton bloom in March, when the days get long enough for photosynthesis.

Damariscotta Lake in a warmer season

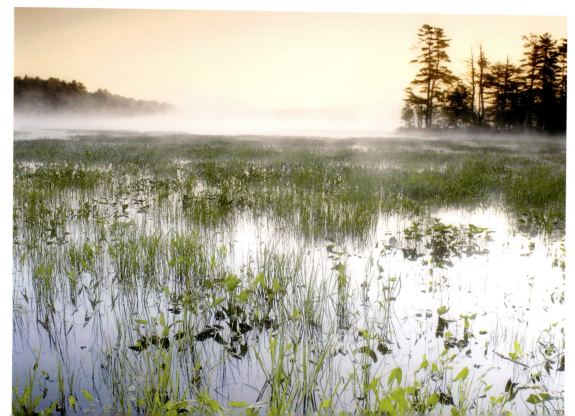

Ice on Damariscotta Lake

Jefferson

Stress is something most of us try to avoid. Or at least we say we'd like to avoid it. And we certainly don't wish it on anyone else. But maybe, in some cases, we should.

Take, for instance, these maple trees. They are, of course, familiar symbols of autumn in Maine. What could be more soothing than gazing upon these bright red, orange, and sometimes yellow beauties at the edge of Davis Stream? In Jefferson, just a short drive inland from the coastal town of Waldoboro, they usually come into their full glorious color a week or two before maples farther inland. Why? Stress.

Yes, even trees can be stressed by extremes in their environment. Maples are among the most adaptive hardwoods in the boreal forests of northern New England, yet the stresses of extreme weather and changing soil conditions can drive them to give up on life prematurely. That is, they stop producing the green pigment known as chlorophyll that is essential for further growth. And as we learned in grade school, when the chlorophyll disappears, the leaf's true color appears.

What could possibly be stressing these maples set in such a bucolic scene? Happily, it's rarely man-made changes in their environment. Usually, ordinary annual changes in the amount of rainfall—too much or too little—can set off a swamp maple earlier than its inland brethren.

Damariscotta Lake

But its stress is our relaxation as we paddle upstream from Damariscotta Lake, enjoying the torpid waters of September. And best of all, life will return to the maples again next spring, along with the promise of yet another slightly unpredictable autumnal display of calm and color. Thank you, Stress.

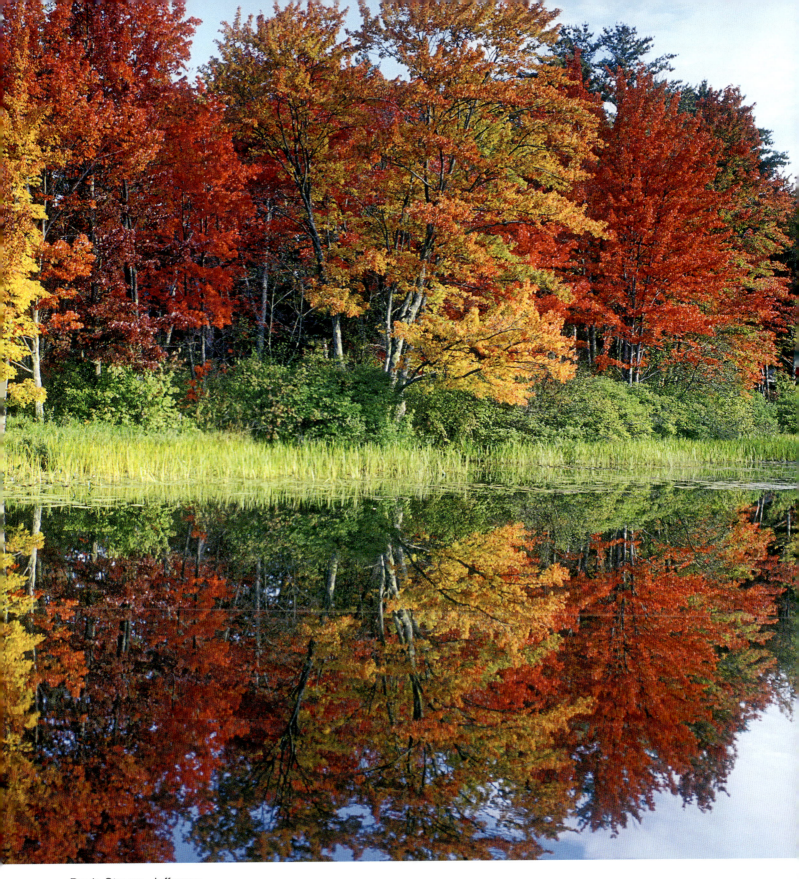

Davis Stream, Jefferson

Washington

The mists of the Gulf of Maine are part of what makes a not-quite-coastal town like Washington feel as if it has salt water in its veins. Blueberries thrive in the soil the mists help create, and blueberry aficionados are particularly appreciative of this happy circumstance because it ultimately makes Maine's low-bush blueberry variety tops in many categories.

To begin with, the cool, moist, short growing season near the coast plays a role in the high sugar content of local blueberries, a much higher content than blueberries grown elsewhere. And those frequent mists rolling in off the nearby frigid ocean waters contribute mightily to the acidic soil and boreal climate the blueberries favor.

As a result, smart chefs prefer Maine blueberries for their naturally sweet taste as well as for a lower overall water content. After all, who wants a watery blueberry pie with loads of processed cane sugar added?

Most of the 60,000 acres of blueberry lands cultivated in Maine are in Washington County in eastern Maine. But wild blueberries *(Vaccinium angustifolium)* grow well throughout much of coastal Maine east of Casco Bay. Blueberry leaves turn bright red in the autumn, a phenomenon locals have noted with pleasure since Native Americans began cultivating the fruit long before Europeans arrived.

Fall color in
Washington

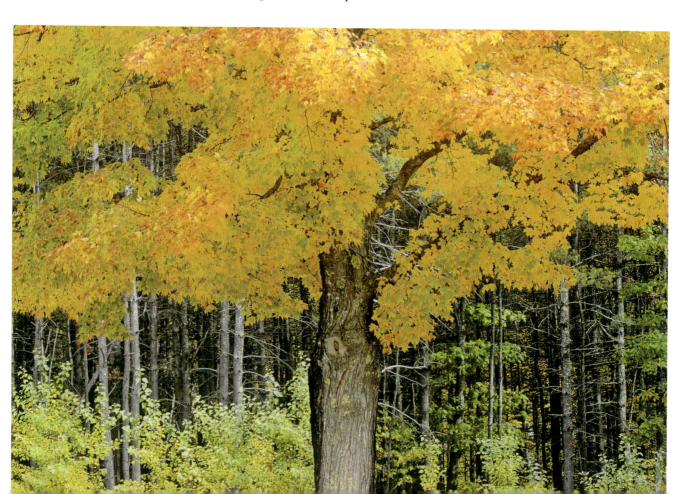

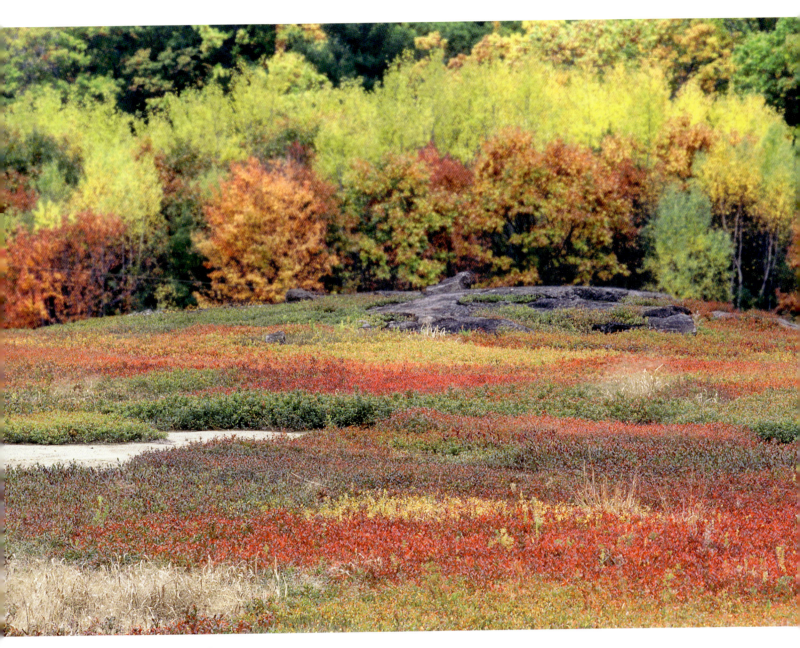

Autumn on the blueberry barrens

Seven Tree Pond, Union

Battered but not forgotten, the canoe survives in Maine despite rampant kayakism nearly everywhere. This old-timer on the shore of Seven Tree Pond in Union offers a freshwater link to salt and a present-day link to the past.

Canoes were how people got around in coastal Maine before Europeans showed up and shortly afterward. On any map or chart of the coast and its associated inland waters, names like Carrying Place Cove, Canoe Point, and other references to this versatile craft pop up with surprising frequency. Indeed, with judicious use of streams, backwaters, and hidden coves, Native Americans and newcomers alike could travel twenty or thirty miles of the coast without exposing themselves to ocean swells and storms.

From Seven Tree Pond, you could paddle this canoe down the St. George River to the sea at Thomaston and beyond. In his 1940 book *Come Spring,* author Ben Ames Williams tells through well-researched and delightful fiction how early settlers in this area used small craft like canoes to connect Union to the rest of the world. Tons of goods were moved from inland to the sea via these versatile craft. They were *sine qua non.*

Today, though, the plastic kayak seems to be the latest craze for enjoying backwaters. Gone is the cooperation between the paddler up forward and the one aft. Kayaks are just me and my boat, usually with other me-and-my-boat folks nearby. No romantic pairs paddling together on a lonely pond. Is something lost in that clean, clear lake water?

Below and opposite: Seven Tree Pond is ideal for canoeing.

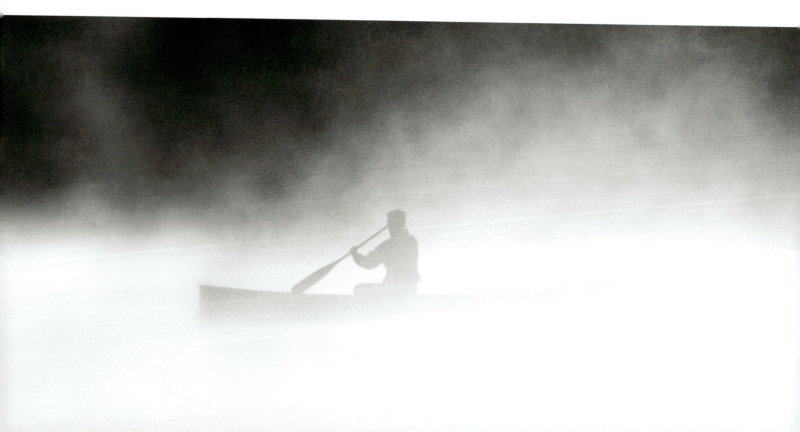

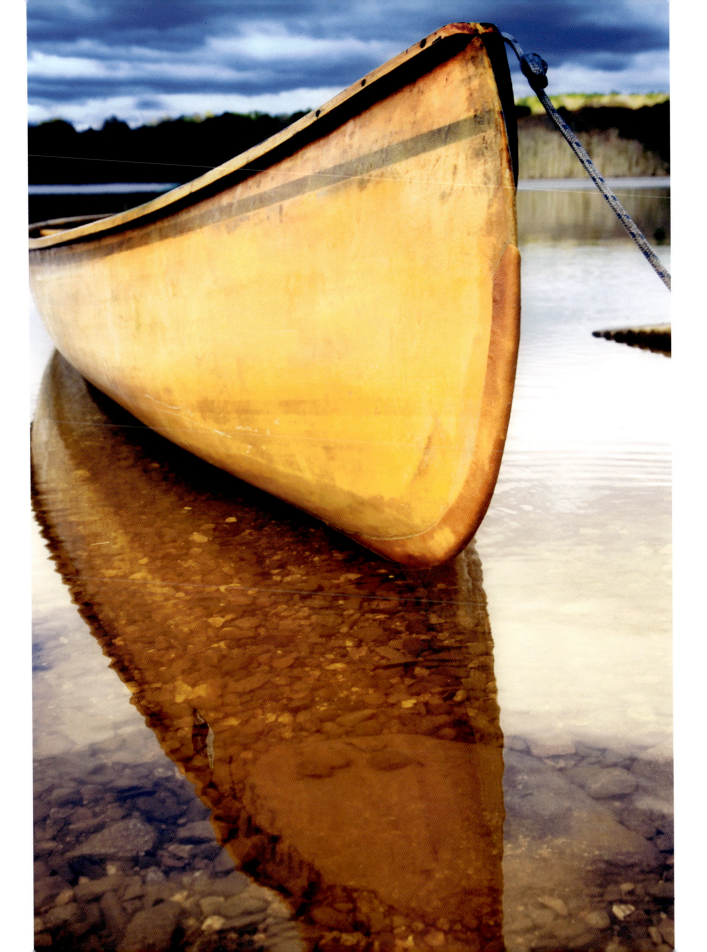

The St. George Peninsula

By the time coastal travelers reach midcoast Maine, they're well acquainted with peninsulas that jut miles southward into the Gulf of Maine. These granite fingers are separated one from the next by glacier-carved river valleys that were later flooded by the rising sea. Turn off Route 1 and head down-peninsula, and soon the seaward vistas become more expansive; the beach roses, bayberry, and bladder wrack creep closer to the road; and a fresh panorama lies around each bend.

We think this St. George peninsula photo was taken from Clark Island looking east toward Two Bush Lighthouse, which stands sentinel over the approaches to Penobscot Bay. Although the season is summer, the lowering sky helps us imagine the winter of 1923, which

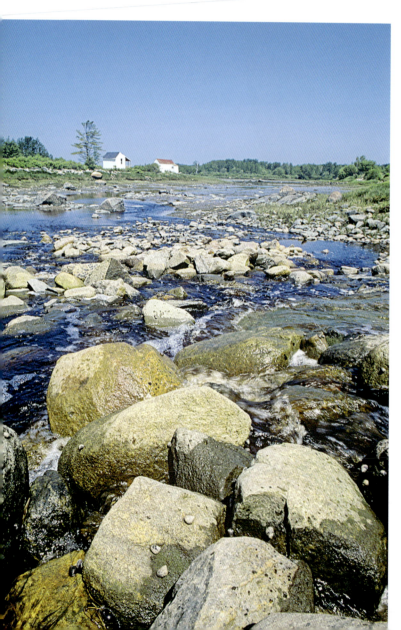

was so cold that the waters between the mainland and the distant island-bound light froze solid. When supplies ran low and a trip to the mainland became necessary, assistant keeper Leland Mann and his son Darrell and two fishermen shoved their 14-foot double-ended boat onto the ice. Sliding it landward, they held on to the sides when they broke through, then rowed and poled until the ice thickened up again and the skiff could be skidded some more.

This soaking, frozen trip probably helped Leland become head keeper in 1927, a scant year after his wife died. That was the same year he broke his hip in a fall on the boat slipway. He managed to serve out his term through 1933, during which time Darrell brought his new bride to barren Two Bush to live with them. But Darrell declined to remain in the service after Leland retired.

East and south of the St. George peninsula stretch the wide waters of the Gulf of Maine, but the west side is bounded by the sheltered St. George estuary, into which these Turkey Cover headwaters drain.

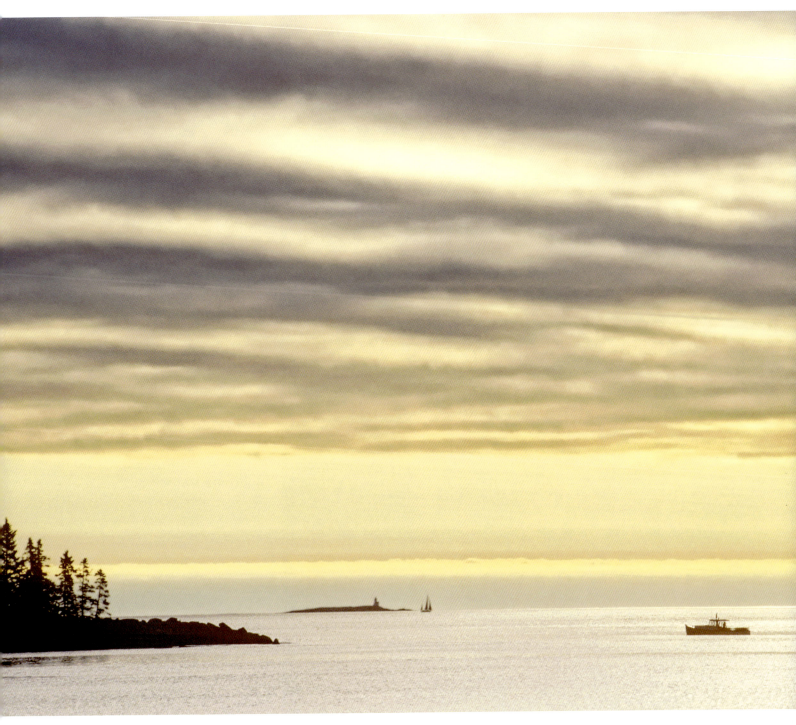

Looking east from the St. George peninsula, Two Bush Island in the distance

Tenants Harbor, St. George

Left-handed lobsterboats like this one in the morning fog at Tenants Harbor are rare, possibly even more so than lefties in the general population. Roughly speaking, southpaws make up 10 to 12 percent of the American population, and it's tough to find a lobsterboat rigged for one.

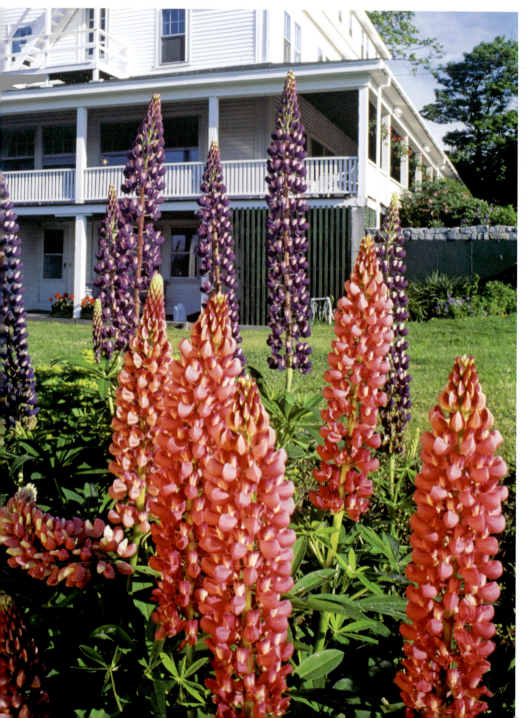

Most lobsterboats carry all their trap-hauling equipment on the starboard (right-hand) side of the boat, along with the helm, electronics, and so forth. And plenty of lefties simply adapt themselves to this arrangement, mainly because it's easier to buy or sell a good used boat with the right-hand arrangement. Mount everything on the port side, though, and you're telling the world that you make your living doing this and you're going to be comfortable, resale value be damned. Bravo, we say.

So the next time you see a lefty lobsterboat emerge from the morning mists, look upon it as you would a four-leaf clover and count yourself lucky.

Left: Lupine outside the East Wind Inn. Opposite: Lobsterboat in Tenants Harbor.

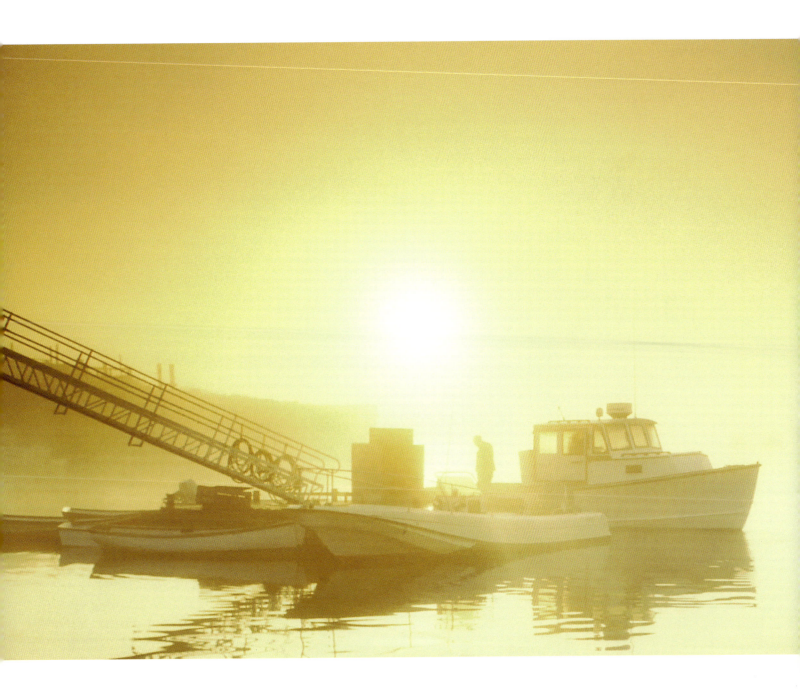

Port Clyde

The village of Port Clyde, in the town of St. George, has changed in recent decades from a hardcore fishing port to a more visitor-conscious destination. Given this ongoing transformation and the decline of Maine's groundfishing fleet, an old fishing dragger beached and moldering away is perhaps to be expected. And the lobster traps casting their shadows on the hull tell yet another story of a fisherman who may be on his way to extinction, because those traps are of the old wooden style, which few fishermen use these days. The maintenance time they require is too demanding, and vinyl-coated wire-mesh traps can be made more cost-effectively. And lobster fishing is all about cost-effectiveness.

The chic shoreline in the distance has yet to overtake this particular corner of Port Clyde, and one hopes it never will. "The Port's" dozen remaining groundfishing vessels constitute the last remaining fleet between Portland and the Canadian border, and local fishermen have launched Port Clyde Fresh Catch, a community-supported fishing venture, to support them. And lobstering is thriving in Maine, with a harvest value of $350 million coastwide in 2012.

The beach at Marshall Point, Port Clyde

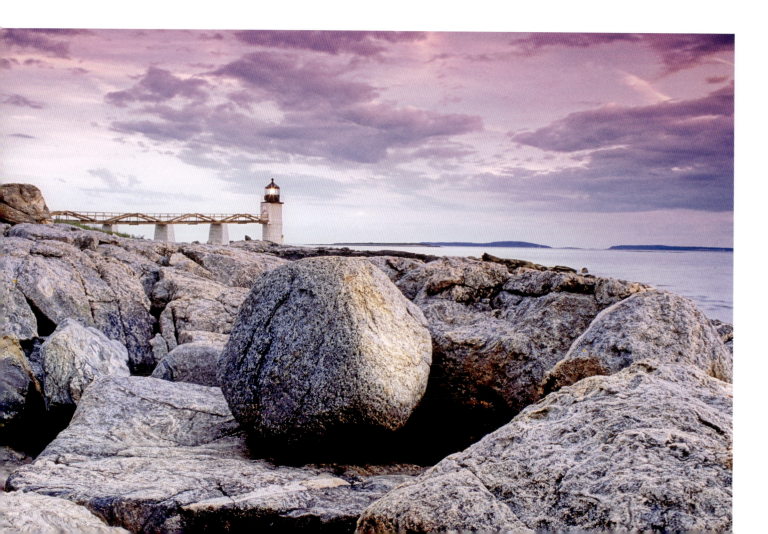

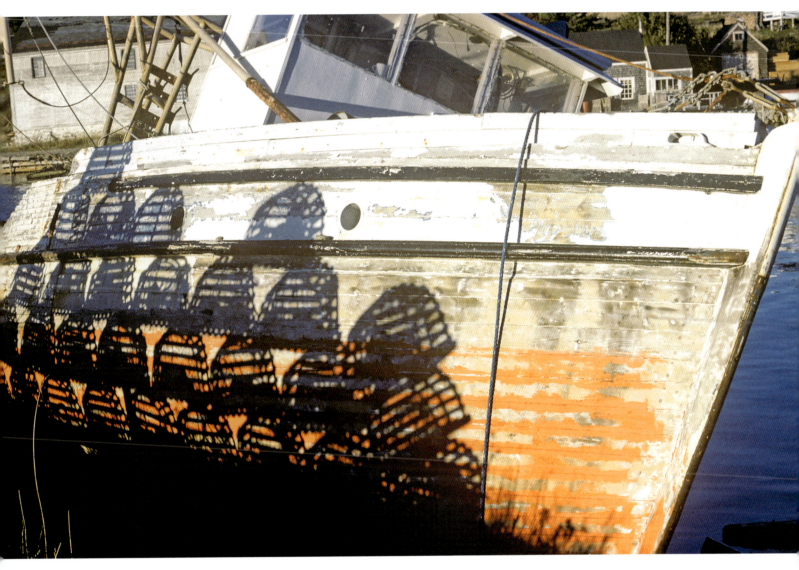

On the bank

Monhegan Island

This is what a seagull sees when day-trippers disembark at the town dock on the offshore island of Monhegan. And the gull's unerring eye will find details among the arriving throngs that are hidden to us.

For instance, Maine's homegrown herring gulls keep a sharp yellow eye out for youngsters, and they're particularly adept at picking out the wee lad or lass who tends to drop Animal Crackers or Oreos as Mom or Dad leads the toddler along.

Indeed, anyone who has spent time watching gulls has to respect their intelligence, if not their manners. We can't tell you the number of times we've seen a gull riding around perched on the bow of a lobsterboat, patiently waiting for just the right scraps to be pitched overboard. No excessive flapping around for some of our pink-legged friends.

And yes, gulls can be downright ruthless and vocal in their never-ceasing pursuit of food or the top of the tallest piling in the harbor. Come to think of it, they are as varied and curious as another two-legged creature we know. Maybe that's why people once believed the souls of drowned sailors resided in gulls.

Monhegan as seen from neighboring Manana Island, with the mailboat from Port Clyde in the foreground

The Cathedral Woods trail: deep moss, green filtered light, tang of salt, whimsical sculptures left by hikers before you, and the muffled moan of surf from the base of the cliffs ahead.

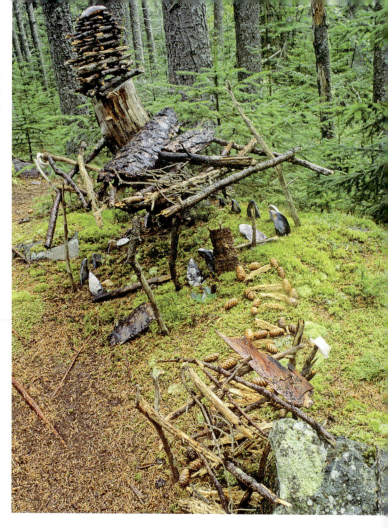

"Yes, as everyone knows, meditation and water are wedded forever."

–Herman Melville, *Moby Dick*

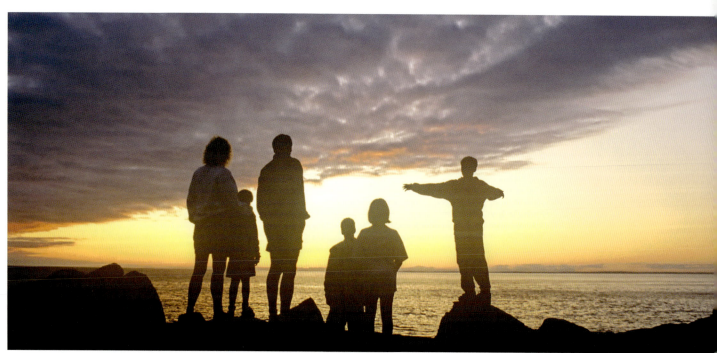

A shed on a foggy day with the Island Inn in the background

Monhegan's seaward-facing cliffs

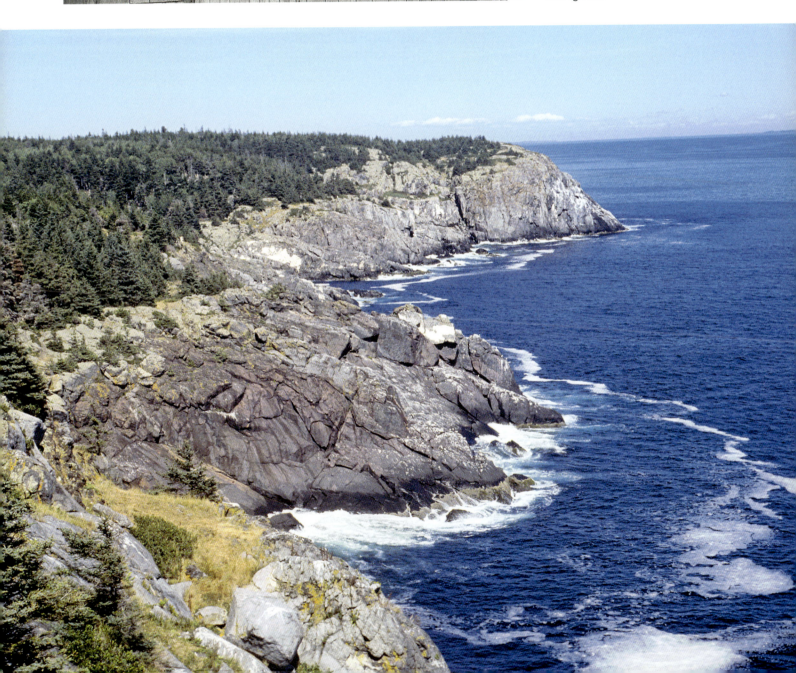

Spruce Head, South Thomaston

Hard by the idled lobster traps and deserted piers of midwinter are always a few boats whose captains continue to fish through the dark months. Even in small, lovely harbors like Spruce Head in Penobscot Bay, the few who go out are often taking a big risk.

Having made their inshore contribution to perpetuating the species during summer, lobsters head well offshore for deeper, less frigid waters during winter. Consequently, the traps must be set farther out, using more fuel and driving up costs.

Then, of course, there's the weather, both predicted and real. A breezy day ashore in January might be a ferocious gale offshore, with spray freezing on any surface above the boat's waterline. Not only does a sheathing of ice make for treacherous footing, but enough ice on the superstructure can make the boat unstable and prone to roll over.

Then why do it? Well, the landed price of lobster can easily double during winter months, sometimes triple. And some boat captains find winter life ashore in a tiny town just a little too quiet. "If I rest, I rust," some say.

Spruce Head,
summer

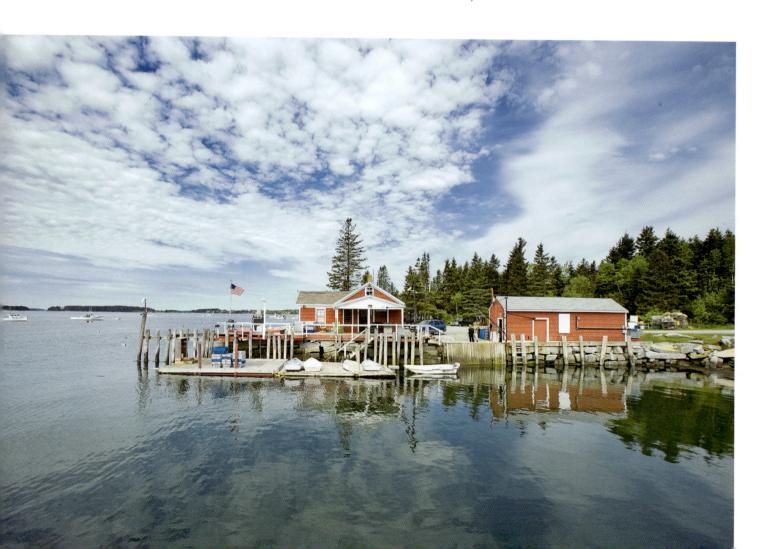

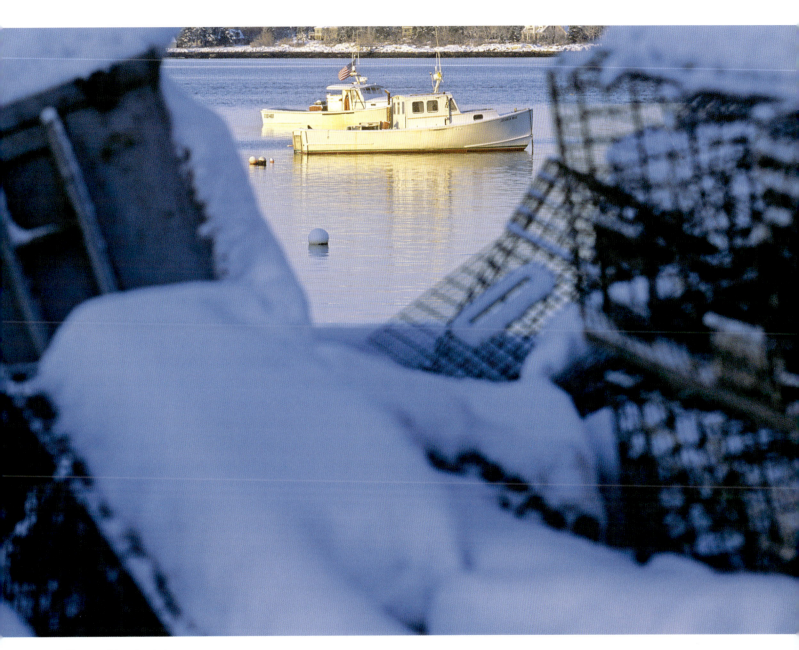

Spruce Head, winter

Owls Head

Catching the last zephyrs of the day outside Rockland Harbor in lower Penobscot Bay, this passenger schooner seen from the state park at Owls Head Light looks peaceful. And for just about everyone aboard, the evening probably is as serene as evenings get. The lone exception would have to be the ship's cook.

The unsung heroes of Maine's windjammer fleet are the cooks. It's no simple matter in the best of circumstances to satisfy the varied palates of twenty or more people, but when your cooking space isn't much bigger than a decent clothes closet and your tools range from old-fashioned to downright antiquated (including, sometimes, a woodburning stove), calling the job a "challenge" is the understatement of the week.

So if you're aboard and find yourself with one more stew than you'd prefer, be kind. That stew made possible those fresh, hot biscuits that few if any could coax out of an oven that tilts, bobs, and heats as unpredictably as the summer wind.

Maine's extensive windjammer fleet sails from at least five ports between Casco and Frenchman's bays, with Penobscot Bay at the hub of the activity. To find the cruise that suits you best, try the Maine Windjammer Association's website at www.sailmainecoast.com for starters.

Owls Head bathed in violet

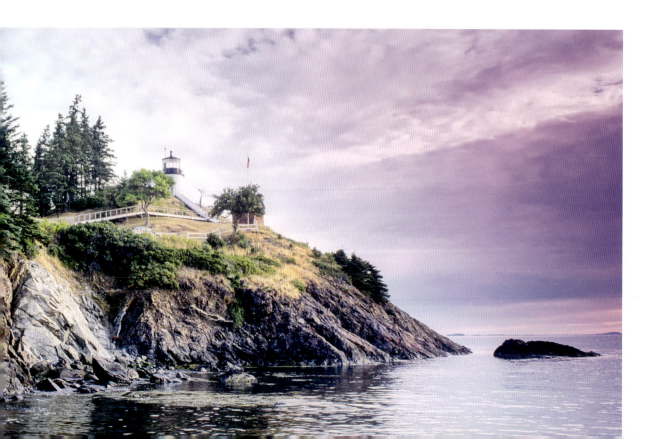

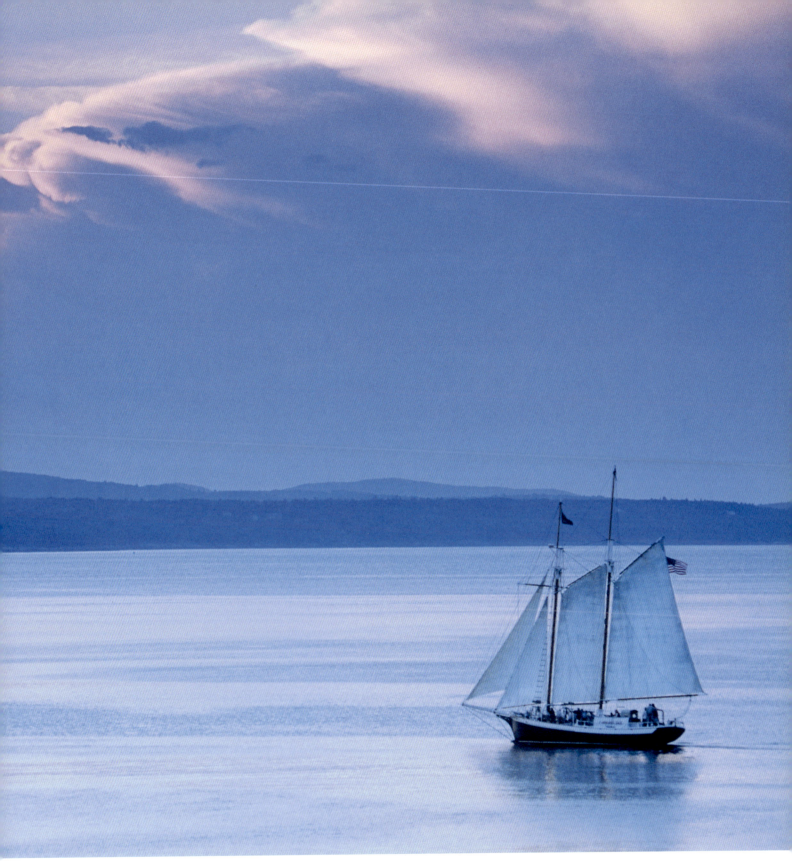

A schooner off Owls Head on Penobscot Bay

43 Rockland

"What do you do in the winter?"

It's a question many summer visitors ask natives on a hot July day, usually with a discernible note of incredulity in their voices. Perhaps they are imagining the entire Maine coast locked in January ice, like Rockland Harbor when this photo was taken. But even the owner of a vessel corralled by a brigade of wandering ice floes is probably enjoying the coast in ways many never dream of. At home in his workshop, he may be putting together a new navigation table as part of his complete rebuild of the pilothouse interior. He whistles a contented tune when he walks down the ice-covered pier to go aboard and take another measurement of the overhead cupboard space. If the wind is silent, he may stand in a sunny spot and bask in a feeble sun that prompts ideas of the coming summer's trip eastward.

Or he may listen to the sounds of winter on the Maine coast. At dawn along the shore of becalmed Rockland Harbor, amid the silent mists of Arctic sea smoke, solid seawater will play its tune, which varies with the state of the tide. Ice floes huddled along the edges of a steep, rockbound shore at high tide impale themselves on granite pinnacles as the tide goes out. Here and there, a floe then lets out a loud, timpani-like "whump," followed by a merry, glass-like tinkling as the rocks split it asunder and it crashes onto the hard gravel beach below. Elsewhere, floes traveling up and down the shores of an estuary on the tide will almost continuously run up and down the scales like tiny bells as they grind and dissipate against the solid mass of the shorebound ice field.

The music of saltwater ice is injected at its creation. When the ice forms at about 28° F, much of the salt is squeezed out in the freezing—but not all of it, hence the somewhat compromised structure of floes. And therefore, the floes don't fracture like cocktail ice cubes, instead emitting a small bit of hidden winter music as they collide with rocks, docks, boats, and each other.

In recent years, however, Rockland Harbor hasn't frozen over as it used to—and yes, the reason is climate change. The surface waters of the Gulf of Maine have been warming slowly for the past century, and the rate of warming has increased to almost half a degree Fahrenheit per year since 2005. It appears that cod are leaving the Gulf of Maine in search of colder waters farther northeast, and copepods—zooplankton at the base of the fisheries food chain—may not be far behind.

In a recent visit to Maine, the president of Iceland noted that Portland and Reykjavich will both be well positioned as international ports when the Northwest Passage becomes a year-round, ice-free shipping route. In the meantime, hardier souls have taken to boating year-round on the Maine coast. In Casco Bay, just outside Portland Harbor, it's common enough to spot a sailboat or three tacking along on a settled January day. Most major harbors stay ice-free the entire winter these days, Rockland included.

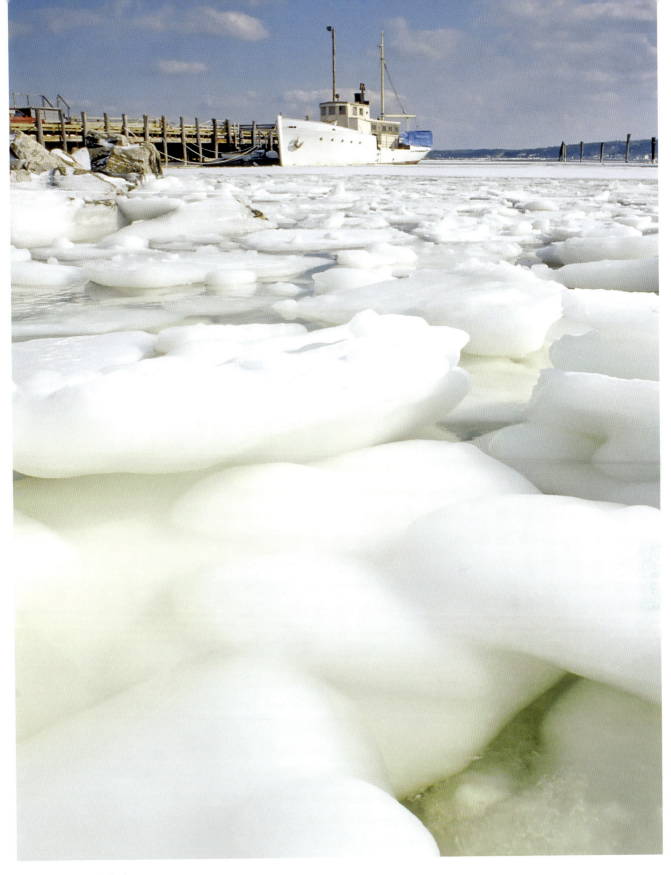

Ice in Rockland Harbor

Arctic sea smoke, Rockland Harbor, with the breakwater lighthouse in the distance

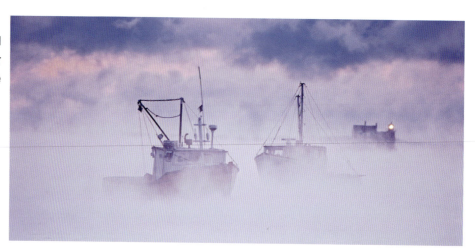

The harbor in winter

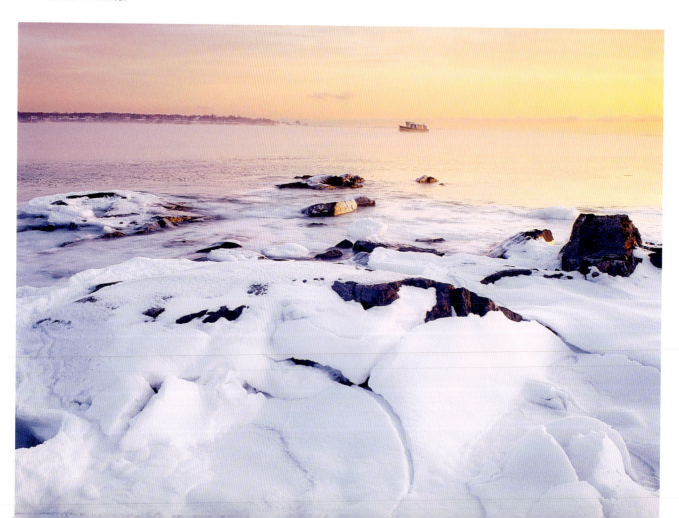

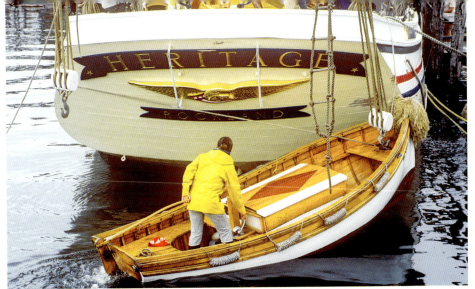

The passenger schooner
Heritage and its yawlboat
on Rockland Harbor

A summer slice of the Rockland
waterfront showing the terminal
for the ferries to North Haven
and Vinalhaven

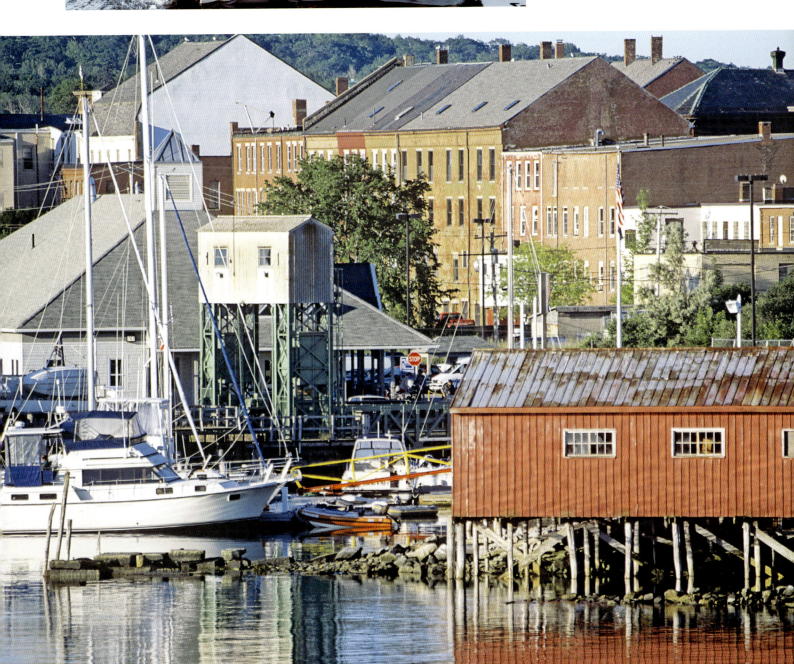

Matinicus Island

Maine's offshore islands with summer residents are numerous, but those with year-round populations are few, numbering only eight or so, each with a distinctive personality developed over generations of living in "splendid isolation." What might those characteristics be?

An aging bicycle on a beach on the east side of Matinicus may be a clue. On an island roughly two miles long and one mile wide, a bicycle seems eminently practical. And although the terrain is rough and uneven, no fancy mountain bike was within the budget of our beachgoer. Just the basics, ma'am, just the basics.

Still, there's more to an island's personality than thrift and common sense. For a more complete rundown, we'd suggest you chat up the good folks at the Maine Sea Coast Mission in Bar Harbor. They know more about the personality of each of Maine's offshore islands than just about anyone. For more than a hundred years, the mission has been visiting these offshore islands and offering a sort of floating combination chapel, diner, and general community center. The trawler-like steel vessel called *Sunbeam V* makes its rounds even in midwinter, providing a place for islanders to relax and be themselves well after summer visitors have departed.

Below: Dock in Matinicus Harbor. Opposite: Beach on Matinicus.

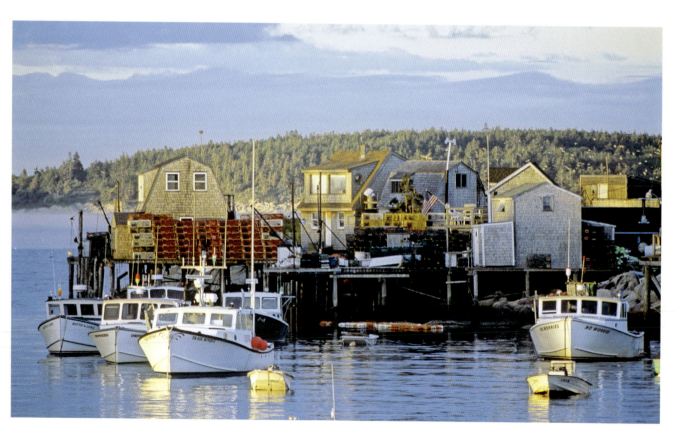

45 Vinalhaven

To paint or not to paint, that is the question. Here on Vinalhaven or in any of the other numerous salt-scoured communities along the Maine coast, paint is a frequent topic of discussion. And opinions are many. For instance, why would a rough, tough lobsterman want to paint his boat a dainty shade of mauve? One common answer is that he has a sense of thrift. We can't tell you the number of fishermen we've known who have put together a few half cans of various colors and come up with something eye-opening that they slapped on their hulls, muttering something like, "Oh, what the heck."

Then there is the thrifty Maine coast aversion to painting the south side of a building. The west, north, and east sides may get a nice coat of gray with white trim and maybe a touch of color here and there, but the south side? "Can't get paint to stick to it anyway, so why paint it?" say the old-timers.

Cedar shingles, however, seem to hold up pretty nicely. That brutal sun, the howling winds, and those persistent fogs and rain need a generation or two before they force the building owner to replace unpainted cedar shingles. Meanwhile, the color is so popular that paint manufacturers often call at least one offering "Seacoast Gray."

Opinions are equally varied when it comes to the best bait for catching *Homarus americanus,* the American lobster. Herring by the ton are delivered every day to hundreds of wharves like the one shown here on Vinalhaven. All along the coast, herring are shoveled, netted, or slid into baskets, barrels, and tubs for each hopeful boat captain to prepare as he sees fit. Those preparations vary, and some are family-held secrets, passed from generation to generation, never to be revealed to anyone outside the family.

But alas, sometimes the baiting potions go too far. Since lobsters will eat just about anything, baits other than the preferred herring have been used of late. Deer hides, moose hocks, freshwater "trash" fish, and a host of other oddities have been employed to save on bait costs and perhaps to find that magical enticement that outfishes everyone else on the wharf. These innovations, however, do sometimes breed diseases with which lobsters were never associated. So in 2012 the Maine legislature had to pass a law to prevent some fish and animal parts from finding their way into Maine's lobster fishery, once again guaranteeing that a Maine-caught lobster is the best, bar none.

Vinalhaven rocks

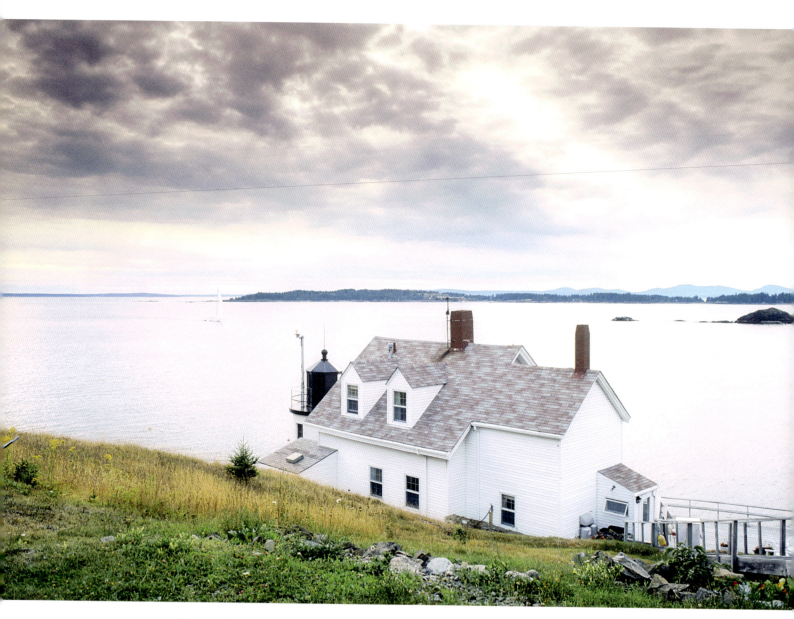

Browns Head Lighthouse on the northwest corner of Vinalhaven, looking west across the approach to Fox Island Thorofare toward North Haven's Stand-In Point, which juts seaward. The Camden Hills are visible in the distance.

A mauve boat, like a boy named Sue, has to be tough.

Loading bait barrels with herring for the never-ending lobster chase.

North Haven

Anachronistic in many ways, Brown's Boatyard on the island of North Haven survives as a vision of how Maine ought to be. For more than a hundred years it has stood at the edge of Fox Island Thorofare with minor adjustments to a changing world, both on and off the water. A round of applause seems in order.

Many newer and highly successful boatyards in Maine are located well away from expensive harbor-front real estate. It has become more cost-effective to use a big truck with a hydraulically equipped "hauling" trailer to pluck boats from the water at a no-cost public ramp and drive them inland for storage. This innovation has helped keep Maine's recreational and commercial boating industry healthy, making it much less expensive to maintain a vessel than it otherwise might be. And as old-fashioned as Brown's may appear, it too depends on modern hydraulics and other innovations for its continued success.

Still, tradition does help keep any business afloat, and Brown's now has its sixth generation of family members building and maintaining boats, wooden and otherwise. Longevity and durability have their benefits.

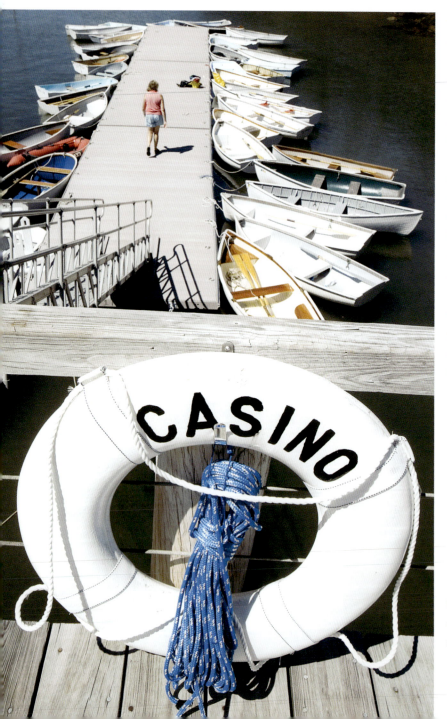

Dinghy dock at the North Haven Casino yacht club, the social epicenter of the North Haven summer community for 100 years

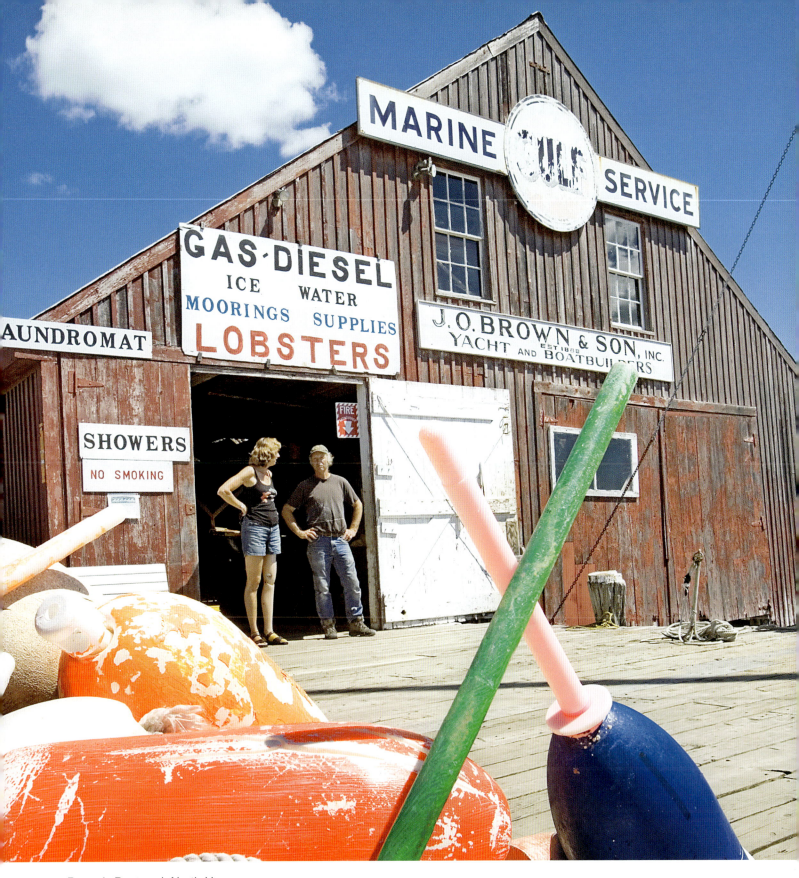

Brown's Boatyard, North Haven

47 Camden

Fog is more than just a major nuisance for anyone spending time on coastal waters. It can also be a source of puzzlement, beauty, trickery, and once-in-a-lifetime experiences. As with fire, though, you must be careful how you deal with it, and how it deals with you.

This ephemeral moment shortly after sunrise in Camden Harbor was probably witnessed only by a few lucky observers, because light parsed by fog sometimes moves quickly even when the mists appear not to be moving at all. Fog has quite variable densities despite what may appear to be a fairly uniform blanket of gray. Sometimes a portion of a fogbank is so dense it can bounce or bend sound or light in various directions, making navigational aids sound and look as if they are located where they aren't.

Likewise, a rising sun shining through variable vapors can suddenly look like a great yellow light exploding in the east. Other rare fog phenomena include spooky, silvery moon halos; arching "fogbows" generated by the moon or sun (though the colors are more muted than a rainbow); and colorful, drifting shafts of light known as crepuscular rays.

A full moon over Penobscot Bay as seen from the tower atop Mt. Battie, where Edna St. Vincent Millay wrote "The world stands out on either side / No wider than the heart is wide…"

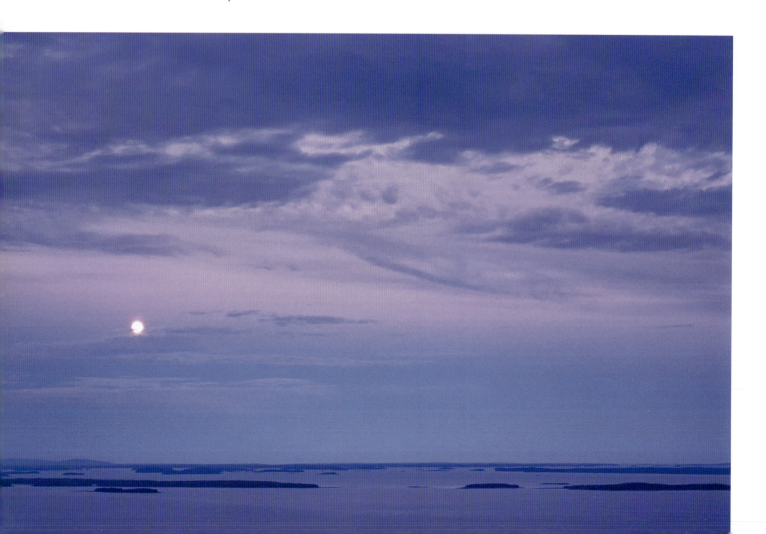

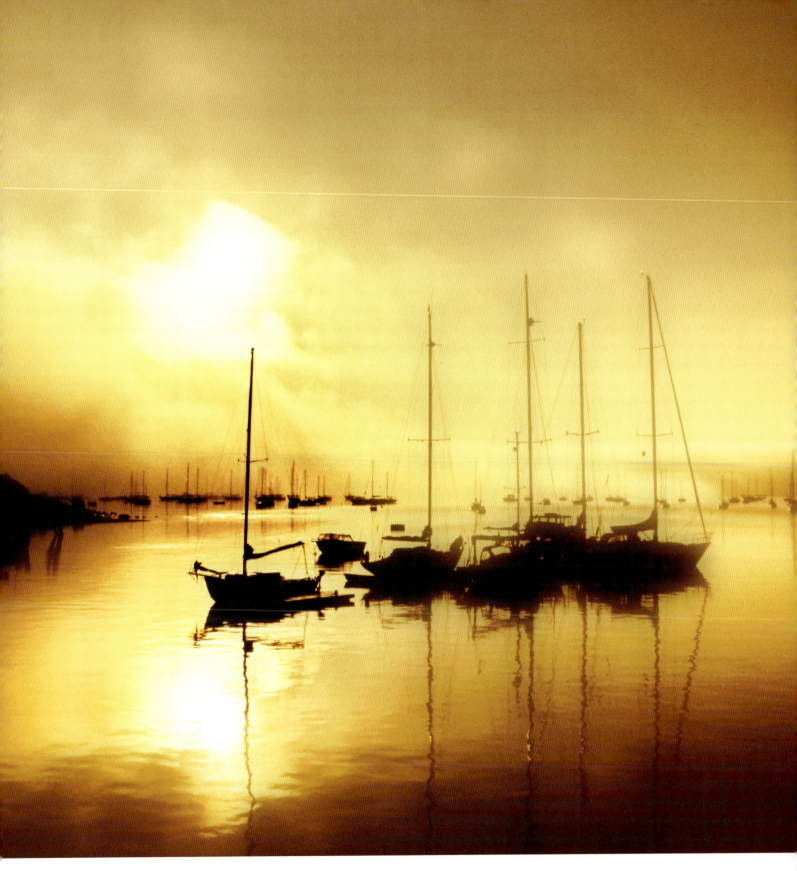

Early-morning fog, Camden Harbor

Islesboro and Warren Island

Islands are as much concept as landform, destinations of the spirit as much as the body. Whether Warren Island in Penobscot Bay or Shakespeare's unnamed atoll in *The Tempest,* an island is attractive for what it represents as much as what it is.

The earliest European settlers of Maine tended to establish themselves first on islands rather than the mainland. Safety was a prime consideration. An island interposes a natural moat between you and anyone who might like to have what you've got, so islands were settled first. Today, many people create their own little "islands" of safety, even within a subdivision of half-acre lots and one of four choices of home design. Much of the attraction still comes from having your lawn mower, SUV, proper television, and a host of other items safe within your "island" of two-by-fours, drywall, and locked doors.

But perhaps John Donne had it right after all when he wrote in 1624 that "no man is an island, entire of itself." A hundred or so years after he wrote that, what would the first settlers of Warren Island have thought of the sentiment?

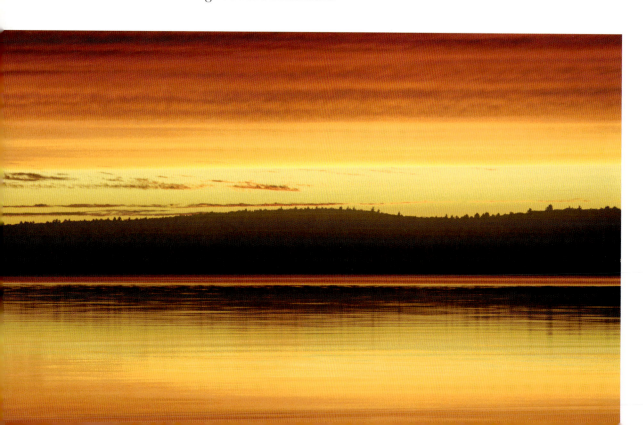

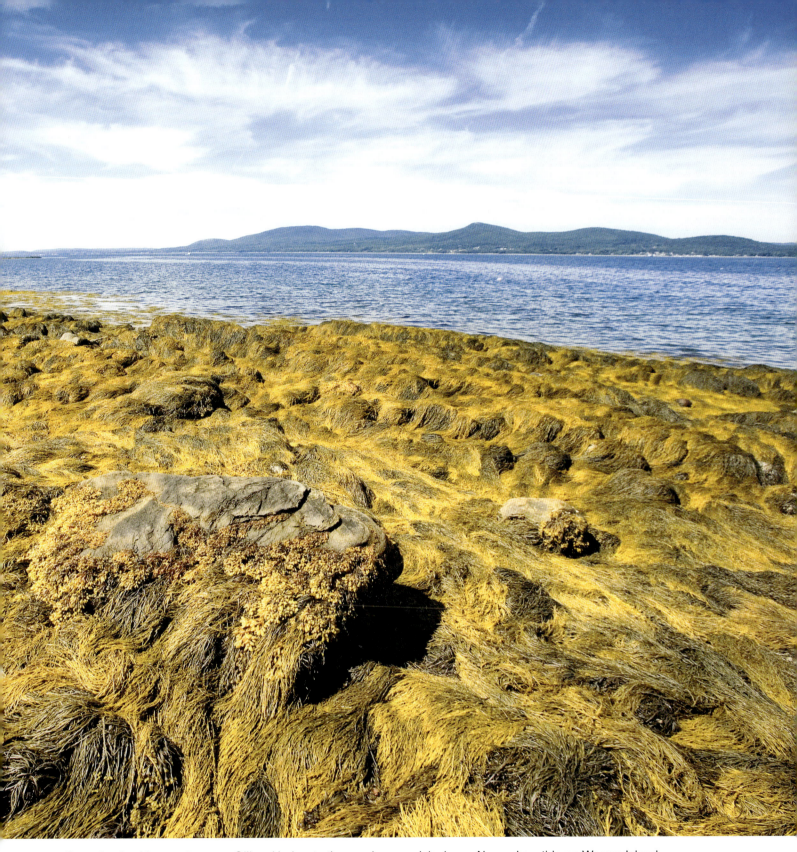

Opposite: Looking east across Gilkey Harbor to the sunrise over Islesboro. Above: Low tide on Warren Island reveals rockweed in abundance, the Camden Hills across the bay.

49 Belfast

More than one mariner has done a double take upon entering Belfast Harbor from Penobscot Bay. And even if you can't get to Belfast by boat, wooden faces and carvings of varying descriptions are just one of the sights that make a visit to the "Heart of the Maine Coast" a smile-inducing trip.

For more than a decade, the works of resident sculptor and Maine native Ron Cowan have been fascinating Belfast visitors, and they just might have given a few fish reason to pause while ascending the harbor's Passagassawakeag River—whose pronunciation should not be attempted by anyone but a local.

The images in the photo opposite, on pilings in Belfast Harbor, are indeed submerged during high tide. They reemerge as the tide goes out, revealing seven distinctive countenances at various points around the harbor. Cowan calls them "The Muses" and encourages onlookers to make of them what they will.

Most of the watery sculptures are removed for the winter lest the ice take them away, but they are dutifully reinstalled after the vernal equinox. And most of Cowan's other works around town can be seen most any time—a testament to a city that cultivates both a sense of humor and solid support for the arts.

The Muses, Belfast Harbor

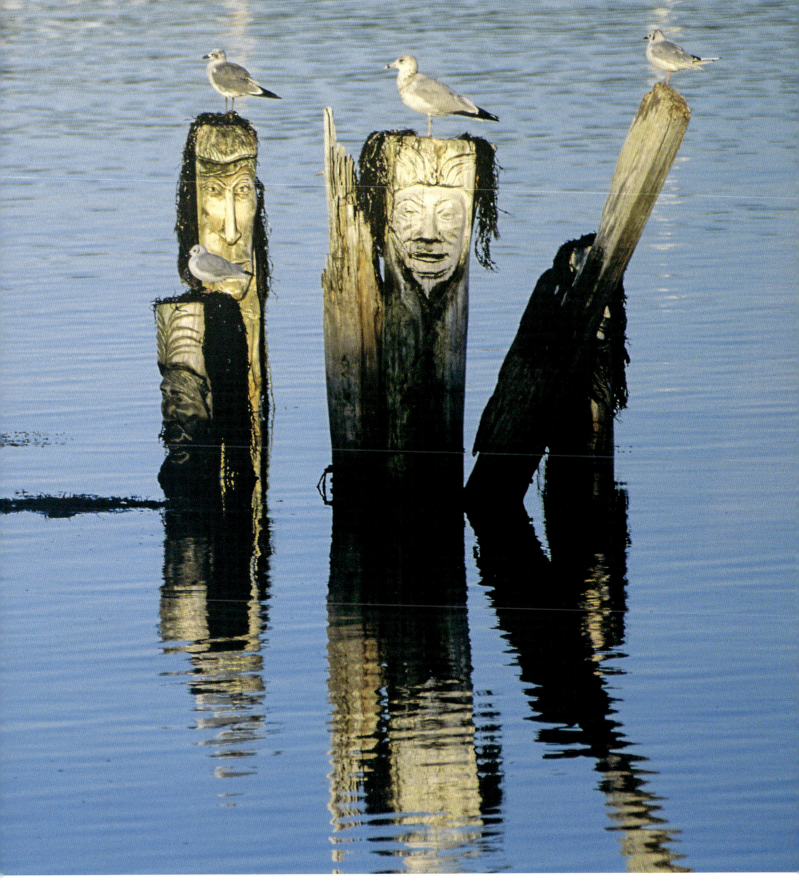

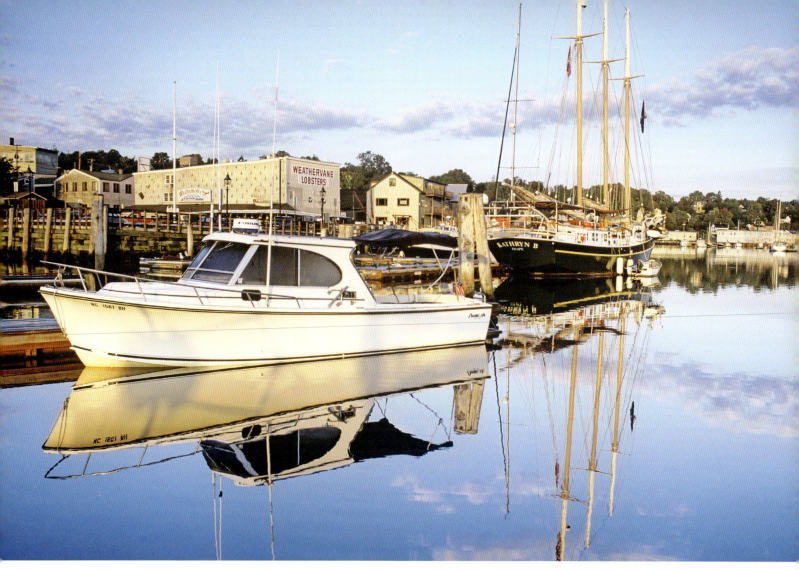

Belfast waterfront, morning

Main Street, Belfast

Belfast Harbor at sunrise, with Castine and Cape Rosier across upper Penobscot Bay in the distance.
Turtle Head, Islesboro, is in the middle distance at right.

Penobscot River

Ascending the lower Penobscot River today is as much a thrill as it must have been 200 years ago. But while today's explorer can enjoy a tidal estuary newly reclaimed from the depredations of the Industrial Age, our agrarian forebears had much more organic riches in mind.

Indeed, ready-made wealth was what settlers saw when they encountered vast marshes like those in Frankfort, a town on the west shore halfway between Penobscot Bay and Bangor. To an eighteenth-century settler, a salt marsh was pasturage that didn't have to be cleared and planted. Many coastal Maine marshes were also big enough to allow a cutting of salty "hay," which could be dried and stored for feeding to livestock through the winter. And business-minded settlers cut extra hay for export to cities like Portland and Boston.

Unfortunately, tides did not always cooperate when the optimum time for cutting hay arrived. No problem, settlers said. We'll just create a system of dikes that can close out the high tide for the week we're harvesting. The remnants of many such dikes can still be seen.

The Penobscot Narrows Bridge connecting Verona Island with the town of Prospect, as seen from the Bucksport waterfront

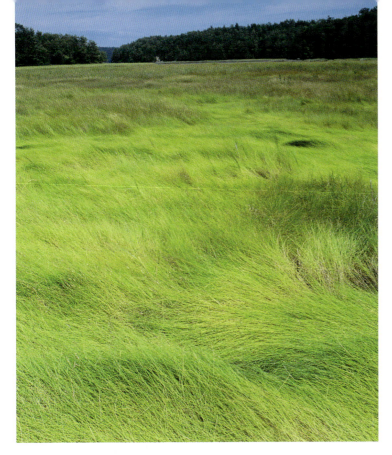

The marsh at Frankfort

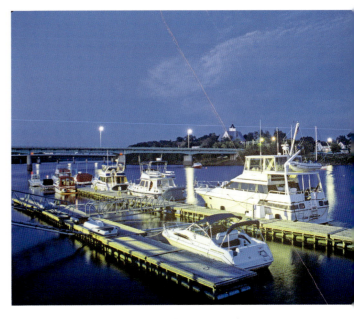

The Bangor city landing, with Brewer on the opposite shore

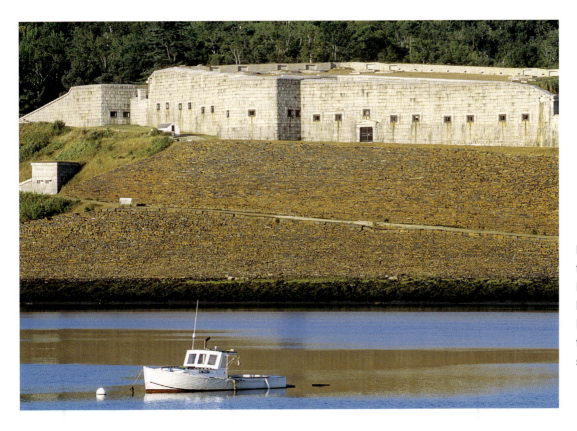

Looking across the Penobscot River from Bucksport to Fort Knox on the Prospect shore

Castine

Something nags at the back of the mind when visiting Castine, like a dream that lingers after awakening. It was a pleasant enough dream, one from a happy past. And then the mind clarifies and the thought occurs: This *is* the past.

The streets of Castine may conjure a dreamy reflection of the past due to the unique source of shade cast over the town's stately homes. Somehow, Castine's magnificent elm trees have survived Dutch elm disease, which wiped out all trace of the ubiquitous shade tree in thousands of small towns nationwide.

The devastation was particularly galling because the American elm is the original Liberty Tree, icon from the days when Revere, Franklin, Washington, and others fought back against despots run amok. In the tree's honor, thousands were planted nationwide in 1876, the centenary of the Declaration of Independence. Pride grew with the trees until around the 1960s.

Of course, even Castine's beauties will someday expire of old age. But happily, a disease-resistant cultivar of *Ulmus americanus* has been developed by the Elm Research Institute of Keene, New Hampshire, so at least the dream of a Liberty Tree can live on, as those in Castine already have.

Sign commemorating the protracted 1779 artillery duel between the Penobscot Expedition (a Colonial naval fleet) and the British defenders of Fort George in Castine. The arrival of a British fleet brought disaster on an epic scale to the doomed Colonial mission.

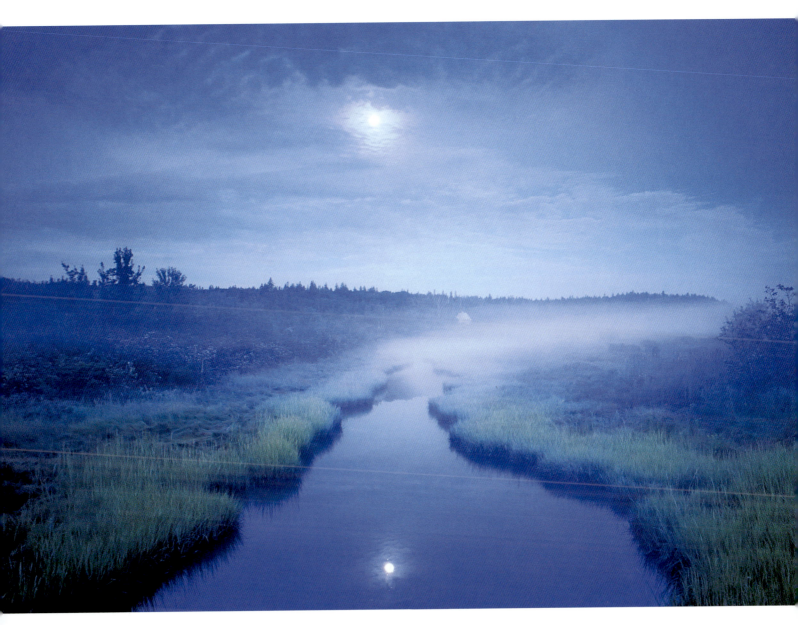

Pre-dawn mist over the British Canal, which was dug across the neck of the Castine peninsula by British soldiers during the occupation of 1814–15, turning the peninsula into an island—ostensibly to prevent soldiers from deserting.

52 Bagaduce River, South Penobscot

Hidden and revealing at the same time, mudflats at low tide are much more than a fragrant reminder of benthic ooze. In fact, some Mainers will look at this scene at sunset on the Bagaduce River and see dollar signs.

Most visitors assume that anyone bent over a Maine mudflat with a long-tined rake (a.k.a. "fork or hoe") is digging clams, and that is indeed one way to make the primordial muck pay. But pound for pound, the most valuable product from mudflats isn't the tasty steamer clam. It's worms.

Bloodworms and sandworms are harvested from the flats at low tide and sold to dealers, who ship them worldwide to recreational fishermen. For the past several years, sandworms have been bringing diggers more than $5 per pound and bloodworms more than twice that, which is more than lobsters, clams, or any fish with the exception of elvers, or baby eels (which yielded $2,000 per pound in 2012, triggering a gold rush, but that's another story).

The harvesting of worms is strenuous to say the least—backbreaking is a more descriptive term. Worms prefer excessively sticky, soft, deep mud, making the walk onto the flats a perspiring affair even before the first forkful of mud is turned. Once exposed by the rake, the worms are quick and prone to snapping in two if you grab them incorrectly or too late. Broken worms are not marketable. Bloodworms will give a digger a toxin-containing nip if given the chance. And conflicts with clam diggers are frequent because some clammers think worming buries and suffocates young clams (though others think it ventilates the flats and improves the clamming in the longer term).

Thus, worm diggers tend to be young, healthy, and brash. They like the idea of no boss, just the dictates of the tides and the seasons. Harvesting hidden treasures on newly revealed mud has its own pleasures.

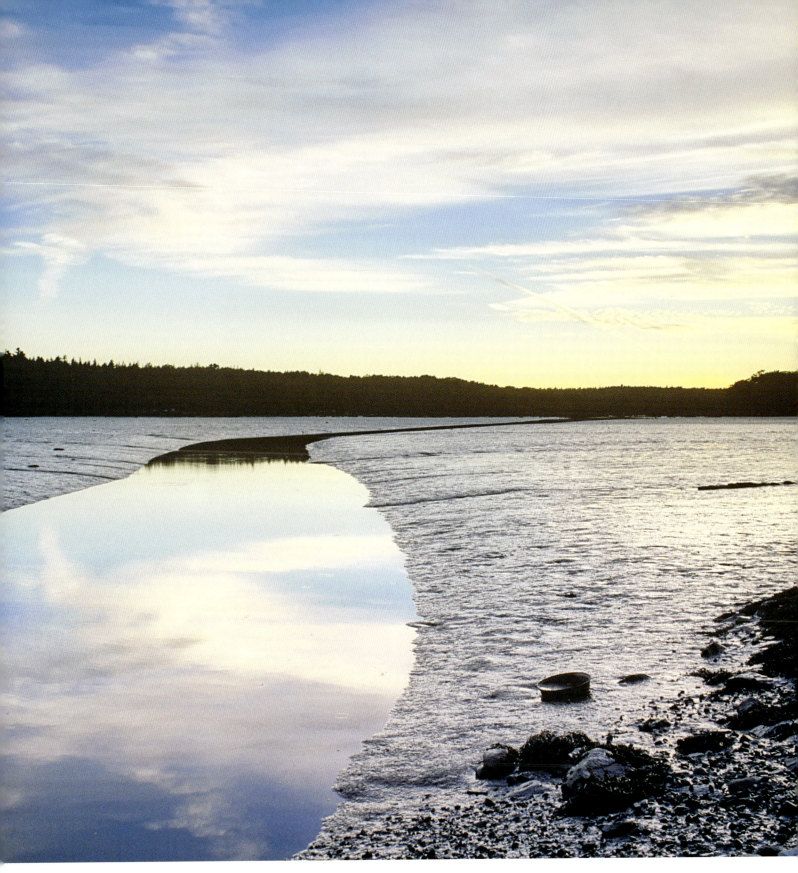

Low tide on the Bagaduce

53 Brooksville

Careening is a lost art in most coastal communities along the Eastern Seaboard. But this lobsterman in Brooksville knows the many values of the tactic. Obviously, anyone attempting to deliberately ground a boat on a falling tide must first understand the vessel's design. This beamy workboat is wide enough to lie on its side and not allow the returning tide to swamp it. A boat with a narrower beam might not be so lucky.

A quiet, unexposed cove also helps. After all, you don't want wind-driven waves or boat wakes crashing into your boat as the tide slowly returns. A hard, gravelly beach is preferable to walking about in muck.

In most places, when your prop is fouled or bent and needs changing, a marina will be glad to pluck you out of the water and charge a substantial fee for the honor. But when a beach for careening is at hand, the tides will giveth what a commercial haulout would otherwise taketh away.

The view across upper Penobscot Bay from the west shore of Cape Rosier

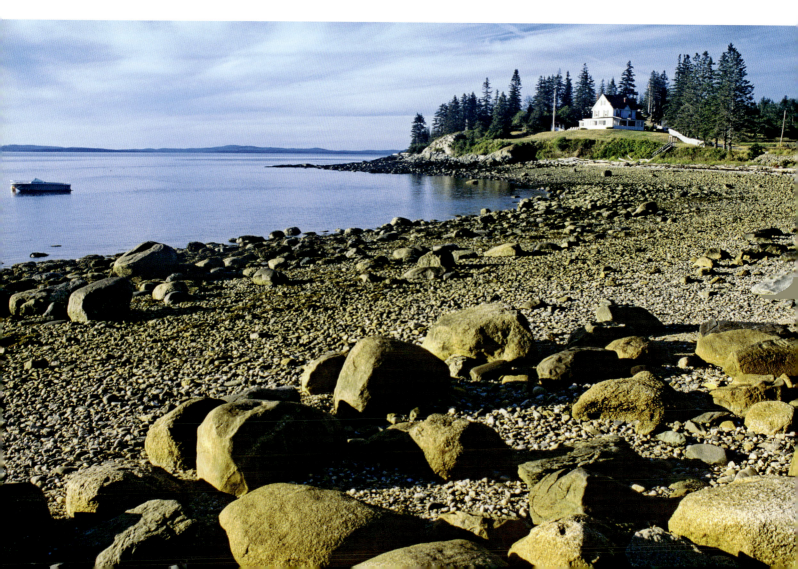

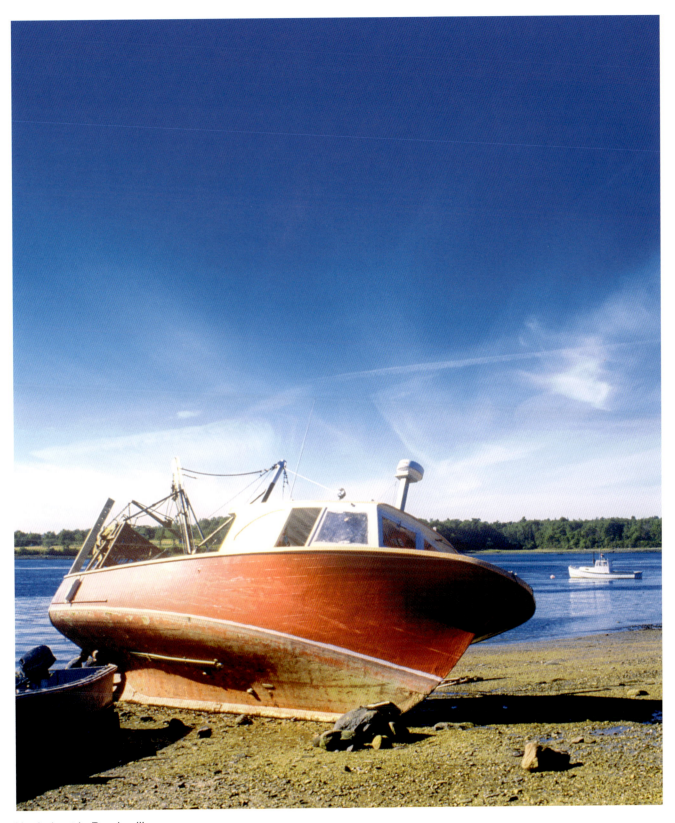

Hauled out in Brooksville

54 Sedgwick

Perfection, the Bard of Avon once wrote, lasts "but a little moment" and then is gone.

Still, for anyone in Sedgwick during that brief time when all of Penobscot Bay glistens beyond the fields of scarlet on Caterpillar Hill, the gates of nirvana are unlocked. It may last a day, or three, or not arrive at all in late September. But if you are among the lucky few who do witness it, you will treasure the little moment for a lifetime.

That's not to say the popular turnout on State Route 15 is ho-hum at any other time of the year. On the contrary, just about any clear day offers a view that can make you feel as if you're one step away from ascending to the heavens.

At your feet just beyond the blueberry fields is Brooksville's Walker Pond, a spring-fed beauty with camps and summer homes and just a few young lads and lasses learning to water ski on its calm waters. A bit farther south and west is Eggemoggin Reach, the much-traveled sheltered waterway between Penobscot Bay and points down east. And in the distance are the islands of Penobscot Bay—Islesboro, North Haven, and others too numerous to name—and beyond them, the Camden Hills.

Autumn and Caterpillar Hill

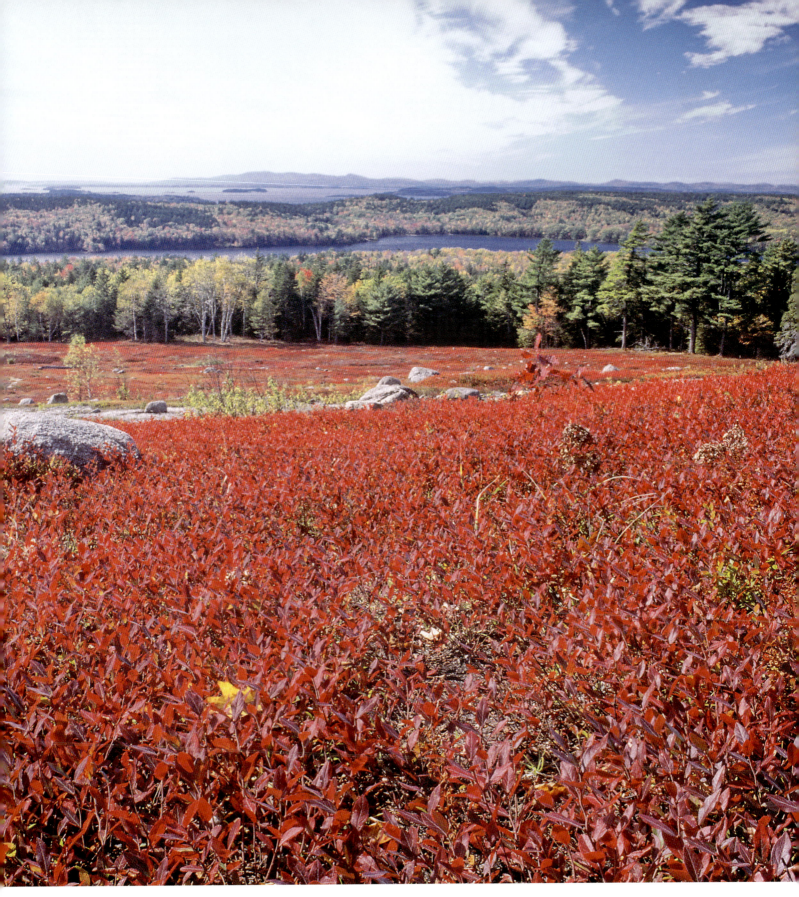

Stonington

Landlubbers will likely say that the photo opposite shows the backs of several buildings on Stonington's Main Street, but many of those buildings are in fact showing their fronts. The architects who designed most of them knew that the "front" they presented to visitors arriving by sea (as most did until well into the last century) was as important as the facade presented to those strolling the town's primary street.

Cupolas and mansard roofs are the best clues to the wisdom of those forgotten architects. Sometimes called (incorrectly) widow's walks, those high cupolas gave visitors magnificent views of Deer Island Thorofare practically at their doorstep, Merchant's Row beyond that, and Isle au Haut rising majestically in the distance. And a nearly flat mansard roof gave overnight guests a chance to be on a spacious third floor and look out dormered windows on scenes as peaceful as this summer morning.

One of Maine's top lobster ports, Stonington was also at one time a granite cutting and exporting powerhouse. Crotch Island, just across the Deer Island Thorofare, was once home to one of the most active quarries on the Maine coast. Crotch Island granite was and sometimes still is prized for its beauty, strength, and durability, qualities noticed as far back as the mid-nineteenth century. As America boomed during the latter part of that century, so too did the resident quarrymen of Crotch increase, at one time numbering as many as two hundred. Granite from the Stonington area ended up in such monumental edifices as the Brooklyn Bridge, the Boston Museum of Fine Art, and the memorial to President Kennedy at Arlington Cemetery, to name just a few. Even today, Stonington boasts veins of granite so rare that architects call for it in the facades of big-city buildings. Which can lead one to wonder, why is Mark Island Lighthouse, marking the western end of Deer Isle Thorofare, built of brick?

One possible reason is that the square lighthouse was built in 1857, when granite quarrying was still in its formative years and brick making was a huge and established export business for the entire Maine coast. Thousands of brick kilns fired up from Kittery to Machias, and millions of the fired-clay results went by the ton to Boston, New Haven, and other rapidly growing cities in the Northeast. Perhaps someone decided to keep a few of those Maine bricks closer to home for the white tower on Mark Island. It's a question worth contemplating as night draws down and a guiding white light flashes faithfully every six seconds.

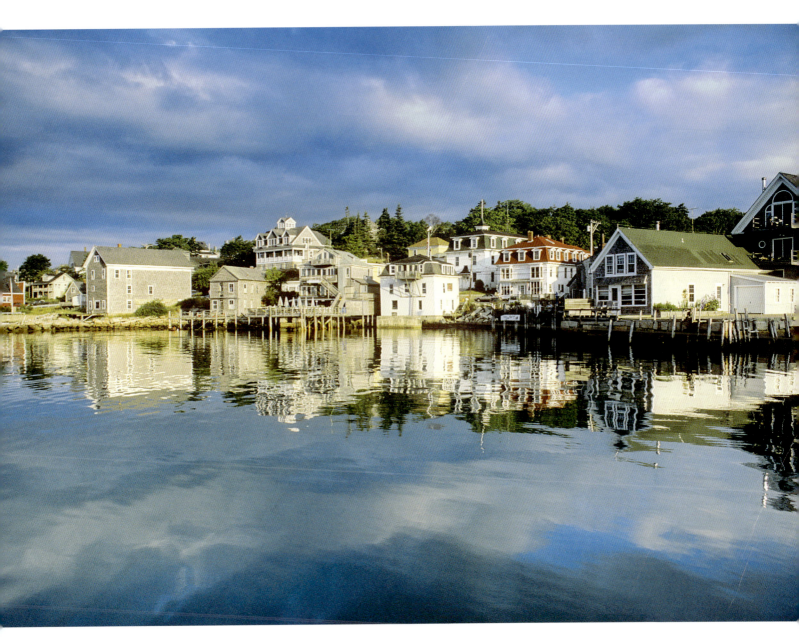

A view of the Stonington waterfront

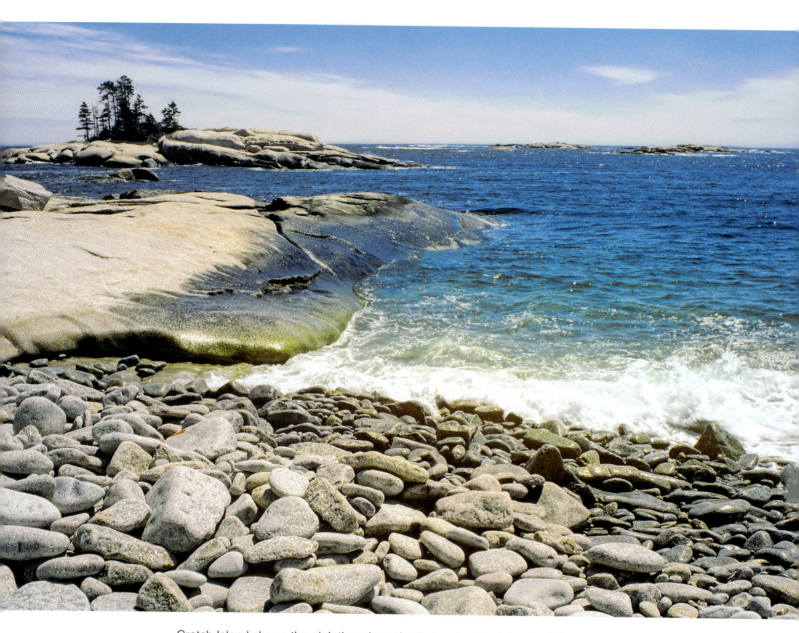

Crotch Island shows the pink-tinged granite that makes the islands of Deer Isle Thorofare and Merchant's Row so striking.

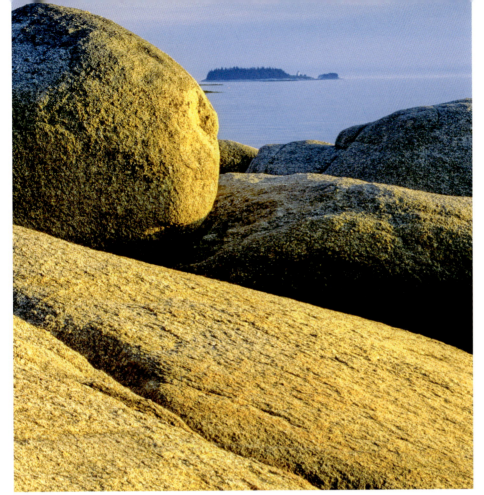

Mark Island as seen in the distance from the Deer Isle shore west of Stonington

The Deer Isle Thorofare from the Stonington shore

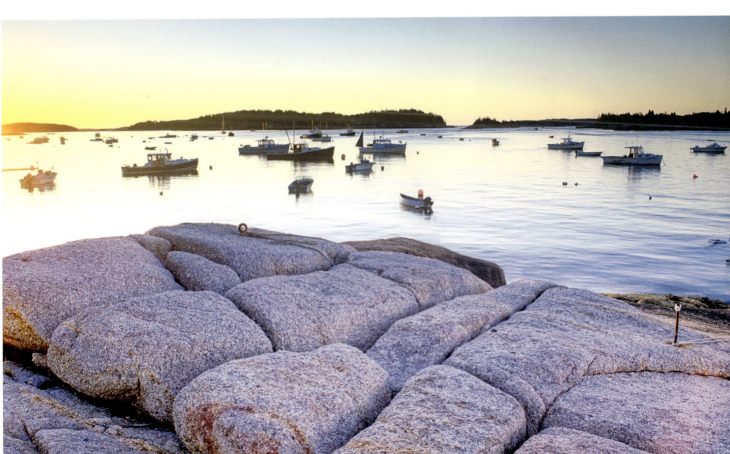

Isle Au Haut

Lucky is the boat owner who gets to Duck Harbor—two-thirds of the way down Isle au Haut's western shore—when the weather is clear and settled, the cove is empty and calm, and the anchor stays put for more than five minutes. That's tantamount to winning the trifecta of Maine boating.

The island's primary harbor, Isle au Haut Thorofare, is at its northern end, three miles north of Duck Harbor. A ferry from Stonington makes the four-mile run south across Deer Isle Thorofare and Merchant Row to the town dock in the thoroughfare on a regular schedule. A number of years ago, that was the extent of ferry services.

But in recent years, Isle au Haut's status as part of Acadia National Park has made it more of a go-to destination, with increasing demand for access. Although you can access the park via a short walk from the town landing, arriving at pretty Duck Harbor puts you smack dab in the middle of park lands and trails. So now there is regular ferry service to Duck Harbor as well as the thoroughfare.

Robinson Point Lighthouse with the south end of Isle au Haut Thorofare beyond it

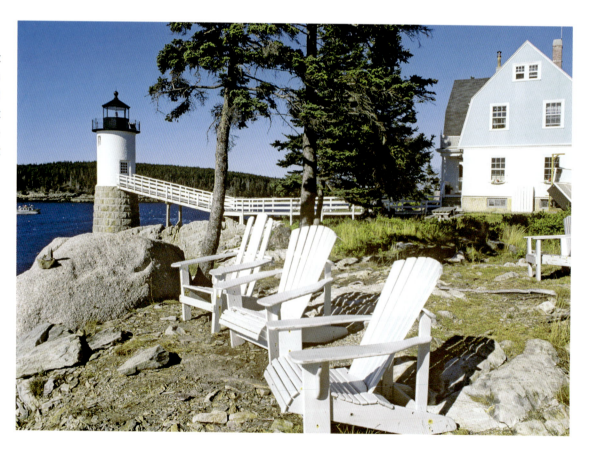

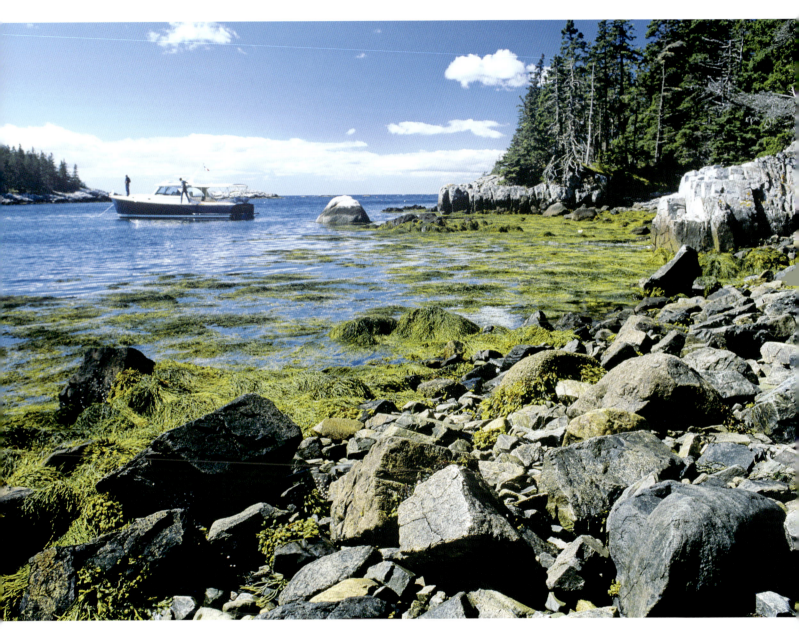

Duck Harbor

Brooklin

A Hollywood makeup artist can make just about any aspiring actor or actress look like the dashing protagonist we all want to applaud. But does the actor have the "bones" to deliver the lines, generate the emotion, and captivate the audience?

The analogy seems somehow relevant to a small rowing boat like this peapod tethered to its mother vessel in a cove on Eggemoggin Reach in the town of Brooklin. Peapods once looked very different from this beauty and were found everywhere along the Maine coast. Indeed, any boatbuilder worth his salt, and many accomplished do-it-yourselfers with a barn and a hammer, knew how to get the bones of this skiff together without one look at a book, plans, or mathematics.

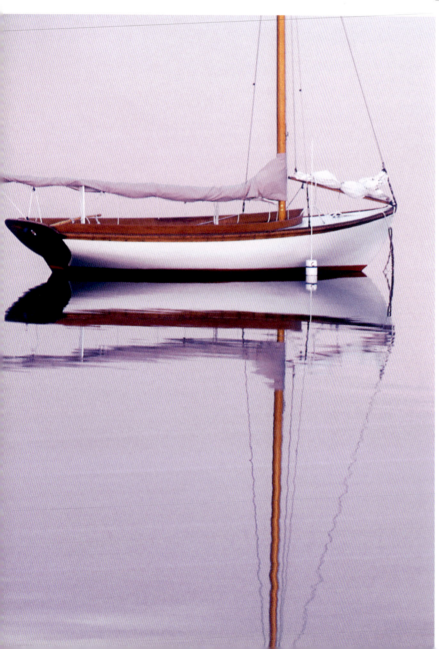

Predictably, those forerunners of this peapod looked a little rough. Planks overlapped each other like clapboards on a house. Varnish was unknown, and even paint was considered optional. And mahogany trim? Why use that when good old cedar, pine, and oak were available at the local sawmill?

But then and now, a peapod delivers. Loaded or light, they cut through the water without fuss, turn around tight on a trap buoy, and get you home reliably if not especially dry. Peapods are worth applause in any scene.

Nathanael Herreshoff may have achieved perfection when he designed the Herreshoff 12½, a boat lovely enough to break hearts.

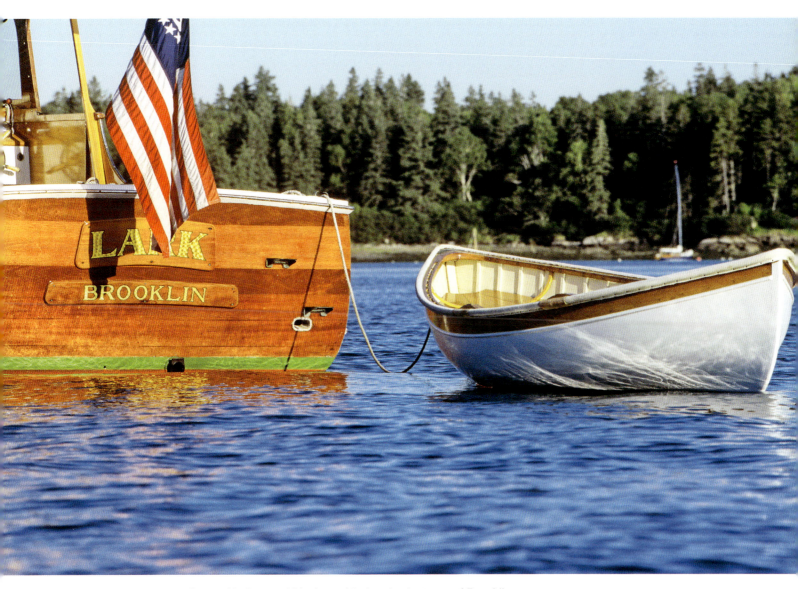

Somewhere between Center Harbor and Naskeag Harbor, in the town of Brooklin

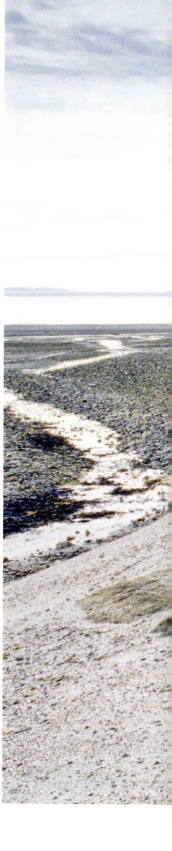

Blue Hill

At first, something seems wrong, but you can't put your finger on it. You gaze at Blue Hill Bay's stunning beauty, marveling at the calm serenity of the northwest end of this sheltered body of water. It looks, smells, and sounds like almost any other Maine coast backwater at low tide. But wait: Where are the lobsterboats? Where are the lobster trap buoys?

Lobsterboats do indeed ply the waters of northern Blue Hill Bay, but they set out precious few traps with their colorful marker buoys, making these waters seem a bit out of context in Maine. And the cause of this paucity is not man-made. Instead, blame a long-gone glacier or glaciers.

Lobsters love to hide out, mostly for their own protection. Thus the predominantly rocky, haphazard seafloor of the majority of the Maine coast is perfect for lobster doings. But advancing and retreating glaciers tens of thousands of years ago scoured flat most of the upper Blue Hill Bay seafloor and then covered this benthic landscape with mud. As a result, there are few submarine places for a lobster to hide. Thus, except around the rocky edges, there are few lobster trap buoys and even fewer lobstermen to tend them in this upper portion of the bay.

Blueberry barrens on Blue Hill, with Mount Desert in the distance

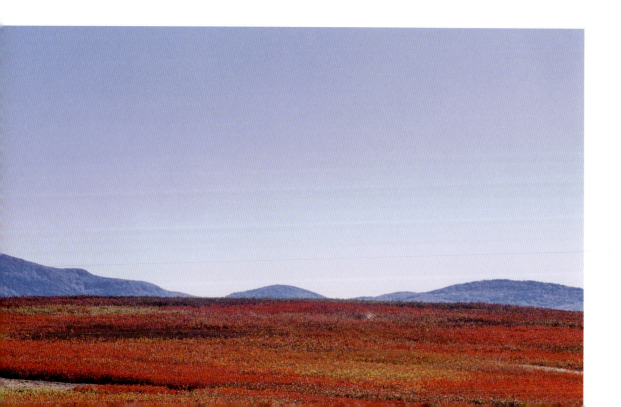

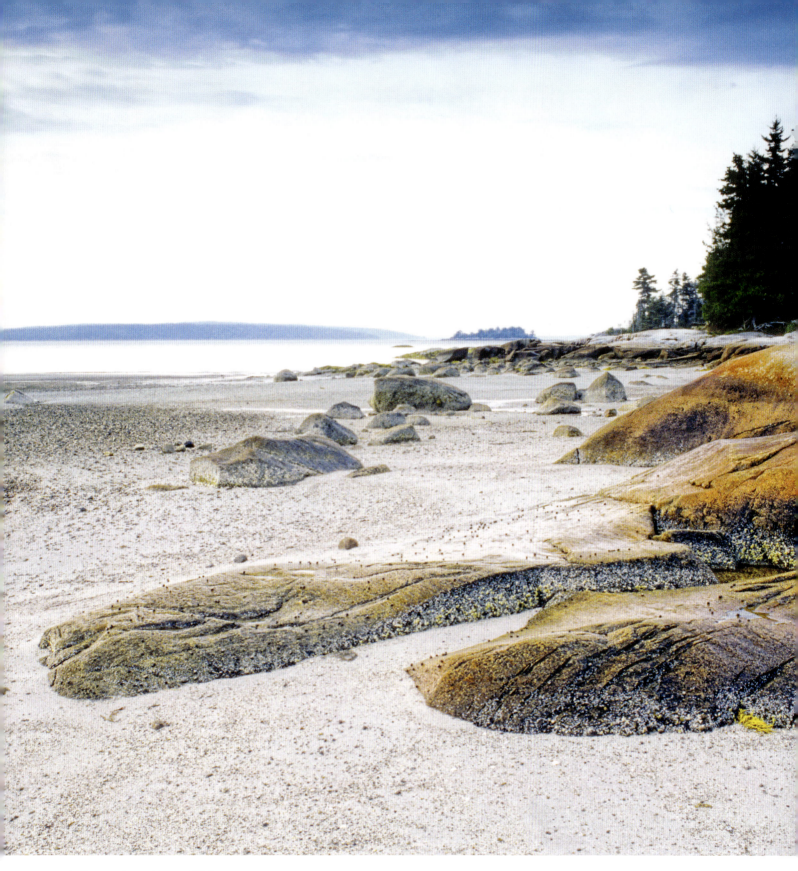

A distant view of Blue Hill Bay

59 Acadia National Park: Cadillac Mountain

An eagle might gaze from this spot atop Cadillac Mountain and see Acadia National Park quite differently from your average human visitor. Looking south toward Otter Cove and the southeast side of Mount Desert Island, it's fairly clear that the day's southwesterly seabreeze has yet to take hold. Those glossy patches just offshore indicate areas of calm surrounded by mere zephyrs.

So perhaps it's best to ride the thermals, gliding and hunting over the magnificent autumn landscape heating up in the early October sunshine. Since it is late morning, some rabbits might be munching grass at the edges of the rocky outcrops just below. That can be an easy swoop-and-scoop for a 15-pound raptor with a seven-foot wingspan that doesn't maneuver easily amid spruce and pine branches.

Later, once the seabreeze kicks in, hunting offshore should become easier, especially with the migrations under way. Those tasty puffins over on Petit Manan Island may have departed already, but acres of rafting sea ducks and their ducklings can be found just offshore. Or perhaps a few young, inexperienced loons have already moved from their summer quarters inland to the bays and are not yet attuned to overhead predators.

Toward sunset, with the tide flooding westward, schools of stripers may be making their way west and south for the winter. Sometimes cod will get sloppy and wander near the surface for a quick snack. And once the sun is down, there is always a chance herring will be near the surface to provide some sustenance.

Looking southeast from Cadillac Mountain

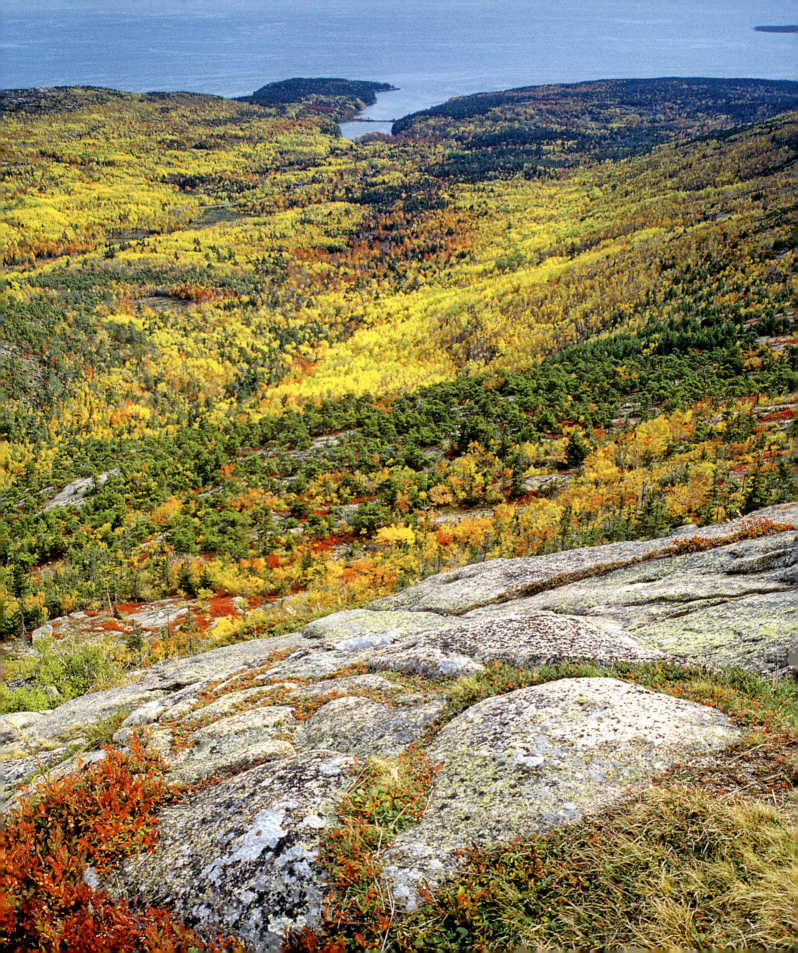

Acadia National Park: Boulders

Odd, unconventional, and deviating from the norm are traits often considered undesirable, and they are also terms that frequently accompany the word "erratic." But for a Maine native and any geologist, erratic says it all, and any accompaniment is just gilding the lily.

For instance, this large boulder sitting atop the barren upper slopes of Cadillac Mountain tells us much about the misty past of the Maine coast. We know tremendous forces were involved in transporting it to this surprising spot. Weighing in at just under twenty tons, this five-foot-tall stone is unlikely to have been rolled this far uphill by men, either European or Native American, nor did it get here by itself.

Glaciologists tell us that a giant, flowing sheet of ice covered Cadillac Mountain 25,000 years ago, and it was that frozen river that picked up this rock somewhere inland and transported it to this spot in Acadia National Park. A geologist could examine the rock and come up with a pretty good estimate of where the stone originated, from Ellsworth to Athens or beyond. And both experts would refer to the boulder by its accepted scientific term: erratic—as in, it doesn't really belong here but here it is anyway.

There are other erratics hidden here, there, and pretty much everywhere along coastal Maine. They are easiest to find on land scraped clean of vegetation, scoured bare by that same glacier, where they are sometimes the only crop produced by the thin soil. The blueberry barrens of coastal Washington County make especially good erratic hunting—and you might find a few unconventional people there too. We like our erratics, whether stony or frisky.

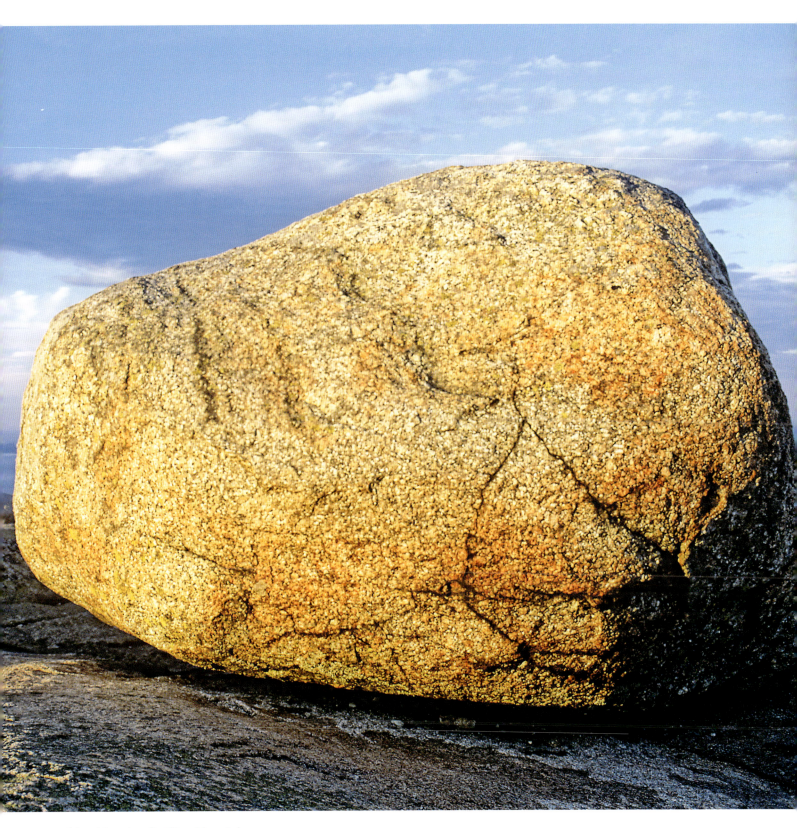

A boulder atop Cadillac Mountain

Acadia National Park: Huckleberries

Like thieves in hiding, huckleberries can be hard to find when weighed down with their "loot." Low to the ground, bearing small green leaves that blend with the surrounding soggy, acidic groundcover, huckleberry plants are the Jesse James of Maine's native fruits. The sweet, dark-blue berries ripen sometime in August, usually in places that are accessible only on foot.

There are lots of challenging hikes in Acadia National Park, but as the bright red leaves of these post-berry, autumnal huckleberry plants attest, the discoveries on the paths less traveled can be rewarding beyond measure. In addition to wild huckleberries, hikers are likely to encounter wild blueberries, blackberries, red raspberries, gooseberries, and, well, you get the idea. And even if you don't give a hoot about wild berries, the animals they attract when they are ripening can be fascinating. From deer, raccoons, and porcupines to bears, coyotes, and foxes, wild berries are on the menu and attract a wide variety of customers—and sometimes, other animals who might like to feast on those customers.

Acadia is not the only island location that provides nearly ideal conditions for growing wild berries. All along the coast, the damp, cool maritime air helps produce the decidedly acidic soil in which many wild berries thrive. Most charts of the Maine coast contain at least one island named raspberry, gooseberry, or something of the sort. Obviously, those fruits once grew on those islands in abundance. And the "berry islands" that are still difficult to reach today often have sizable crops available for whoever takes the time and effort to reach them. Bears and coyotes need not apply.

Egg Rock Lighthouse in Frenchman's Bay, seen from the Bar Harbor shore

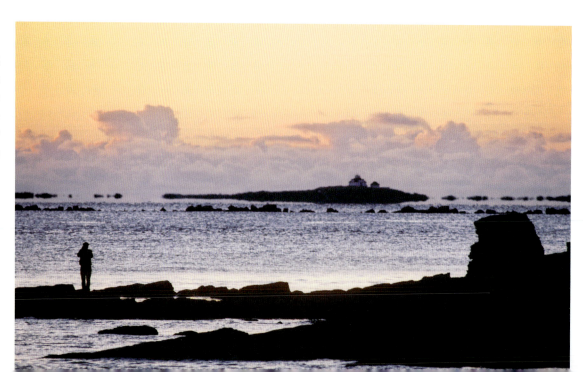

Autumn huckleberry foliage

62 Acadia National Park: Great Head

Great Head may look in this photo like a piece of Arizona relocated to Acadia National Park, but it could hardly be less like a desert. Despite the desert-like, cobalt-blue summer sky and the rocky, soilless terrain, this is the hidden Maine coast at its finest, as many of the state's school children learn from an early age.

Life is the main difference between this piece of Maine and the Arizona desert. The tide pool in the foreground holds at least as much living variety in its several thousand gallons of seawater as several hundred square miles of desert can support—maybe more. Generations of school children on class trips have delighted in finding five species of crabs, a dozen varieties of shellfish, a score or more species of seaweed, all sorts of newborn fish, and much more in these pools. Even immature specimens of Maine's most famous crustacean, the lobster, can be found in tide pools all along the coast along with thousands of single-celled plants, animals, and hybrid combinations of the two.

Getting to a tide pool can prove a bit of a challenge. This one in Acadia National Park requires you to follow the moderately difficult Great Head Trail to the southeast corner of Mount Desert Island. There, if the seas are calm, the tide low, and the spirit and body willing, you descend from the trail amid the rocks and boulders to reach this cornucopia of life.

Great Head, Acadia National Park

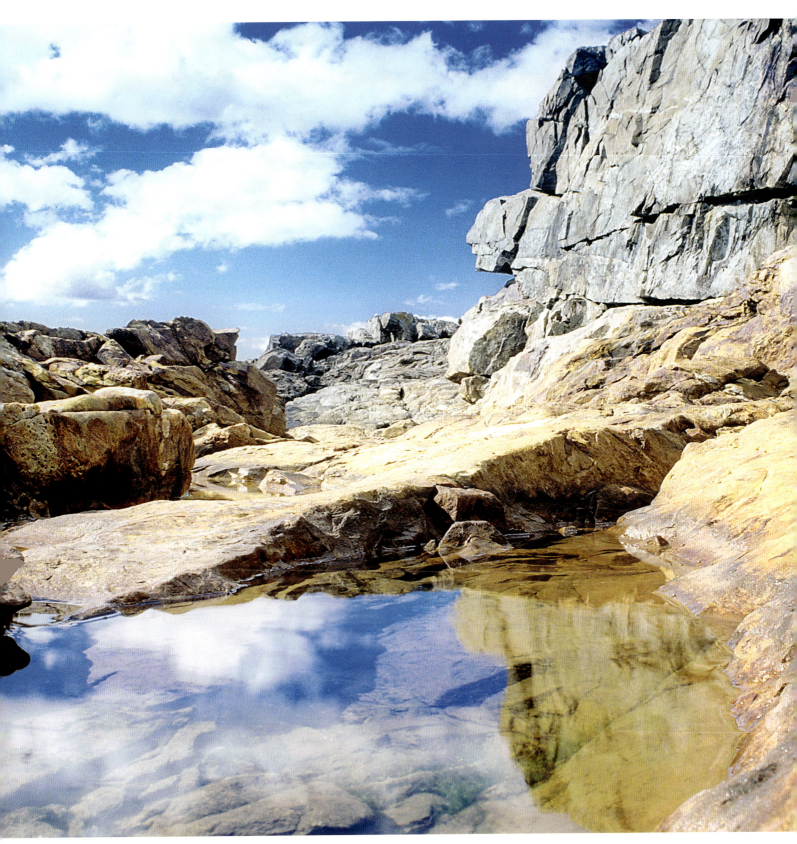

63 Acadia National Park: Jordan Pond

To claim that Jordan Pond is hidden seems ludicrous, so we make no such claim here. But there are some little-known facts about this ultra-popular Acadia National Park attraction one may want to contemplate.

Consider, for instance, the carnivorous bladderwort. In addition to having an amusing-sounding name, these plants float around Jordan Pond in great numbers. Despite the "carnivorous" aspect of their lifestyle, they don't eat the flesh of humans—who aren't allowed to swim in Jordan Pond anyhow. (Nor is your dog.) They can, however, consume small fish fry, emerging tadpoles, water fleas, plankton, and other animals that also hang out in great numbers in Jordan Pond.

Even better, Jordan Pond's waters are among the clearest in Maine. Visibility in the water is normally around 45 feet, and reliable reports place it as high as 60 feet when conditions are right. Thus the lucky biologists who get the gig to study bladderworts in Jordan Pond have the time of their lives watching tadpoles being snatched up in the plants' floating bladders which reportedly take only 10 to 15 thousandths of a second to attract and ensnare their prey. Alas, all is not serene even in the watery world of the avid bladderwort watcher. There are invasive bladderworts in some Maine lakes and ponds that now threaten to crowd out the homegrown variety, to mention just one problem with the invasives.

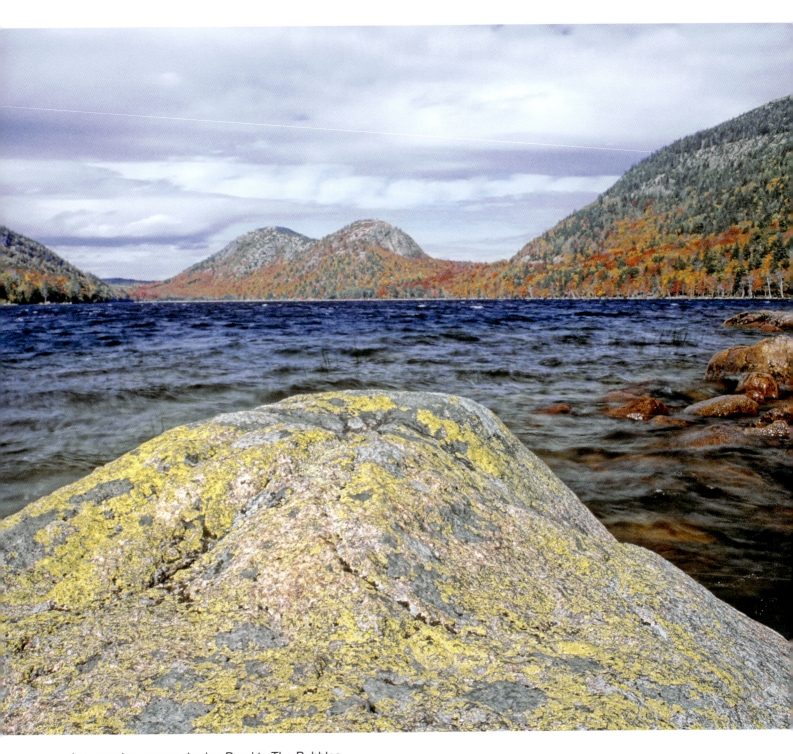

Autumn view across Jordan Pond to The Bubbles

Southwest Harbor

Paddling is believed to be the first means of propulsion humans used to get from one watery place to another. Perhaps a Cro-Magnon man grabbed a leafy tree branch and sat athwart a handy log as he crossed a river to escape a pursuing saber-toothed tiger. Or maybe he was the predator, not the prey, crossing the water with spear aboard to reach the antelopes grazing on the other side.

Whatever the case, paddling—in this case, rowing—is still an ideal means of propulsion for anyone intent on escaping to the backwaters of Mt. Desert Island. And yes, there is indeed escape from the multitudes who visit Acadia National Park every summer. A rowing skiff as sleek and rugged as this Ralph Stanley–built skiff on a dock at Southwest Harbor would be just the ticket.

In fact, any cartop rowing vessel would be perfect for the launching ramp near the village of Pretty Marsh, on the northwest side of MDI. From the end of Bartlett's Landing Road, miles of ideal rowing coast with lots of protection from heavy wind and waves are at your feet—or the end of your paddle, as the case may be. The inshore side of the island also tends to be less foggy and the water a little warmer too. But not bikini-warm.

If freshwater rowing is what you have in mind, Pretty Marsh can still accommodate. Back out on Maine State Route 102, the road swings past the northern end of Long Pond, where there is a launching ramp. The pond itself is about four miles long and, by the end of July, warm enough for swimming. The southern and western shores are part of Acadia, and the scenery is dramatic in the vertical sense.

Ghosting through Southwest Harbor on a dying evening breeze

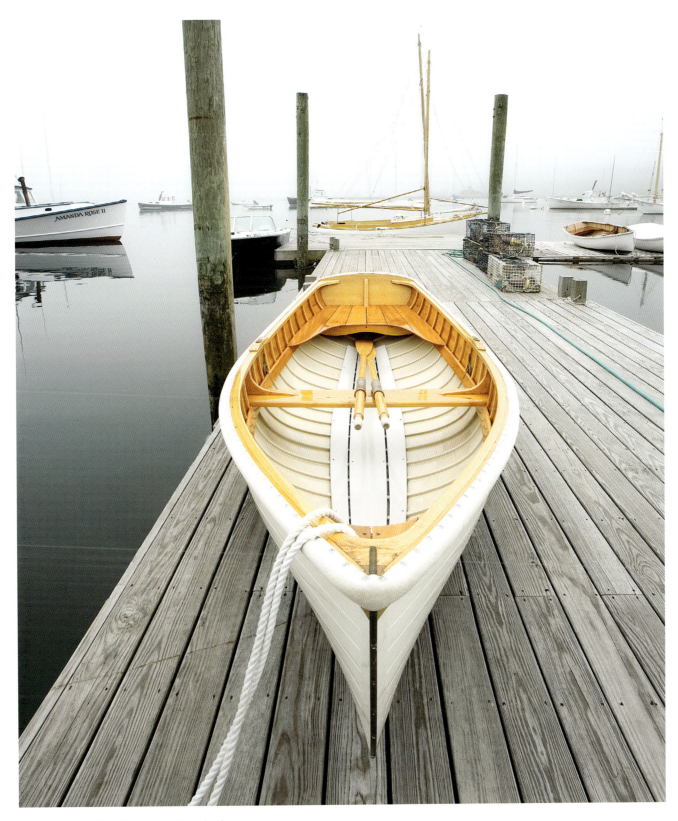

Rowboat on a Southwest Harbor dock

Bass Harbor

Bars in Maine—even the ones that serve no adult beverages—can be as rough and tough as any waterfront dive the world over. Bass Harbor Head Light, for example, marks a bar that can knock a sailor on his can more surely than a roundhouse right.

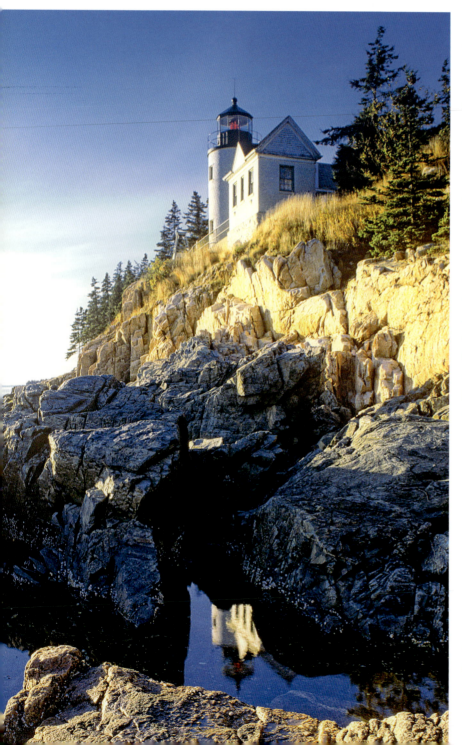

Unlike the sandbars with which most beach lovers are familiar, Maine bars are of a quirkier, flintier breed. While sandbars usually run parallel to a beach, the Bass Harbor Bar extends nearly a mile directly offshore, south to Great Gott Island. Moreover, there is very little sand on this bar. It's mostly solid granite with giant boulders here and there, and maybe the bones of a misguided vessel or two. Given its low-tide depths of 8 to 14 feet, you might think it doesn't pose much of a hazard—but you'd be wrong.

When the flood tide rushes in from the east, it slams into this bar and starts to tumble. Odd waves appear, currents swirl, and cold, deep water can make fog a little thicker along its length. And when a wind blows against that tide, watch out. Square or pyramidal waves like you've never seen before start to heap up and can eat a small vessel for lunch. The reverse is true on the ebb tide.

Opposite and left: The changing light at Bass Harbor Head Lighthouse

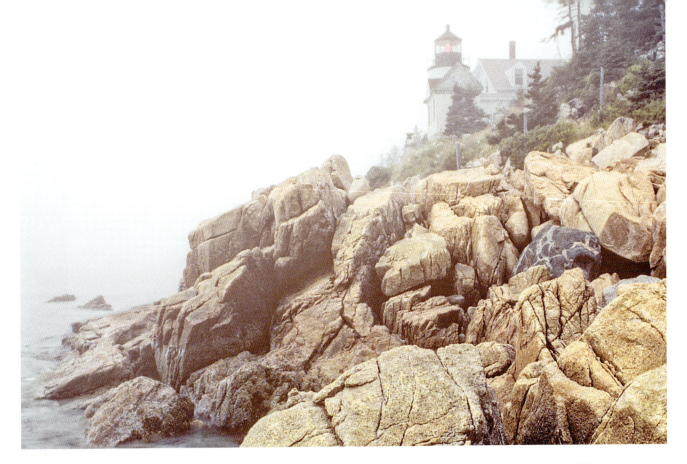

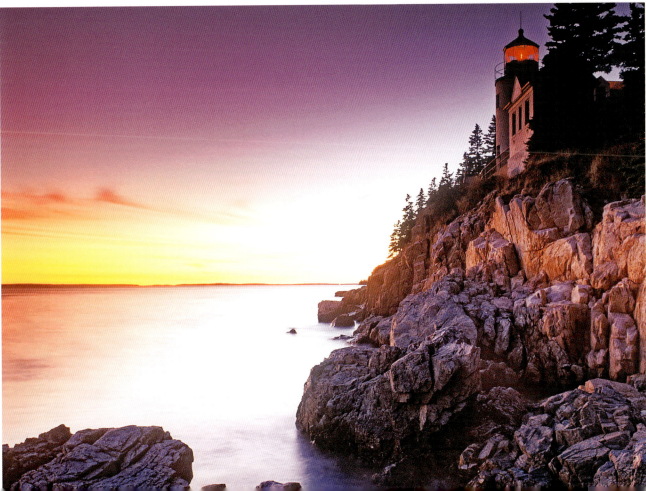

Bernard

At first glance there is nothing particularly hidden in a scene of diners enjoying lobsters on a wharf in Bernard. But if one could listen to this scene and sniff the air, an otherwise invisible uninvited guest would become apparent. Always hidden somewhere on the Maine coast is the pesky, persistent, omnipresent mosquito.

Indeed, Maine is home to some 44 species of our flying friends, two of which are particularly fond of hanging about salt marshes and shoreside pools of warm salt water. High runs of tide trigger the birth of even more of them than usual. Fortunately, screening mesh has been around for nearly 200 years and became available by the yard in Maine about a hundred years ago. And citronella oil has been recognized as an effective insect repellent for more than 60 years.

So screened diners on a wharf need only put up with the whine of skeeters just outside the screen and the scent of citronella candle smoke as they enjoy their *Homarus americanus* with or without sides of steamers and corn on the cob.

Bass Harbor
from the
Bernard shore

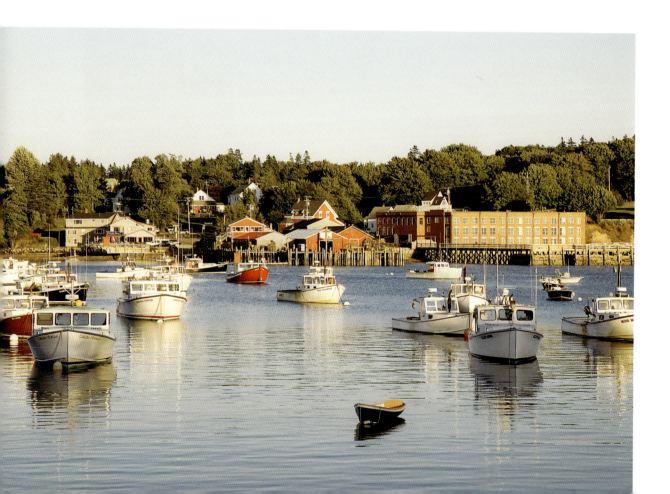

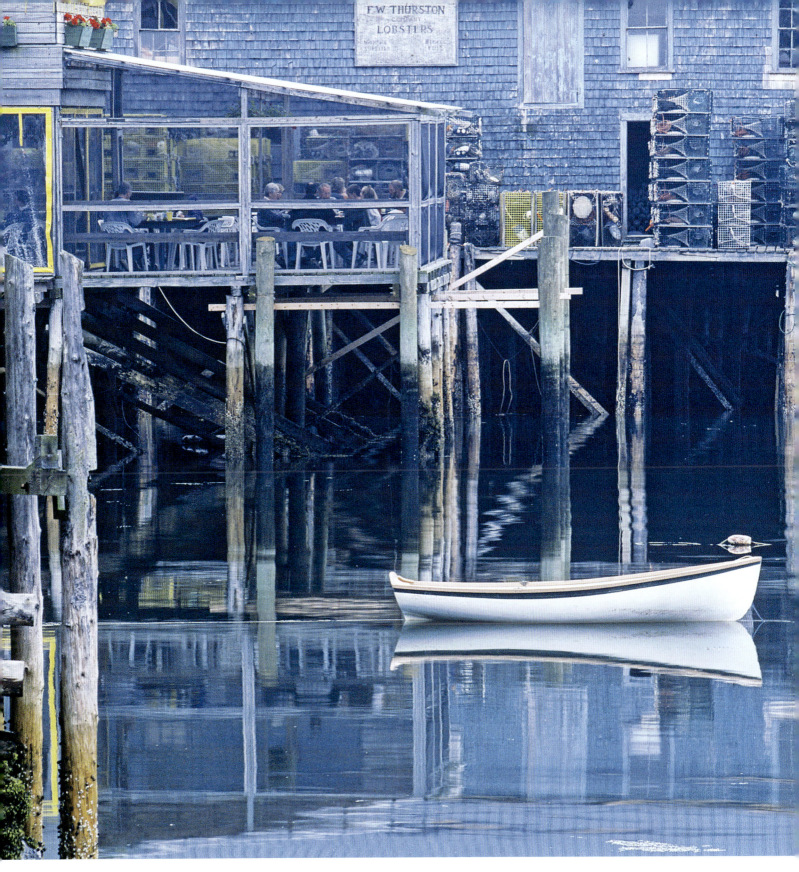

F.W. Thurston's, Bernard

67 Swans Island

Shore lights can be a double-edged sword. This bright white light on the lobster co-op wharf in Burnt Coat Harbor on Swans Island, just offshore from Mount Desert Island, was probably installed with the best of intentions, most likely to lengthen an already-long day of processing lobsters, dispensing bait, pumping fuel, and work, work, work. It might also prevent a strolling visitor from tripping over a misplaced porch chair, running into an otherwise invisible railing, or walking off the edge of the dock. And this lone shore light is unlikely to confuse an incoming mariner the way the multiple shore lights of a busy port sometimes do, masking the lighted navigation aids to the point of inducing groundings, collisions, and worse. So what's the downside?

Alas, it also interferes with star gazing, which, on Swans, is absolutely spectacular. Why? Because the island is so far away from the shore lights that tend to obscure the best of the night sky in nearby Southwest, Northeast, and Bar harbors.

Pot warp

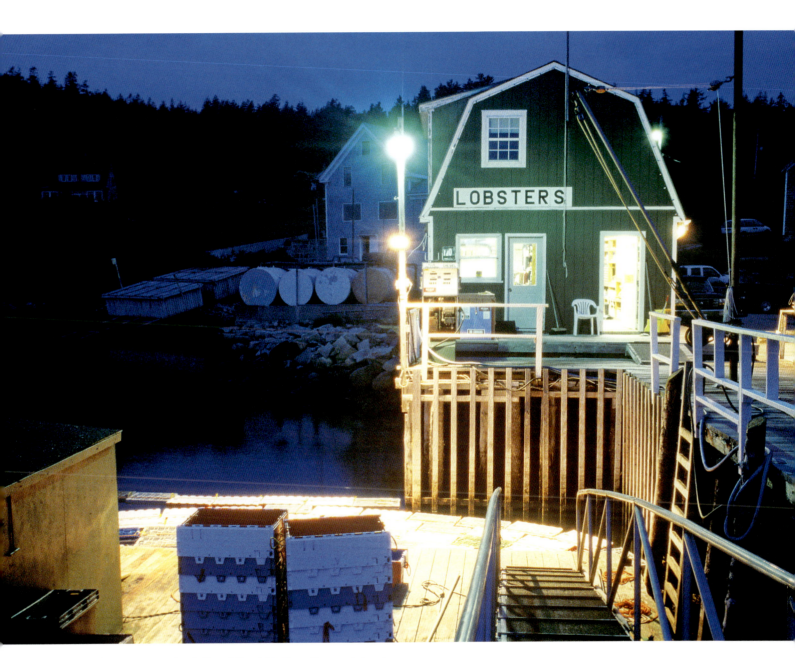

The lobster co-op wharf, Burnt Coat Harbor, Swans Island

Frenchboro, Long Island

Imagine for a moment a place where even the most individualistic people are polite and cooperative. Then visualize all these people working hard at their chosen endeavors, largely refraining from whining or complaining about their lot in life. Finally, consider that these people live in paradise three months out of the year and, to put it politely, in a challenging environment the rest of the time.

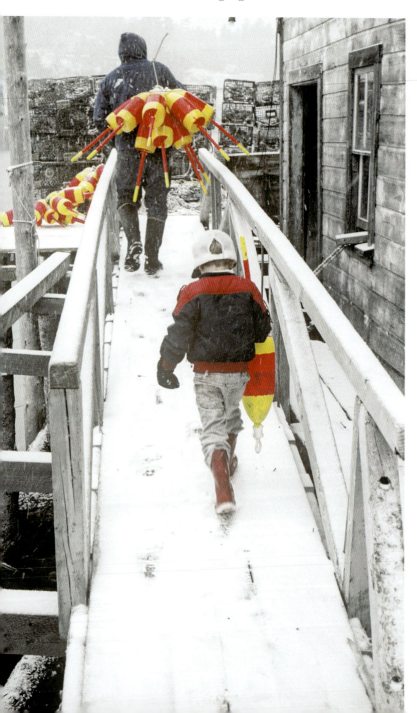

Year-round residents of Frenchboro might quibble quietly with parts of that description of their village on Long Island, some eight miles off Mount Desert Island. But with only 60 residents in a place that can be cut off from the mainland for weeks at a time, they are indeed a special breed.

Frenchboro welcomes summer visitors, but they are only a minor part of island life and making a living. Lobsters are the mainstay, the beginning and end, the axis around which success and failure revolve.

Attitude is also key. If you go, don't take one with you. Cooperation and getting along are what make a real island community a success, as Frenchboro has been since the 1820s. As on a ship at sea, it's in everyone's best interest to "take an even strain."

Left: Helping dad on a Lunt Harbor wharf.
Opposite: A seaward beach on Long Island.

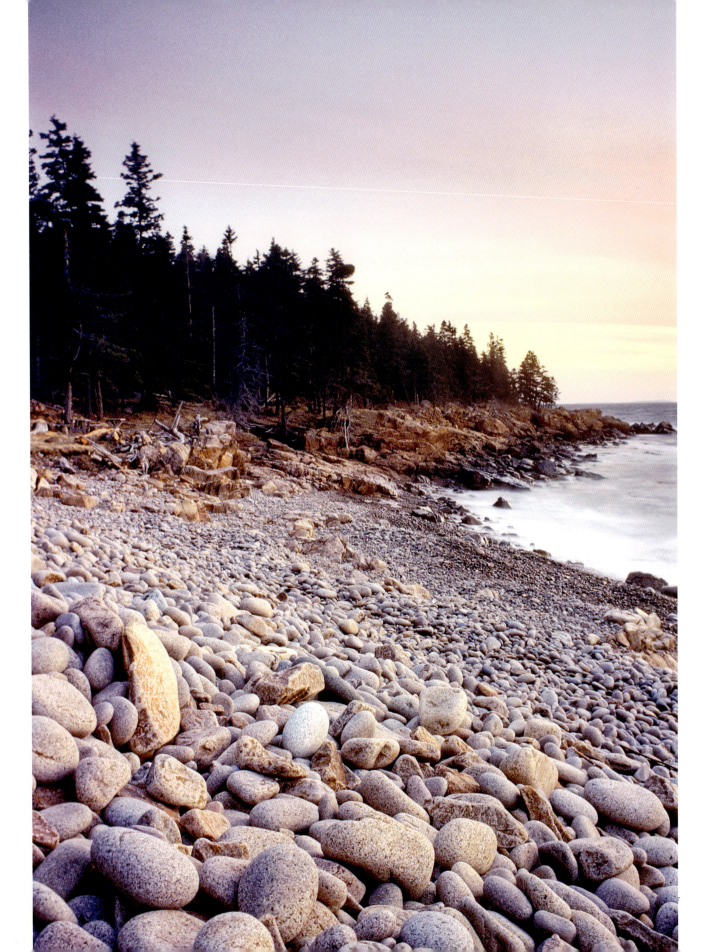

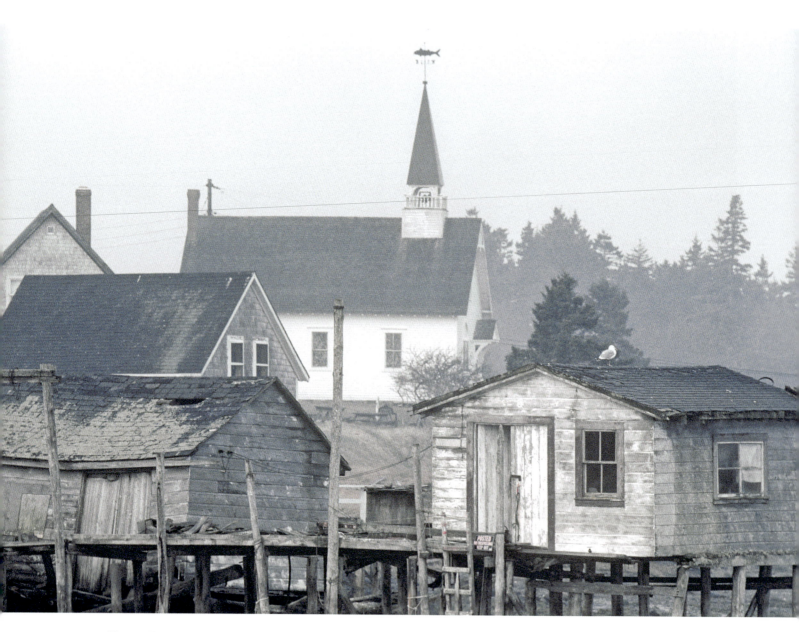

Above: The view across Lunt Harbor to the Frenchboro skyline.Opposite: Frenchboro under a lowering sky.

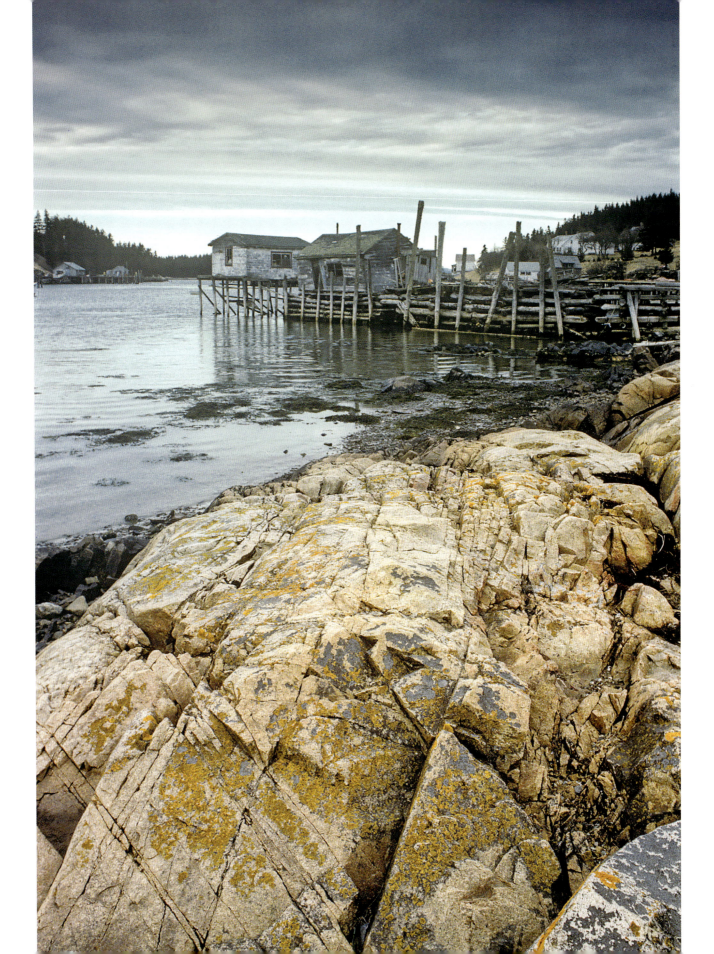

Schoodic Peninsula

The Schoodic Peninsula is home to the "other Acadia," the 2,266-acre Acadia Park annex that is only a few miles east of Mount Desert as the seagull flies but an hour away by road. This hidden corner is a place of elemental power, a prototypical granite Maine peninsula thrusting into the open Atlantic, where rock contests with water. Rare is the visitor who wants to walk a beach full of big round stones such as those on the shore near Birch Harbor on the upper peninsula, but on seaward shores where the surf grinds rock to cobbles, the effect is intricate and the walking easier.

Take a hiking trail away from the shore, and within a hundred yards you're in a spruce-fir forest where fog tangles in lichen-encrusted trees, moss and lichen cover exposed granite ledge, and hermit thrush and white-throated sparrow add counterpoint to the muffled surf rote.

A beach on the outer Schoodic Peninsula

Above; A clearing on a Schoodic Peninsula hiking trail. Opposite: Surf wash on a Schoodic shore.

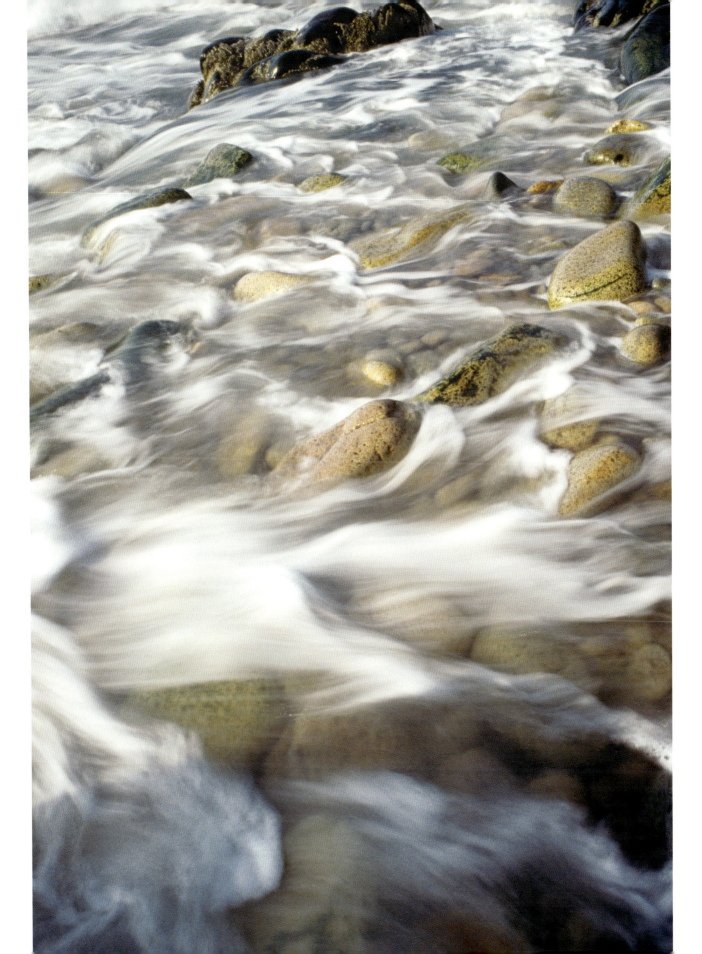

70 Corea

"High up in the North in the land called Svithjod, there stands a rock. It is a hundred miles high and a hundred miles wide. Once every thousand years, a little bird comes to this rock to sharpen its beak. When the rock has thus been worn away, then a single day of eternity will have gone by."

The writings of Hendrik van Loon in his famous children's book, *The Story of Mankind*, often come to mind when the rocky shores of Maine are considered. On the shore above the high-tide mark near distant Corea, one "bird" whittling away at the granite is lichen.

Lichen, however, is a strange bird. Though considered a plant, it is actually a fungus that lives symbiotically with an algae, the two pairing up to produce chemicals that break down even the hardest granites—given enough time. Lichen takes nourishment from the air, and it finds moist maritime air especially nourishing.

An experienced biochemist or ecologist might be able to explain why such a wide variety of colors is associated with the lichens that cling to coastal rocks, though not without a chemical analysis of the rock, a measurement of the acidity of the air, and a consideration of related factors for each lichen. Perhaps a van Loon–like explanation of colorful lichen is preferable even for adults.

Corea shoreline

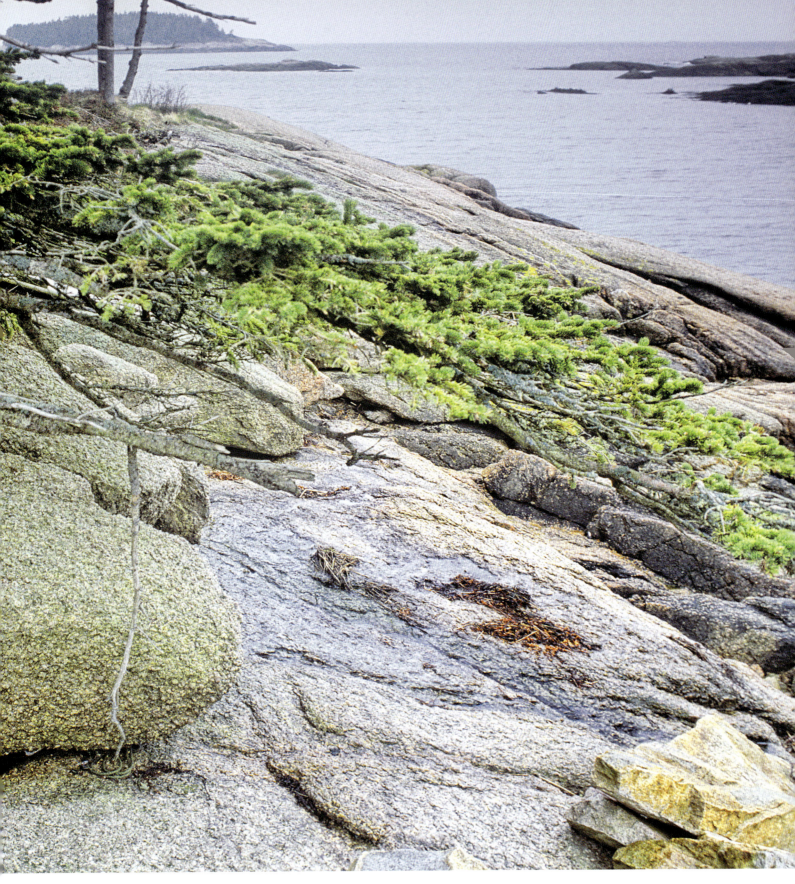

Addison

Tough, pretty, and persistent, the pink sea roses growing on the shores of the Pleasant River near Addison might be considered symbolic of the town itself. But *Rosa rugosa* arrived in Maine long after this shipbuilding town was incorporated in 1797.

In fact, this ubiquitous riparian plant, found in just about every nook and cranny of coastal Maine, is native to East Asia and Japan and is designated as an invasive species in Maine. Exactly when *R. rugosa* arrived here is uncertain, but mention of it in various botanical texts begins only well after the Civil War. It goes by quite a few names, including beach rose, salt rose, spray rose, beach tomato, sea tomato, beach plum, and shore eggplant.

The references to fruits and vegetables are due to the sea rose's life after its fragrant pink blossoms disappear some time in midsummer. The blossoms are replaced by what is commonly called rose hips, which are reddish, round fruits about the size of a cherry tomato. High in vitamin C, the fruits are edible once you neutralize their sourness with loads of sugar or some other disguise. Cooking is usually essential too, or you can make rose-hip tea.

Once established, the thorny bushes on which sea roses appear are difficult to discourage. Saltwater dousings, droughts, fire, and human interference have little effect. Like the residents of the town of Addison, they just keep surviving and generally have a salutary effect on most anyone who encounters them. Indeed, these are the roses of childhood to most Maine coastal residents, inducing some to argue that there ought to be a statute of limitations on "invasiveness" where *Rosa rugosa* is concerned.

The Pleasant River estuary

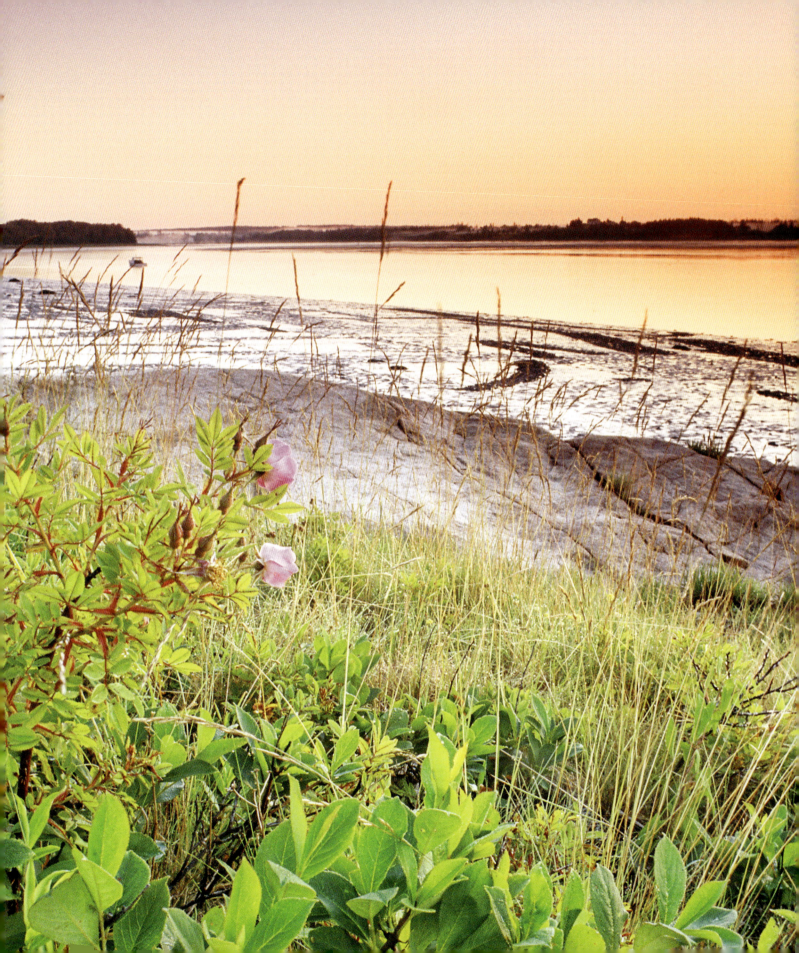

South Addison

In a tough world, only the tough survive, and South Addison can count itself among the toughest, with its hard granite shores jutting out into a restless Atlantic. This place is far—very far—from amenities most take for granted. No pizza delivered here.

With that in mind, poppies are an ideal flower for the dooryard of an old South Addison farm. Once established, they come back every June without much fuss. Cultivated worldwide for thousands of years, poppies have come to symbolize endurance, longevity, even the eternal. Even before John McCrae immortalized them in his poem "In Flanders Field," they evoked fortitude and reliability.

Indeed, the entire scene brings to mind the farsighted wisdom of the fishing and sometime-farming folks who still inhabit this area. Among the poppies are other reliable perennials such as daisies and hawksbeard. And beyond them are an apple tree and a lilac bush, two more survivors whose annual appearance of color is all but assured.

Even the house itself is plain and simple and designed for living, not for rapid appreciation. No McMansions and no flipping here. Only the self-reliant and philosophical last long.

Cape Split,
South Addison

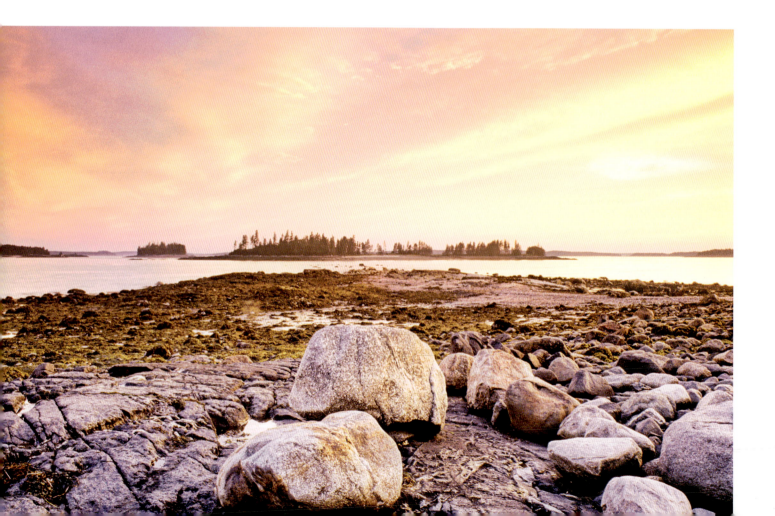

South Addison farmhouse

Columbia Falls

Winding its way through miles of muddy marshes, the upper Pleasant River estuary in Columbia Falls today looks serene as a sigh. But if you look carefully at the tidal river's banks while you ascend on a rising tide, you'll notice something of its raucous past.

Red bricks can be seen amid the brown mud. At first they are just here and there, then entire shores seem peppered with bits and pieces of bricks, as if some great building once stood on these shores. It wasn't a building, though. It was an enterprise.

Brick kilns once lined the shore of the upper Pleasant, creating an export item (and income) for locals willing to engage in the backbreaking process of making bricks out of local clay. These wood-fired kilns ran for days, then were left to cool off. Later, large sailing ships would tie up next to the piles of bricks, load them, and then sail off to points south.

Indeed, Columbia Falls also boasted of ship-yards, sawmills, and grist mills, among other enterprises. Hydraulic power to run all these businesses was provided at the point where the tide met the Pleasant River's tumbling inland waters, which is where the once-bustling town was, and still is, located—minus the bustle.

Tidal marsh on the Pleasant River, Columbia Falls

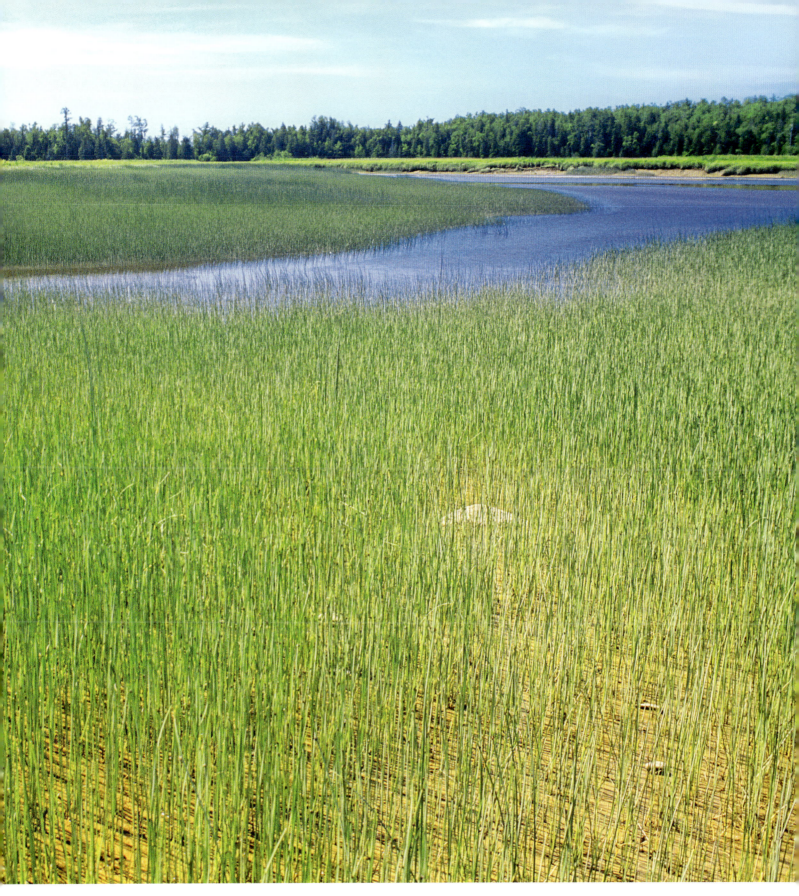

Jonesport

Sit near the water cooler and you can learn a lot about what's on the minds of people in the office where you work. The place to hang out in Jonesport is at busy Sawyer Cove, where you'll learn a lot about a town decidedly out of the mainstream—and with its own way of discussing it.

For instance, if you hear a lobsterman talking about being "spleeny," don't be concerned about his medical condition. He's just using a local expression describing someone's temperament, falling somewhere between squeamish and cautious.

Likewise, if a couple of clam diggers are talking about "yowans," don't assume they're talking about the surname of their neighbors. They're actually talking about very young children in general, using a local word the origin of which has yet to be determined.

Fortunately, though, most Jonesporters are really quite "meet," which is another local locution describing someone who is polite, agreeable, and generally proper in social situations. The public launch ramp and pier at Sawyer Cove may not be quite as hip and up-to-date as the company water cooler and its associated conversations, but they're every bit as instructive.

Sawyer Cove, Jonesport

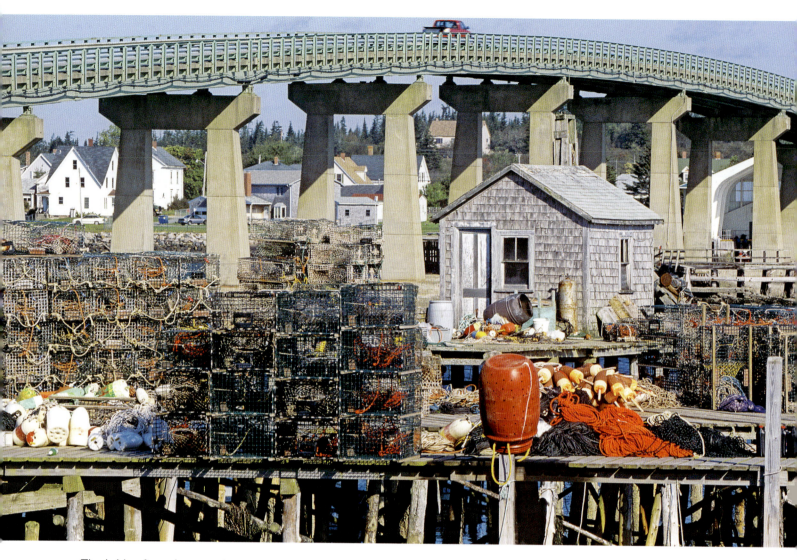

The bridge from Jonesport
to Beals Island

Gulls on a Jonesport roof

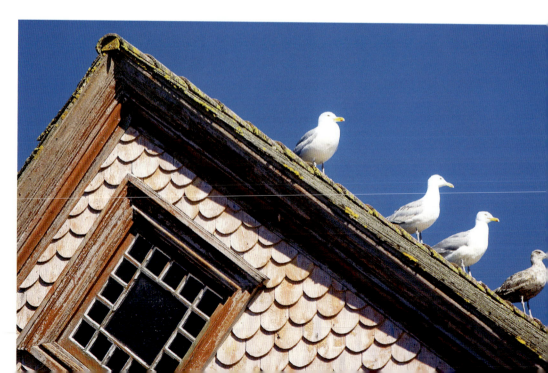

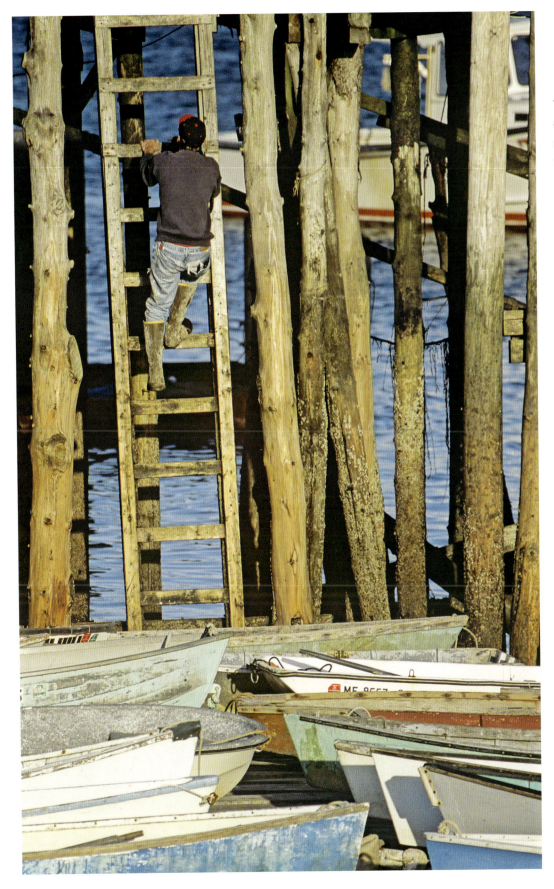

Tidal ranges increase down east. They're substantial in Jonesport but even larger farther east.

Sunset and fishing nets once had a great deal of meaning for those who lived on the Maine coast. And it's likely quite a few Beals Islanders remember the connection between these nets and sunset. But it is becoming a more hidden connection with every passing year.

Seining is a style of fishing in which fish (usually herring) are netted, largely during the nighttime hours. In fact, the darker the night, the better. The fish are less jumpy on moonless nights, all the better to surround them with the net.

Among the oldest types of seining is what's called "stop" seining. As schools of herring move into small coves during the night, the open end of a cove is closed off, or "stoppered," with the net, which extends from floats on the surface to the shallow seafloor.

The net is then drawn closed around the school of herring, packing them tightly together. Then they can either be dipped out of the water using large dip nets or vacuumed out using a special suction pump and hose.

The catch is still measured and sold by the bushel (equal to about eight gallons) or by the hogshead (about eight bushels), but even that is giving way to measurement by pounds. Most seined herring is sold for lobster bait, but it once was valuable as a canned fish, still known these days as sardines. Those of us who still eat sardines wonder how much longer it will be before they're gone too. It'll be a dark night indeed when they are.

Left: This Beals Island hull has been "wooded" (stripped to bare wood) and repaired, and if luck holds, will fish at least another generation.
Opposite page: Nets on Beals Island.

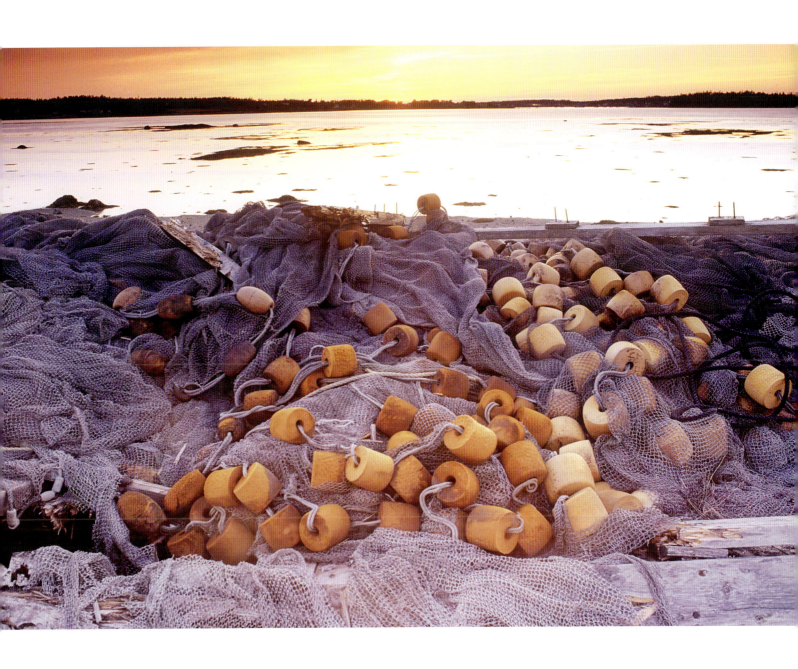

Great Wass Island

Jokesters call it a wind gauge. When the teetering rock is blown off its base, it's considered a windy day.

Exactly who balanced this teetering rock near the water's edge on Great Wass Island—and why—is unclear. Indeed, some Jonesport locals claim it just ended up there after a big storm. We sort of doubt that, given that it's well above the extreme high-tide level.

But it does seem to have survived quite a few windy days on the shore of Eastern Bay. It usually takes ten or more years for lichens to form and thrive on exposed rocks. This teetering rock looks about as lichen-covered as the rocks on which it sits and the surrounding exposed bedrock, suggesting that it's been there a long time.

Whatever the case, the image of it captured several years ago required quite a bit of hiking and a serendipitous discovery. Whether it is still there or not, we can't say. But we can say that hiking around the trails of Great Wass Island is always worthwhile, windy days notwithstanding. If you don't discover this rock, you'll discover much else.

Perfect balance on Great Wass Island

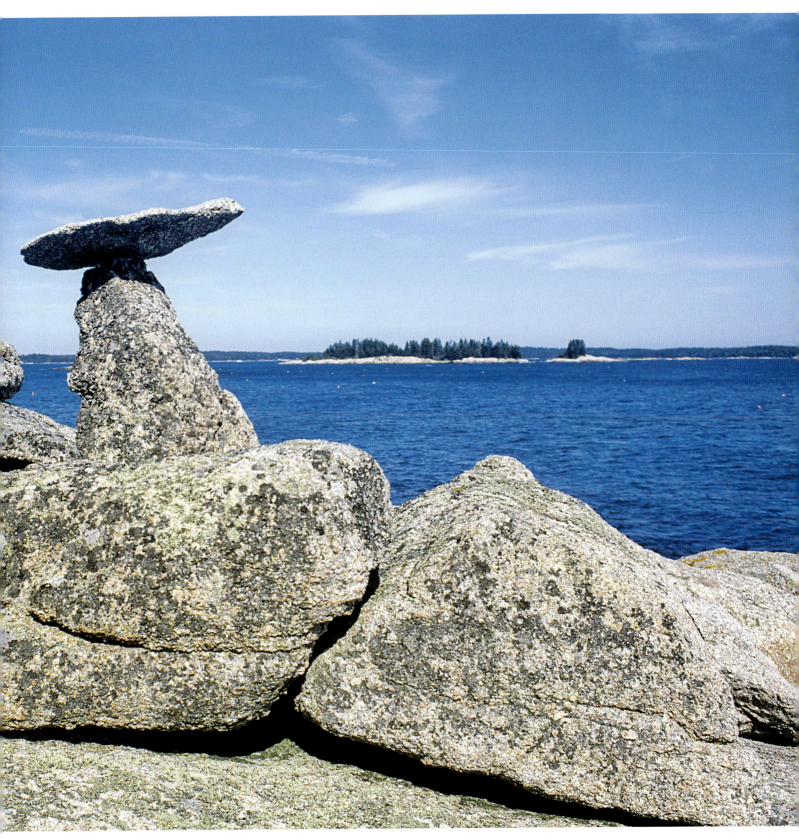

77 Roque Bluffs

The men opposite are not fishing. They may look as if they are fishing, and indeed they have fishing poles in hand with lines extending into the waters at Roque Bluffs in far eastern Maine. But what they are actually doing is far more complex.

An ethologist might insist that the three men are pooling their collective knowledge of fish and fishing in an effort to catch tinker mackerel, tom cod, harbor pollock, or whatever might be running in these chilly, near-shore waters on this day.

But most honest recreational fishermen (yes, there are some) will concede that a day of fishing from a pier is about getting away from life's complexities. Just a pole, some bait and a couple of other guys to chat with are all that's needed. Life then gets pretty elemental, fog or not. In fact, most guys leave their cell phones behind. Horrors!

So this is not fishing off an old pier at Roque Bluffs. This is living a small part of one's life to the fullest—quietly, intently, and with conversation at its simplest. How did the Red Sox do last night? It's a counterpoint to modern life. The fish are a side show.

Bringing in the clams

Roque Bluffs pier

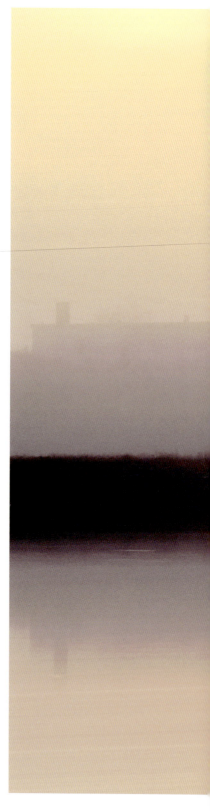

Machias

Xerxes had his Salamis, Villeneuve had his Trafalgar, and Ichabod Jones had his Machias. And although the first naval engagement of the American Revolutionary War may not quite measure up to other decisive naval engagements, it still resists fading quietly into the mists of history.

Mr. Jones was a persnickety merchant in 1775, tight with the British bigshots back in Boston. Shortly after British defeats at Lexington and Concord, he was sent to Machias for supplies. With two ships and an armed British Navy vessel as escort, he cruised into town and immediately irritated locals with his high-handed business practices and threatening manners.

Tempers soon flared, and locals attempted to arrest Jones and the British officer accompanying him, James Moore. Jones escaped into the woods, but Moore tried to sail away. Machias men went after him, and after a brief battle in Machias Bay, the British officer was mortally wounded and his ship was captured.

Throughout the rest of the Revolutionary War, Machias was notorious as a hotbed of hot heads intent on liberating themselves from the yoke of British tyranny. Today it is reported to be a considerably more peaceable town.

An East Machias church

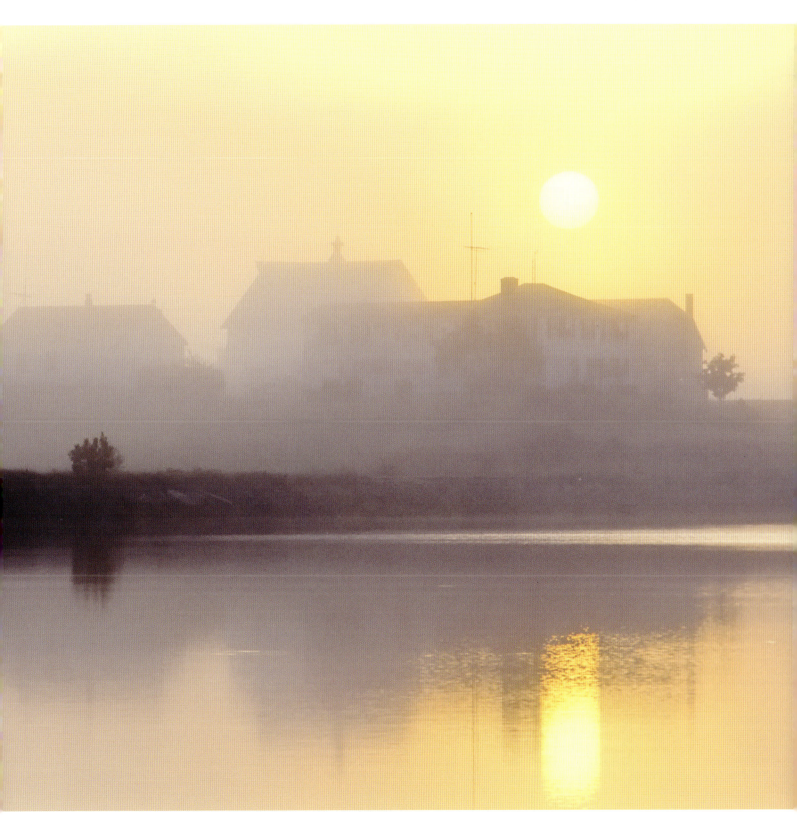

Machias wrapped in Washington County fog

Cutler

Even the venerable Oxford English Dictionary is unclear how the basically Germanic word "bold," meaning daring or audacious, also defines coastal topography like the shore east of Cutler. Still, marketing types in recent years have been heavily promoting "The Bold Coast," and sometimes it does take a person a bit more daring and audacious than normal to enjoy it.

In nautical parlance, a bold coast is one that rises steeply from deep water. Cutler's Bold Coast fits that definition perfectly, rising in some spots more than 200 feet above sea level while just a short distance offshore depths are well over 100 feet. As one might imagine, heavy swells rolling into this natural fortification burst pretty spectacularly into foam and mist.

Back in the snug harbor of Cutler, this shoreline is well respected. Those who fish for lobster here must always be aware of oddball currents and wave patterns generated by the interplay of high land and deep water. Traditional watercraft and methods dominate.

As a result, the town sometimes appears a bit indifferent to hikers who have discovered the trails of the nearby Cutler Coast Public Reserved Lands. Up to ten miles of trails skirt the cliffs overlooking the Bay of Fundy and the Atlantic Ocean beyond. Challenging to hike, the trails offer views beyond compare.

A dory in Little River (also known as Cutler Harbor)

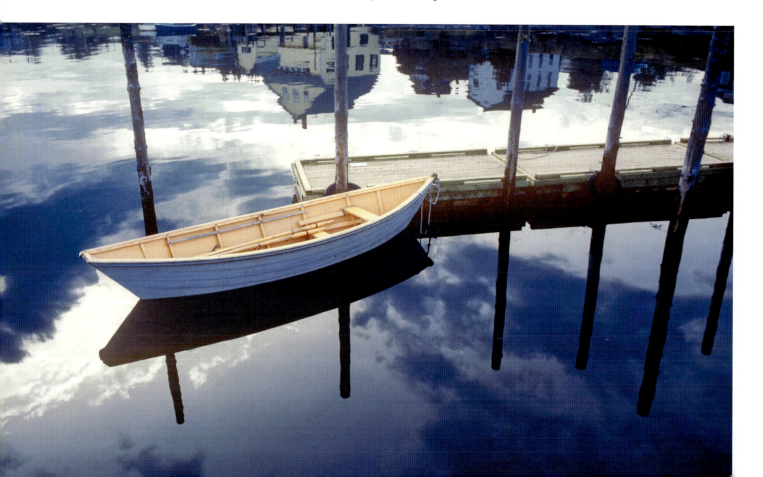

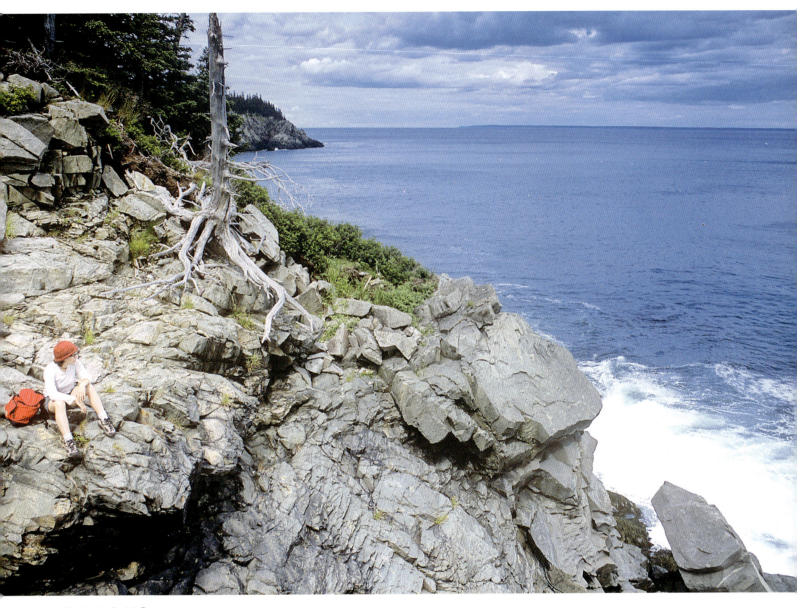

Cutler's Bold Coast

Machias Seal Island

Want to exchange a boiled lobster dinner for a live puffin? The connection may not be quite that direct, but a 2012 report on the increasingly perilous lifestyle of Atlantic puffins makes us wonder: Can they survive what biologists call "changing habitat?"

Even on a lonely offshore island like Machias Seal, the ever-growing crowds of *Homo sapiens* elsewhere have their impact. The problem for puffins seems to be the herring supply. Herring are prime bait for lobster traps in Maine and elsewhere, but they're also central to the puffin diet. And by most accounts, herring are becoming more and more scarce in the Gulf of Maine, whether due to overfishing, climate change (cod and other northern species are shifting their ranges northward as ocean temperatures rise), or a combination of factors.

When puffins can't find enough herring, they switch to items such as butterfish, an apparent newcomer to the Gulf of Maine that may be extending its range northward as the Gulf of Maine warms. Butterfish grew faster earlier in the spring in 2012 due to an early phytoplankton bloom, which itself may have been temperature-fueled. Puffin chicks have trouble ingesting the big butterfish their parents bring them, and hundreds of starved chicks have been found in Maine's colonies, some with uneaten butterfish piled next to their carcasses.

This interplay of factors is every bit as complicated as it sounds, probably more so. But the result is uncertainty whether the Atlantic puffin, successfully reintroduced to Maine after almost being wiped out for eggs and feathers in the late 1800s, will be able to hang on here at the southern end of its range.

A puffin on Machias Seal Island with its bill full of herring

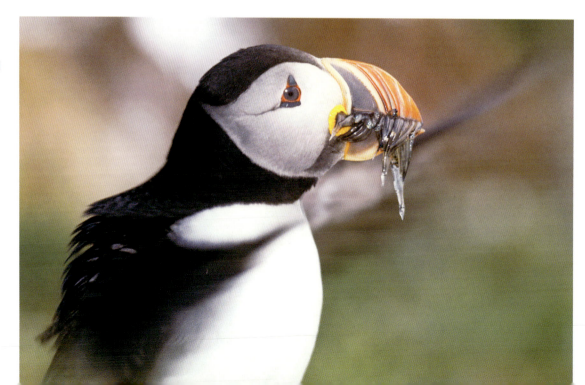

Do puffins yawn?

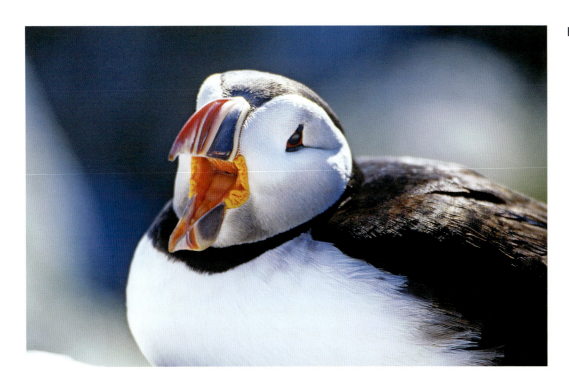

Machias Seal Island, ownership of which has been contested by the U.S. and Canada

81 Whiting

Fireweed may be beautiful, but it rarely indicates that someone's life has taken a turn in the right direction. And even a proximity to tidal waters couldn't save this homestead in the small town of Whiting from a fireweed fate.

The plant's name comes from its status as an early regenerative wildflower in burn areas. Following common practice through much of Washington County, this Whiting homesteader may have regularly burned fields that were not worth cutting for hay. A quick, inexpensive burning, usually in early spring, keeps the field from reverting back to forest. Some in the area still burn to keep fields clear.

Looking more closely at this field of fireweed, one sees unpruned apple trees. The upper bricks on the chimney have begun falling down, and a climbing vine has had several years to establish itself on cedar shingles that haven't seen paint in decades, if ever. Even the lead flashing around the chimney has been removed, presumably for its salvage value.

Nor could the modern-day rush to buy saltwater frontage save this particular riparian outpost. With access to deep water only for a few hours at high tide, and lacking expansive views of crashing surf, beaches, and the like, this particular parcel might have been appealing only to a fisherman, and once the fishing fell off decades ago, the fireweed was ready to move in.

Fireweed in a grown-over Whiting field

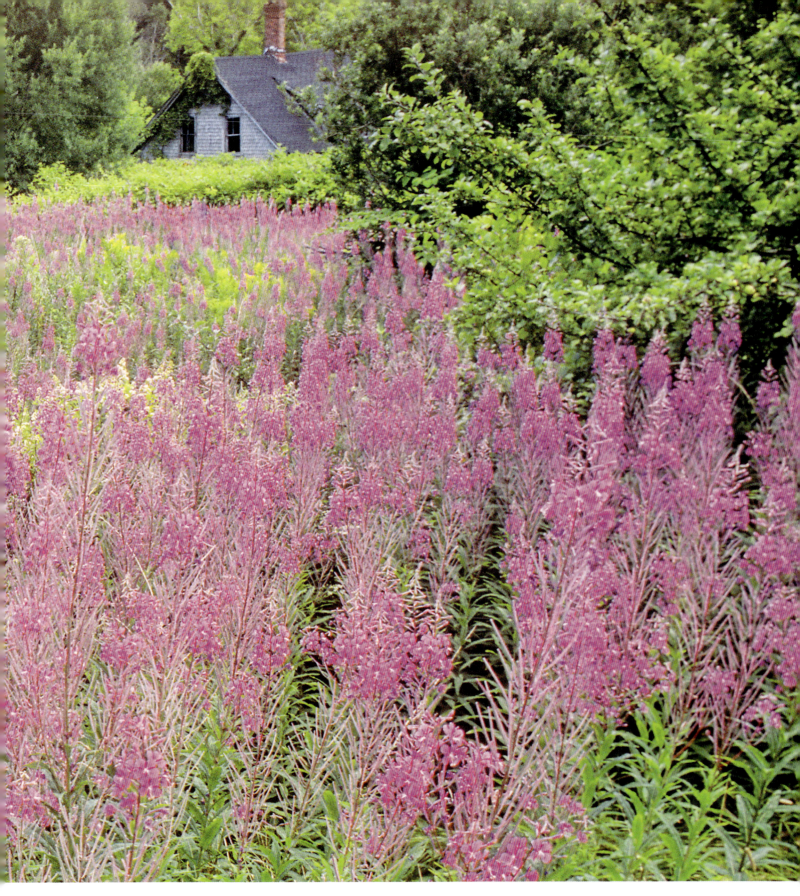

Edmunds

Too small to continue as a town, Edmunds was de-organized into a township in 1938. But its saltwater orientation endures and makes it an ideal destination for anyone looking for true gems along the Maine coast.

Hard on the shores of Whiting Bay (a branch of Cobscook Bay), Edmunds is home to Maine's biggest (and some say best) saltwater park, Cobscook Bay State Park. Its nearly 900 acres of trails, campsites, tours, and wildlife galore make it a prime destination that rarely is what anyone might describe as "crowded."

Not enough for you? Well, right next door to the state park is Moosehorn National Wildlife Refuge, with another 7,200 acres of preserved land that in part borders the shores of Whiting Bay. With 50 miles of trails plus hunting and fishing opportunities, Moosehorn also has had a resident bald eagle named Bart, whose handicapped wing has made him a pet of the local rangers.

Still not enough? Then go check out the eighth generation of the Bell family's farm, known these days as Tide Mill Organic Farm, also on the shores of Whiting Bay. They offer tours and some pretty good stuff to eat too. And that pretty much rounds out all there is to do in Edmunds, which is not bad for a town that's not even a town.

Cobscook Bay
State Park
vista

Looking across the southern end of Whiting Bay

Pembroke

Whirlpools, overfalls, standing waves, and mystery sounds are just some of the phenomena generated by the 25-foot tides of Cobscook Bay. Even on a calm day, a place like Reversing Falls Park in Pembroke features all four of these hydrological oddities.

Whirlpools were made famous—or rather, infamous—by Edgar Allen Poe's memorable short story "Descent into the Maelstrom." Reading that on the Pembroke shore while Atlantic waters swirl just yards away is guaranteed to give you an afternoon you'll remember for a long time.

But overfalls are less well known. Essentially, they are breaking waves created solely by a large amount of water passing over an irregular bottom at a high rate of speed. In layman's terms, the water just trips over itself.

A standing wave is similar to an overfall but doesn't break. Instead, it stands up above the surrounding water, looking like a great block of watery ice and packing a punch almost as formidable as an errant Arctic floe.

Pembroke goldenrod

And the sounds? Well, some silent, windless summer night, just stand beside some notoriously turbulent water in Cobscook Bay. Mutterings, murmurings, splashes, and even squeaks are among the ethereal sounds that abound.

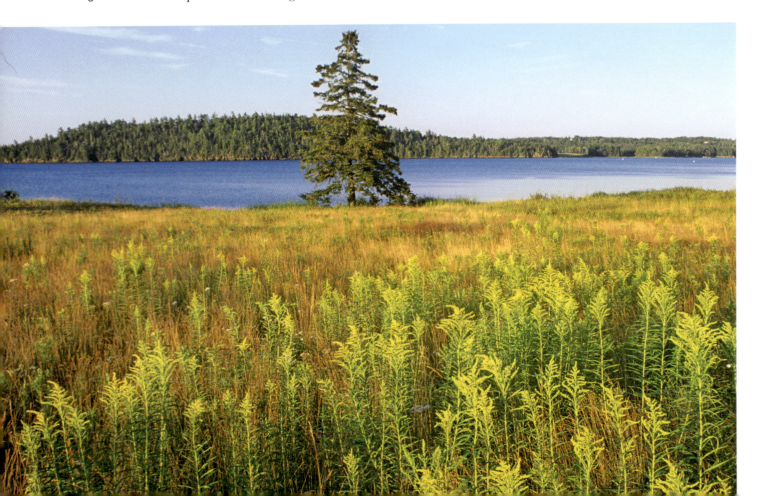

The reversing falls in Pembroke

Pleasant Point and Eastport

84

Bar Harbor enthusiasts are usually unaware that there are two Bar Harbors. There's the high-rolling, bustling heart of Acadia National Park on Mt. Desert Island, but there is also this more subdued Bar Harbor at the far eastern edge of the Maine coast.

Actually part of the Pleasant Point Reservation for the local Passamaquoddy Indian tribe, this Bar Harbor is rarely used as a harbor. A rocky, unimproved channel leading into the protected surroundings is part of the reason many mariners avoid it. With tumultuous tides rushing in and out twice daily, it's just too tricky for deep-draft strangers to try their luck.

For small, shallow-draft vessels, however, it was once quite an active little passage. In fact, before Europeans arrived, this Bar Harbor was part of a handy shortcut between Passamaquoddy Bay and Cobscook Bay, obviating a long and dangerous paddle southeast around what is now Eastport.

But alas, overland transportation demands always seem to supersede the nautical approach. The causeway built between Pleasant Point and Carlow Island, and then connecting Carlow with Eastport, shut off that ancient shortcut. So today, Bar Harbor East is just a lovely place to watch the sun set.

Bar Harbor, Cobscook Bay

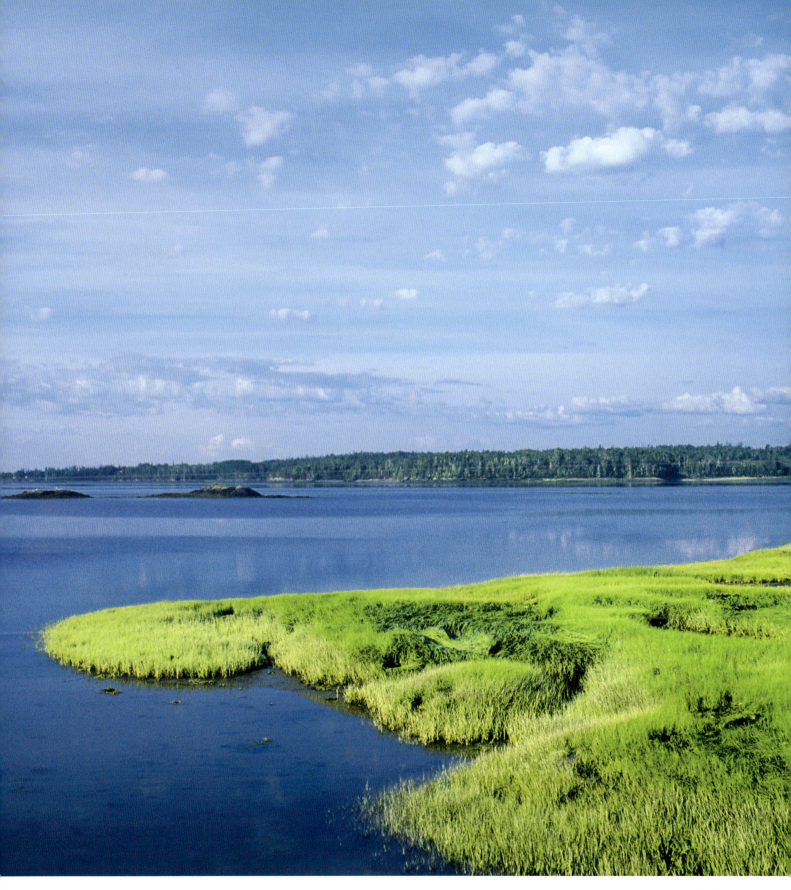

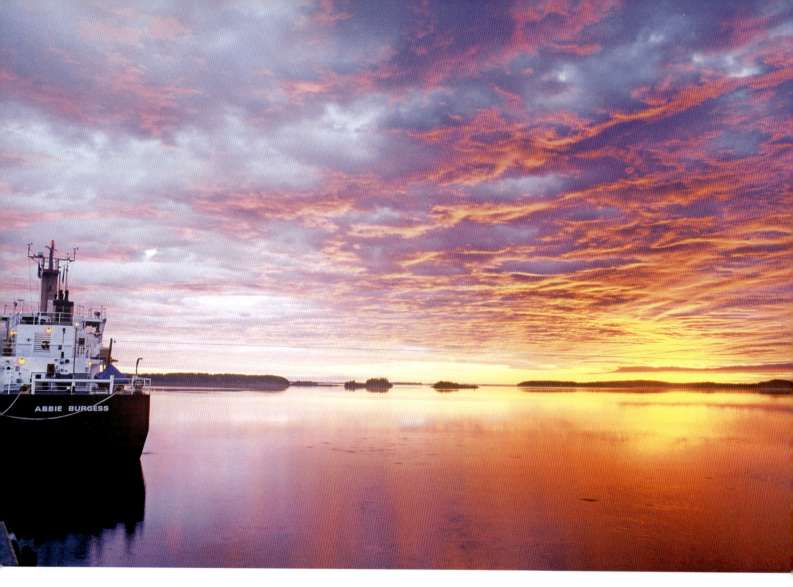

Above: Eastport sunrise.
Right: Looking west from Friars Head, Campobello Island, at sunset. Eastport is across the water to the right of this field of view.

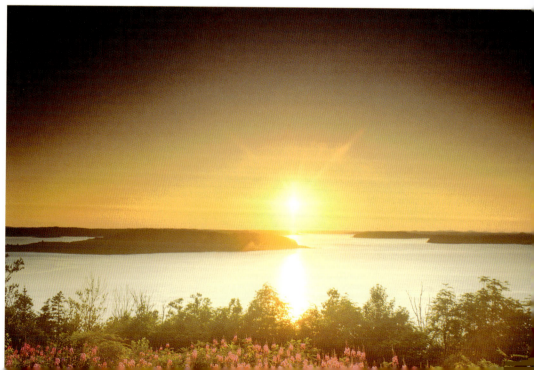

196

Salmon farming, Eastport

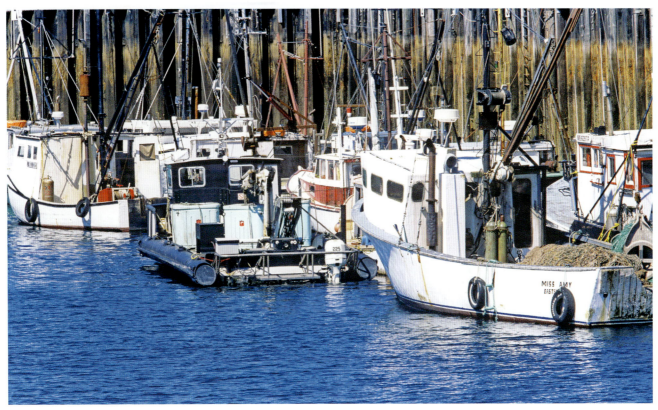

Fleet's in, Eastport, low tide

85 Lubec

Smuggling has a long and murky history along the Maine coast. Stories abound even at the innocent-looking Roosevelt International Bridge in Lubec, including those of stormy midnight passages in small rowing boats with an empty dory left idle on a beach the next day.

Like Jesse James and Billy the Kid, smuggling is romanticized once it's safely in history's rearview mirror. The vilified bootleggers of the 1920s are now portrayed as blameless, intelligent people who just saw the foolishness of an ill-conceived government policy long before everyone else did. They also made a few dollars in the process.

So how will the midnight "importers" of today be looked upon 75 years from now?

We have no idea, but we're pretty sure the backwaters of Maine will still play a minor role in whatever stories are told in the future. Just don't expect the descendants of those who profited from a fog-shrouded voyage or two to have much to say. The great-grandchildren of those 1920s hooch runners are pretty tight-lipped even today.

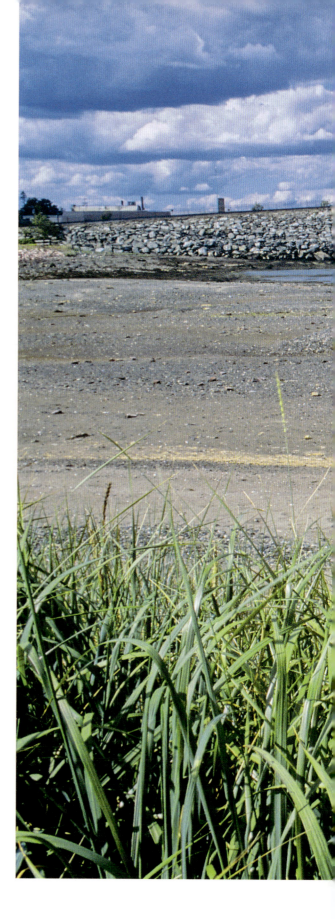

Beached dory, mid-tide, Lubec Narrows

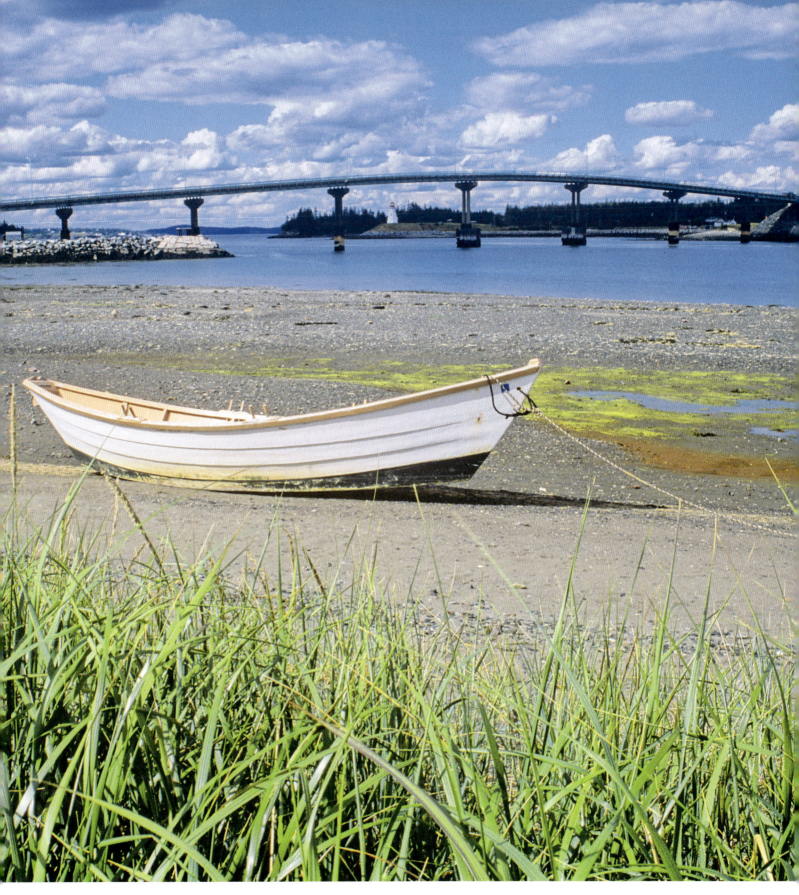

Above: Dory above high
water, Lubec.
Right: Pitcher plant.

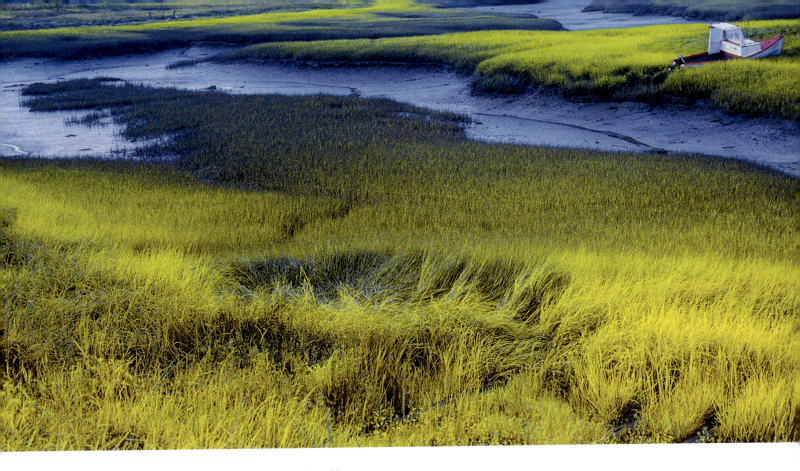

Above: Tidal creek, Lubec. Below: Fog in Lubec Narrows.

West Quoddy Head

Tides are a conundrum few people fully understand. Even locals living and working within sight of West Quoddy Head Light, which lords over the biggest tides in Maine, sometimes misread tidal complexities. And the complications are numerous. Take, for instance, how you get a 22-foot tidal range at this Lubec location.

As many know, tides are caused principally by the gravity of the moon. But there are also the sun's gravity and declination, the moon's declination and perigee, the earth's orbit and revolution, celestial alignments, and certain centrifugal and Newtonian forces to consider.

The bulge of water caused by all of the above factors arrives twice a day from the east, traveling more than 1,000 miles an hour until it bangs into southwest Nova Scotia, the submerged Georges Banks, and Cape Cod. Those three obstructions act together like a thumb over the end of a garden hose, forcing the water to accelerate as it heads for its destination.

It's the squeezing and acceleration that makes the water pile up at Lubec, giving the waters near West Quoddy Head Light a reputation for swirling and crashing about like no other place along the Maine coast. Add some weather to the equation, perhaps a strong easterly gale for a few days or so, and the tides increase by several more feet, with additional chaos in the nearby waters

So a calm spring morning near low tide is all the more appreciated by any visitor to America's easternmost lighthouse. And on most days, at this location, you'd be the first person in America to see the sun come up.

West Quoddy
Head
Lighthouse

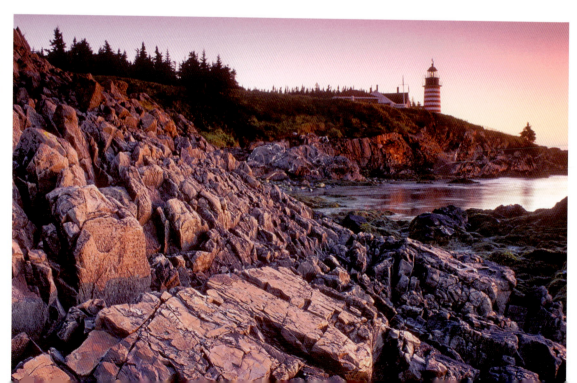

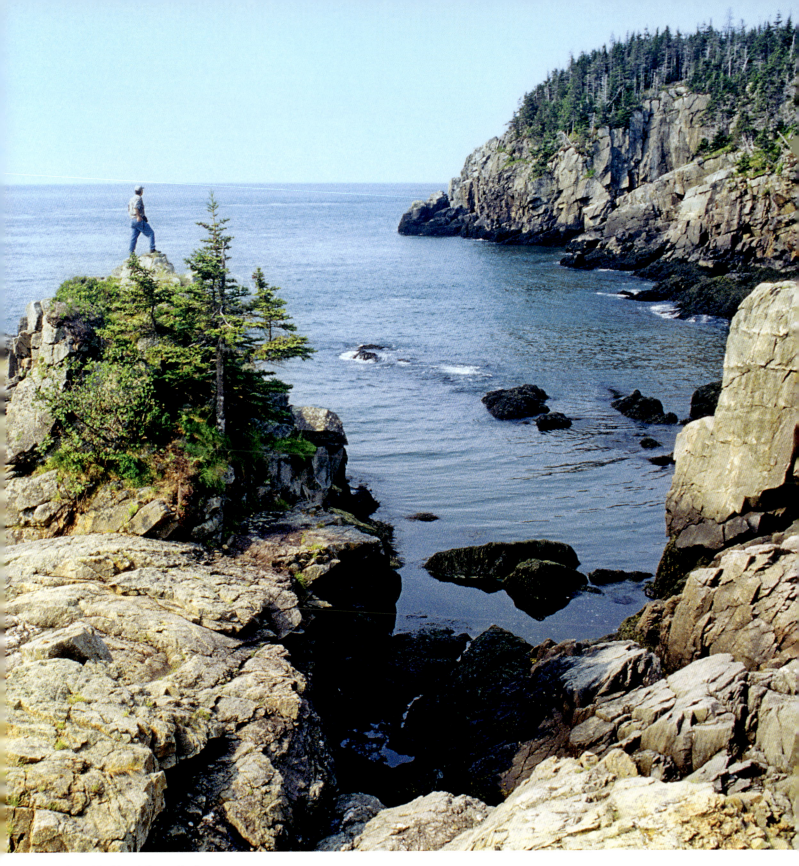

Quoddy Head State Park

How to Get There

1. The Isles of Shoals: Ferries depart from Portsmouth and Rye, New Hampshire, several times daily during the summer. New Hampshire's Star Island—host to a hotel, a conference center, and midsummer weddings—is the immediate destination. Some online research should get you from there to Appledore.

2. York: Thronged with beach-goers during the summer, York Harbor is well worth a visit in the off-season, particularly if you are a history buff. Just a one- to two-hour drive from the Boston metro area, York Harbor requires a slight detour down U.S. Route 1A. No fewer than eight historical buildings and museums are maintained by the York Historical Society (www.oldyork.org), all within easy walking distance of the harbor. Elsewhere, the town offers Short Sands and Long Sands beaches and the excellent Dockside Restaurant.

3. Cape Neddick: Happily for a northbound traveler, the Cape Neddick exit off the Maine Turnpike (Exit #7 off I-95) comes just before you have to go through Maine's most expensive toll plaza. After exiting, follow the signs to U.S. Route 1A (not to be confused with U.S. Route 1) and head north. The ride is a lovely beachside ramble, but mostly stop-and-go during the high summer months. Eventually, signs for Long Beach, then Cape Neddick, and then Short Beach turn up in rapid succession. A right-hand turn anywhere along this mile or so will end up opposite The Nubble lighthouse. Relax and be prepared for lots of pedestrians and go-slow drivers.

4. Ogunquit: Impossible to miss on U.S. Route 1 just north of York, Ogunquit is a popular destination for daytrippers and long-term seasonal residents. A visit is best planned well in advance. Beach lovers should try to go when low tides are scheduled for afternoons, thus maximizing space on the sands and leaving an evening free to visit the Ogunquit Playhouse.

5. Wells: A visit to the backwaters of the Wells area often begins with what's lately being called the Wells Reserve at Laudholm. Just a mile or so north of downtown Wells on U.S. Route 1 is the right-hand turn for Laudholm Farm Road, which takes you to the magnificently restored farm from which a half-dozen well-tended trails meander through the reserve. Plan to spend an entire day, and save the next day for the Rachel Carson Wildlife Refuge. Less hidden area attractions include Wells Beach, Drake Island Beach, Laudholm Beach, Crescent Beach . . . you get the idea. The Maine Diner on Route 1 is at hand if you get hungry.

6. Rachel Carson Wildlife Refuge: The headquarters for the eleven different tracts along the southwest coast of Maine that make up the Rachel Carson National Wildlife Refuge is located just off U.S. Route 1 in Wells, a short drive down Post Road (State Route 9), just north of town. Staff there can give you guidance to the other tracts between Kittery and Muscongus Bay.

7. Kennebunk and Kennebunkport: Placed squarely on the map by Presidential comings and goings, Kennebunkport is easy enough to find after taking Exit 25 off the Maine Turnpike (I-95) and following State Route 35 to the sight and smell of salt water. The beaches are the main attraction, but people also visit the 'Port and neighboring Kennebunk to shop in and around Dock Square. Some say the best fried clams in Maine are at The Clam Shack.

8. Ferry Beach, Saco: Put away your GPS when you head for Ferry Beach, because it's likely just to confuse you. Take Exit #32 off the Maine Turnpike (I-95) and proceed eastbound on State Route 111. This terminates at State Route 9, which takes you north to Ferry Beach—except that you'll actually be headed southeast much of the time as you stay in the road's northbound lane. No worries, just keep going and ignore some of the industrial portions of Biddeford and Saco, because they do not hint at the relaxing vistas and sands you will enjoy at the 100-acre Ferry Beach State Park facility. As might be expected, parking is an issue, so arrive early and be ready to share the vista with residents lucky enough to own summer homes on this strand.

9. Old Orchard Beach: Copious directional signs take visitors from Exit 36 on the Maine Turnpike to OOB. The sandy strand packs an international flavor not found anywhere else on the Maine coast. In addition to the multitudes of Canadians who visit every year, you'll also hear Lithuanian, Turkish, Russian, Latvian, Spanish, and Irish folks. Most of the non-Canadians work in the hotels and restaurants of OOB and are only there for the summer. Still, it is a polyglot delight and should be on anyone's Maine bucket list.

10. Prouts Neck: If tempted to visit Prouts Neck, bring your walking shoes and your wallet. Although located conveniently at the end of State Route 207 (Black Point Road), parking is a major issue and towing is possible. It's easier to pay to park at Ferry Beach park (also at the end of 207) and walk to Prouts from there. The Portland Museum of Art offers guided tours of Winslow Homer's studio, spring and fall only, via PMA's van from Portland.

11. Scarborough Marsh: Rare birds, animals, and fish are among the many reasons to visit Scarborough Marsh, which is perhaps best accessed via the Maine Audubon Society's Nature Center near the heart of the marsh. From U.S. Route 1 in West Scarborough's Dunstan Corners neighborhood, turn onto Pine Point Road (also marked as State Route 9). The nature center is located just under a mile on the left. The marsh's backwaters can also be accessed via kayak or canoe from Ferry Beach or Pine Point Beach in Scarborough.

12. Portland Harbor: Ironically, the best place to view Ram Island Ledge Light might well be from another lighthouse, Portland Head Light in Cape Elizabeth, next-door neighbor to South Portland. Take Exit #1 from

Interstate 295 and head north on U.S. Route 1 for a mile-plus, then turn right onto Broadway and follow it for several miles until it intersects with Cottage Road, where you turn right. Cottage Road turns into Shore Road at the Cape Elizabeth line. Look for signs for Fort Williams Park, of which Portland Head is part.

13. Sebago Lake The state park on the north shore of Sebago Lake is your best bet for a spur-of-the-moment escapade. From Interstate 95, head north on U.S. Route 302 until the diminutive signs for the state park entrance show up around South Casco. A public launching ramp, picnic tables, swimming beach, and other amenities are available in the park.

14. South Freeport: Assuming you can find downtown Freeport and its crowded shopping district (and who can't?), the quickest route to South Freeport is to turn south off Main Street onto Bow Street and look for the right-hand turn onto South Street. This eventually turns into South Freeport Road, and after a few miles you come to a four-way intersection, where you turn left onto South Freeport's Main Street. Parking near the water is at an extreme premium.

15. Wolf's Neck Woods State Park, Freeport: Head out of downtown Freeport on Bow Street, then turn right onto Flying Point Road a long mile out of town. Turn right off Flying Point Road where it intersects with Wolf Neck Road, which takes you to the park. Parking is sometimes a problem, but it's worth an extra effort for the well-tended hiking trails, picnic spots, and views of Casco Bay and its tributaries.

16. Harpswell: To catch your very own striped bass, we'd suggest hiring a charter boat captain who specializes in them anywhere between Harpswell and Thomaston. The Kennebec River is the hardest-fished area for stripers, suggesting it's easiest to catch them there. But Harpswell is just fine, with plenty of diversion for those uninterested in fishing. (Yes, they exist.)

17. Cundys Harbor: To visit the small village of Cundys Harbor on what is technically an island (Sebascodegan by name), you must first go to Brunswick and head north on the four-lane stretch of U.S. Route 1. Within miles, you must get off at the Cooks Corner exit (no apostrophe), find State Route 24, and head south on it for about four miles. The left turn onto Cundys Harbor Road is easy to miss, but once on it, reaching your destination is assured. The village offers a tiny library, a general store, and a wharf where basic eats (read: lobster) can be had at a fair price.

18. Merrymeeting Bay: Access to the bay is widespread through the eight towns that border it, but the town of Bowdoinham offers one of the best and most relaxed points of entry. Follow Interstate 295 north from Brunswick to the intersection with State Route 125/138 at Exit 37. Go eastbound on 125, sticking with it even after 138 veers off to elsewhere. When you reach downtown Bowdoinham, the Cathance River (which drains into Merrymeeting), the town's waterside park, and the launch ramp will be directly ahead.

19. Bath: The easiest and safest way to get waterborne on the Lower Kennebec is to contact the Maine Maritime Museum, which is in Bath just south of the Bath Iron Works shipyard. Regular tours of the river depart from the docks of the museum, which also welcomes visitors arriving via the water.

20. Popham Beach, Phippsburg: To reach Popham Beach, follow State Route 209 from Bath 14 miles south to Phippsburg, and follow the signs to the park.

21. Seguin Island: Even if you lack a seaworthy boat, you can visit Seguin Island via scheduled cruises sponsored by the Maine Maritime Museum in Bath. Check the museum's web site for the latest cruise schedule (www.mainemaritimemuseum.org) or check out Friends of Seguin Island Light (www.seguinisland.org), which maintains lightkeepers and a small museum on the island during the summer months.

22. Reid State Park, Georgetown: The long and winding road to Reid State Park begins just across the Kennebec River from Bath at State Route 127, heading south. About eight miles later, look for a large American flag painted on a rocky outcrop, where you take a right on Seguinland Road. Just past Walter Reid's former home called The Mooring (now a bed-and-breakfast) is the gate for the park, which includes a sandy tidal pool that's perfect for youngsters and even toddlers. The park is open year-round.

23. Five Islands, Georgetown: A mention in a major New York newspaper briefly made parking and eating on the wharf at Five Islands a hassle. But that was years ago, and now a long drive down to the southern terminus of State Route 127 should be relaxed and rewarding. The 127 turnoff is at the north end of the bridge across the Kennebec River at Bath on U.S. Route 1. The simple seafood-oriented meals available on the wharf are served *al fresco*, sometimes with an extra helping of mosquitoes.

24. Boothbay Harbor: With maximum diversions for summer visitors, Boothbay Harbor first offers a pretty, winding drive down State Route 27, which is a right turn off U.S. Route 1 for a northbound vehicle just after going through the town of Wiscasset. Several kayak rental outfits are available in Boothbay, along with trolley tours, fishing expeditions, the outstanding Boothbay Botanical Gardens with its inviting trails, and dozens of eateries.

25. Ocean Point, East Boothbay: The choice to be made as you near Boothbay Harbor on State Route 27 is whether to head for the downtown hubbub or opt for the harbor town's alter egos, East Boothbay and Ocean Point. To choose the quieter route, take a left on State Route 96 where it intersects Route 27 at a traffic signal. Route 96 will take you to the quiet village of East Boothbay and even quieter Ocean Point beyond. But if you stay on Route 27, it's Boothbay Harbor for you, with scads of eateries and diversions for almost any taste.

26. Newcastle: A visit to the twin towns of Damariscotta and Newcastle amply rewards the short diversion from U.S. Route 1. Visible from the highway, the two

towns offer numerous architectural wonders and details along their back streets and shops, eateries, and the fine Skidompha Public Library (Damariscotta) in their combined downtown district. Plus, this is a convenient gateway for the peninsular sights of South Bristol and Pemaquid Point.

27. South Bristol: Sometimes forgotten down a long peninsular road, the town of South Bristol is a worthy side trip. Leave U.S. Route 1 at Damariscotta for the drive south on State Route 129, and you will arrive eventually at what there is of "downtown" South Bristol. The bridge over The Gut swings open for boats traveling between Damariscotta River to the west and Johns Bay to the east. If you cross the bridge and drive a little farther on Rutherford Island, you'll reach lovely Christmas Cove.

28. Pemaquid Beach: Perhaps one of the most overlooked bodies of water on the western Maine coast, Johns Bay is well known to residents of South Bristol to the west and Pemaquid Beach to the east. To reach either town, leave U.S. Route 1 at Damariscotta/Newcastle and head south on State Route 129/130. Take the Route 130 fork to reach Pemaquid Beach, where you'll find a quarter-mile length of white sand beach, the Colonial Pemaquid State Historic Site (on the site of a 1620s settlement), and Fort William Henry with its rooftop vista of Pemaquid Harbor and Johns Bay. And Pemaquid Harbor is only a short drive from New Harbor and Pemaquid Point.

29. New Harbor: Although a long way down-peninsula from Damariscotta (on Route 130) or Waldoboro (on Route 32), the lobsterfishing village of New Harbor is well worth visiting. A small but interesting nature preserve, a full-service restaurant, and boiled lobsters on the wharf are among the attractions, and Pemaquid Point Lighthouse is a five-minute drive south.

30. Pemaquid Point, Bristol: Open to the public during most seasons, Pemaquid Point Lighthouse requires a pretty drive down State Route 130 from the twin towns of Damariscotta and Newcastle or State Route 32 from Waldoboro to Route 130 in New Harbor. Drive an additional few minutes south from New Harbor and you're there. The town of Bristol maintains a small park, museum, and "learning center" at the light, which was used as the model for the engraving on the 2003 commemorative Maine quarter. A small seasonal gift shop and modest restaurant are also nearby. In midsummer, parking spaces are at a premium.

31. Pemaquid Pond, Nobleboro: Traffic on U.S. Route 1 passes within a couple hundred yards of the northern tip of this six-mile-long, 1,500-acre freshwater pond about halfway between Damariscotta and Waldoboro. A public launch ramp is visible and readily accessible from the highway, but parking is limited.

32. Medomak River, Waldoboro: The best access to the Medomak River estuary is via the public launch ramp at the end of Dutch Neck Road. Turn south on State Road 32 from U.S. Route 1 at Waldoboro. After about two miles, make a left turn onto Dutch Neck Road, and the ramp will be obvious when you get to it. If the weather isn't conducive to swimming when you get there, check out the nearby Osborn Finch Wildlife Sanctuary with its inviting walking paths and varieties of flora and fauna.

33. Damariscotta Lake: Of the three towns bordering Damariscotta Lake (oddly enough, Damariscotta isn't one of them), Jefferson is the one with the state park. Turn off U.S. Route 1 at Waldoboro and follow State Route 32 about eight miles north to the park. Or turn off Route 1 onto State Route 215 at Newcastle until you come to State Route 213, which, after four miles or so, takes you to the public boat launching ramp.

34. Jefferson: There are several ways to get there, but we think the best approach to Jefferson and Davis Stream is via State Route 215, which you pick up at Newcastle, just off U.S. Route 1. After turning off, the countryside immediately becomes relaxing, and water views are numerous. Be careful to turn north onto State Route 213 within a few miles. It parallels Damariscotta Lake, with more vistas, a boat launch ramp, and eventually the village of Jefferson, where you'll find Damariscotta Lake State Park. Here you can launch your canoe or kayak for the delightful paddle up nearby Davis Stream and its bucolic shores.

35. Washington: Well off any beaten path along the Maine coast, Washington can be reached by State Route 17 eastbound from Augusta. After 18 or so miles, look for a left turn to State Route 220, which takes you to Washington village. Follow Route 220 north from Waldoboro (crossing Route 17) to reach Washington from U.S. Route 1. The main attraction in town is nearby Washington Pond, which is easiest to enjoy in some sort of car-topped vessel like a canoe or kayak.

36. Seven Tree Pond, Union: Paralleling the beaten path of U.S. Route 1 is State Route 17 between Augusta and Rockland, which takes you through the town of Union and near Seven Tree Pond. Only 45 feet deep, with little more than 500 acres of surface water, the lake has a launch ramp at its northwest corner, just a little way down State Route 235 from Route 17 (or north on Route 235 from Waldoboro).

37. The St. George Peninsula: To travel the St. George peninsula toward Tenants Harbor and Port Clyde, leave U.S. Route 1 in Thomaston for State Route 131 heading south. The General Henry Knox Museum stands prominent over the intersection and is well worth a visit.

38. Tenants Harbor, St. George: The little village of Tenants Harbor in the town of St. George lies 8 miles south on State Route 131 from Route 1 in Thomaston. The chief impediment to your drive will be the temptation to slow down significantly at numerous bucolic turns in the road.

39. Port Clyde: From Tenants Harbor, another few miles south on State Route 131 takes you to the harbor and village of Port Clyde, where art galleries perch within smell of bait barrels. A ferry to Monhegan Island runs daily, and Marshall Point Lighthouse with its museum and lovely vistas guards the harbor entrance.

40. Monhegan Island: Tour boats from three harbors make daily trips to Monhegan, departing from Boothbay Harbor, New Harbor, and Port Clyde on various schedules. You can check them all out by visiting www.monheganwelcome.com. Hiking is a favorite visitor pastime, along with seeking out the vantage points from which iconic paintings by Rockwell Kent, Edward Hopper, Jamie Wyeth, and other artists were created. There is overnight accommodation on the island.

41. Spruce Head, South Thomaston: The village of Spruce Head is in the town of South Thomaston. Take State Route 131 south from Thomaston, turning left on State Route 73 after about five miles. Another couple of miles takes you to Spruce Head. Check out the Craignair Inn if you need another reason to visit this peaceful town, and if you're a bibliophile, the Lobster Lane Bookstore, at the far end of the causeway on Spruce Head Island, is not to be missed.

42. Owls Head: To reach Owls Head State Park, drive south from Rockland on State Route 73, turn left onto the Owls Head road two miles out of town, and follow the signs.

43. Rockland: Home of the Farnsworth Art Museum, the Blues Festival, the Maine Seafood Festival, award-winning restaurants, art galleries, and more, Rockland welcomes visitors in any season. If you're on Route 1, you can't miss it, and you shouldn't.

44. Matinicus Island: A ferry and the island's landing strip represent the two ways most visitors reach Matinicus, a trip of some 20 miles from Rockland. During the tourist season, the ferry departs twice a week and is subject to cancellation due to the weather. Penobscot Island Air makes two flights daily, Monday through Friday, from Knox County Regional Airport in Owls Head, and charter flights are also available. Once there, be prepared to entertain yourself, although islanders are generally generous with suggestions on hiking and beaches.

45. Vinalhaven: To reach the Penobscot Bay island of Vinalhaven, take the ferry from Rockland. The boat will drop you in Carvers Harbor, where architectural details and lobsterboats are more plentiful than tourist diversions. It's a stroll-around town, or you can eat at The Harbor Gawker or rent a bicycle from the Tidewater Motel to wander the backroads.

46. North Haven: Your own boat or the state-run ferry is the handiest way to get to North Haven during the summer. Departing from Rockland three times a day, the ferry takes a little more than an hour to get to the island. Although you could take a car to North Haven, the town, what there is of it, is very walkable, and a bicycle works fine for exploring farther afield.

47. Camden: Always a prime destination on Penobscot Bay, Camden comes by its reputation as a vacation hotspot honestly. A few miles north of Rockland on U.S. Route 1, Camden offers a snug and scenic harbor; a fleet of passenger schooners; a small but varied downtown with specialty shops and eateries; clear, inviting Megunticook

Lake; the Camden Snow Bowl (with winter downhill skiing, three-season hiking and biking trails, and the U.S. National Toboggan Championship in February); and access through the Camden Hills State Park to Mounts Battie, Megunticook, and their sister summits north of the town center.

48. Islesboro and Warren Island: A boat of just about any description is the only means by which visitors can spend a night (or several) camped on the 70-some-odd acres of Warren Island State Park, which is almost due east of Lincolnville. The state-run Lincolnville car ferry to Islesboro provides kayak-toting visitors passage across Penobscot Bay, and from the Islesboro terminal, a paddle of a few hundred yards will get you to Warren Island. Moorings for larger boats are just southeast of the island. All sorts of trails, excellent camp sites, drinking water, and campfire wood are available on the island. A modest resident and nonresident fee is charged for overnight stays.

49. Belfast: North of Camden, between U.S. Route 1 and the sea, Belfast is an easy town to navigate, with just about any street headed downhill ending at the water's edge after taking you past a variety of fine restaurants.

50. Penobscot River: For a tour of the Penobscot River estuary, leave U.S. Route 1 for U.S. Route 1A at Stockton Springs, a few miles north of Searsport, and follow Route 1A north to Frankfort. Part of the town's vast marshes are contained in the Medall Marsh Wildlife Management Area, a 370-acre preserve that is best visited during non-mosquito seasons and with a willingness to go bushwhacking. Continue north to the head of tide (and navigation) in Bangor, with its many diversions, then cross one of the bridges to the Brewer shore and follow State Route 15 south to Bucksport, where you'll meet Route 1 again. Fort Knox and the Penobscot Narrows Observatory (420 feet above sea level, with access from the fort's parking area) are well worth visiting.

51. Castine: To reach the fascinating town and surrounding countryside of Castine, turn south from U.S. Route 1 onto State Route 175 at Orland, following 175 until signs direct you to State Route 166, which takes you to the town, home of the Maine Maritime Academy and many other attractions. Follow any street downhill to the wharves on the Bagaduce River and the heart of downtown, attracting hungry visitors to various eateries and boatloads of scenery.

52. Bagaduce River, South Penobscot: Numerous access points for the Bagaduce River dot its serpentine shores, but one of the best is at South Penobscot. Turn off U.S. Route 1 at East Orland and onto State Route 15, then turn right at State Route 199 to its junction with State Route 175, where you turn left. Town Landing Road is about a mile down the road.

53. Brooksville: Brooksville is a lovely Penobscot Bay town that you will miss if you don't pay careful attention to where you're going. In part that's because there is a South, West, and North Brooksville and a Brooksville Corners, not to mention Harborside (on Cape Rosier),

all in the same municipality. Turn south onto State Route 175 from U.S. Route 1 in Orland and be sure to stay on 175 despite weird turnoffs, merges, and forks in the road. Eventually, 175 joins 176, and that's about where the Brooksvilles begin. Alternatively, turn south onto Route 15 from U.S. Route 1 in East Orland and follow it through Blue Hill and beyond (again, sticking doggedly with it through stop signs and turns) until you can take a right onto Route 175 and enter Brooksville from the other side. South Brooksville is perhaps the most popular of the villages, with tranquil Bucks Harbor, a marina, and a market and attached restaurant dominating things. Cape Rosier, where the featured photo was taken, is also well worth circumnavigating by automobile.

54. Sedgwick: Be prepared for a few possible wrong turns en route to Caterpillar Hill. Turn south on State Route 15 from U.S. Route 1 in East Orland and follow it through the town of Blue Hill, where it joins up with State Route 176. Stick with Route 15 even though 176 departs at one point and State Route 175 joins at another. (Take the right onto 175 to reach Brooksville.) When you reach the much-photographed overlook at Caterpillar Hill, you'll know it. "Downtown" Sedgwick (an oxymoron) is a few more miles on 175, after 15 branches off for Deer Isle and Stonington.

55. Stonington: To reach Stonington from U.S. Route 1 in East Orland, take State Route 15 to its end. You'll zig and zag through lovely countryside—and through the town of Blue Hill and over Caterpillar Hill—before you cross the 1930s-era bridge that deposits you on the north side of Deer Isle. Another several miles of fine countryside and ocean vistas gets you to Stonington, where you can learn a lot about town history at the Deer Isle Granite Museum on Main Street.

56. Isle au Haut: Worth the effort required to reach it, Isle au Haut is home to a hundred or so year-round residents, more in the summer. A road trip to Stonington gets you in line for a ferry trip (usually non-auto) that is restricted because visitor numbers are limited by various Acadia National Park regulations and laws. Hiking on park lands (2,700 acres, or about half the island) is encouraged, while biking on park trails is discouraged. Overnight camping must be planned well in advance with reservations. The fully automated Robinson Point Lighthouse is a bed and breakfast.

57. Brooklin: One way to reach Brooklin is to follow State Route 15 south over Caterpillar Hill (see Sedgwick directions), and turn left a mile or two farther along onto State Route 175, which is here known as the Reach Road and, true to its name, hugs the shore of Eggemoggin Reach. This is E.B. White and wooden-boat country. It's a winding road, but one you won't regret taking.

58. Blue Hill: If you can schedule a visit for Labor Day Weekend, take in the Blue Hill Fair and watch the draft horses, oxen, and sheep dogs perform amazing feats. Or climb to the summit of Blue Hill, the town's eponymous 900-foot peak, for a breathtaking view of Blue Hill Bay and Mount Desert Island.

59, 60, and 61. Acadia National Park, Cadillac Mountain: To visit these spots on and near Cadillac, make your way to Acadia National Park, then turn onto the mountain's access road from the Park Loop Road between Bubble Pond and Eagle Lake Road. Drive to the summit parking area and follow the walking path to the eastern side of the mountain. (Arrive before dawn if you want to be the first person in the U.S. to witness the day's sunrise.) Various trails with their levels of difficulty plainly noted lead to other Acadia attractions. Elsewhere in the park, a network of gravel-surfaced carriage trails welcomes bicycles and horses as well as hikers. Quite simply, Acadia National Park is a national treasure.

62. Acadia National Park, Great Head: To reach Great Head and the tide pool there, drive south on Acadia's Park Loop Road until you get to the Sand Beach parking area. The trail, which is rated moderate for experienced hikers, begins at the obvious cliffs next to the parking area.

63. Acadia National Park, Jordan Pond: With Jordan Pond parking at an absolute premium, we recommend would-be summer visitors use the free Island Explorer bus from either Bar Harbor or Northeast Harbor on Mount Desert Island. The bus will drop you at the Jordan Pond House Restaurant, where the photo of The Bubbles, was taken. Hiking trails around the lake begin at the drop-off location, and there is ready access to the park's wonderful network of gravel-surfaced carriage trails, which accommodate bicyclists and horseback riders as well as walkers.

64. Southwest Harbor: Having become a more chic destination in recent years, Southwest Harbor no longer quite belongs to the "quiet side" of Mount Desert Island. Still, it's pretty easy to get there. You and many others simply get off U.S. Route 1 at Ellsworth and follow State Route 3 south toward Acadia Park. Once on MDI, get off 3 almost immediately and stay strictly on the State Route 102 portion of what the signs will say is State Route 102/198, heading south. You'll know when you're in Southwest Harbor, because traffic will slow to a brisk walking pace in midsummer. It is a town made for walkers, so we suggest parking whatever you're driving, putting on your sneakers, and strolling to enjoy.

65. Bass Harbor: To visit Bass Harbor Head Light, follow State Route 102 south across Mount Desert Island to 102A, which becomes Harbor Road. Look for Lighthouse Road on your right, which takes you to a small, rough parking lot. Be respectful of the Coast Guardsman's residence when you find the path to the light.

66. Bernard: Located on what is known as the "quiet side" of Mount Desert Island, the town of Bernard can be reached by either leg of State Route 102, which begins an elongated loop just south of Somesville. One leg takes you through Pretty Marsh and Seal Cove, while the other winds through Southwest Harbor, Bass Harbor, and Tremont. Either way you win.

67. Swans Island: The Maine state ferry from Bass Harbor on Mount Desert Island is the only way people lacking a boat can reach Swans Island. Follow the ferry signs to the Bass Harbor terminal and hop aboard or take the car. It's a healthy walk from the Swans ferry landing to Burnt Coat Harbor. The biggest single attraction on Swans is the Sweet Chariot Music Festival in August. Check out www.sweetchariotmusicfestival.com for details of this long-running hoot.

68. Frenchboro, Long Island: The passengers-only ferry to Long Island and the town of Frenchboro departs from Bass Harbor twice on Fridays year-round. A state-run ferry is also available on Wednesdays, Thursdays, and Sundays. The town's popular annual Lobster Festival is held the second Saturday in August. A network of walking paths covers the island.

69. Schoodic Peninsula: The secluded Schoodic Peninsula juts miles into the Atlantic in the near distance across Frenchman's Bay from Mount Desert Island, but getting there by car requires backtracking to Ellsworth in order to head east on U.S. Route 1 (though the signs will say "U.S. Route 1 North") to the Acadia National Park turnoffs. In the summer there is a car-free ferry service from Bar Harbor to Winter Harbor, and the Island Explorer bus service will take you from the Winter Harbor terminal to the park lands. A six-mile one-way loop road takes you around the shoreline perimeter of the outer peninsula, giving access to four hiking trails (0.5 to 1.1 miles long) and the terminal two-way road to dramatic, pink-granite Schoodic Point at the peninsula's tip.

70. Corea: Few visit the small, tucked-away fishing village of Corea even though it gained widespread notoriety in a book titled *The Peninsula,* by Louise Dickinson Rich. Devoted to lobster fishing, it is part of the Hancock County town of Gouldsboro, which is on U.S. Route 1 east of Ellsworth. State Route 195 offers a right-hand turn near West Goldsboro and takes you through Prospect Harbor (also part of Gouldsboro) just before reaching Corea.

71. Addison: The town of Addison spreads out on both banks of the appropriately named Pleasant River. In fact, the estuary is the town's prime attraction with launch ramps in downtown Addison, in South Addison, and midway down the west (Harrington) shore. The road south to Addison leaves U.S. Route 1 between Harrington and Columbia Falls at what is known locally as The Four Corners, marked by grocery stores and filling stations.

72. South Addison: To reach South Addison, head for the east side of the Pleasant River via the bridge in downtown Addison, after which you'll find the East Side Road and follow it south for about ten miles.

73. Columbia Falls: The town of Columbia Falls is about an hour east of Ellsworth on U.S. Route 1. Perhaps the most intriguing point of interest is the Thomas Ruggles House, which was completed in 1820 and is now a museum open to the public. Tours give an essential picture of what life was like in the early nineteenth century in distant Maine.

74. Jonesport: The turnoff from U.S. Route 1 for Jonesport is a long hour east of Ellsworth. Just east of Columbia Falls, turn right onto State Route 187, and about ten miles later you'll be in Jonesport. There are a couple of bed-and-breakfast outfits in town but no restaurants to speak of. The local IGA grocery store and the local marina near Sawyer's Cove can give you advice on local doings, which annually include the lobsterboat races on the Fourth of July.

75. Beals Island: Take the bridge across Moosabec Reach from Jonesport to visit Beals Island. Both towns are intent on fishing and little else, except high-school basketball and the lobsterboat races on July Fourth.

76. Great Wass Island: Connected to the mainland via the bridge between Jonesport and Beals, Great Wass Island is largely owned by the Nature Conservancy, which maintains a preserve of some 1,500 acres and nearly five miles of trails. There is limited parking for visitors at the north end of the preserve. Amenities are few in this area, and visitors should bring with them what they might need.

77. Roque Bluffs: Careful navigation is necessary to find tiny Roque Bluffs, population approximately 300. Take U.S. Route 1 to Jonesboro, a small town that straddles the road. There, turn south at the east end of the Chandler River bridge, putting yourself on Roque Bluffs Road. Signs to the 274-acre Roque Bluffs State Park should help you get to the town's primary shoreside attraction, which is located on Schoppee Point Road, just off Roque Bluffs Road. Hiking, picnicking, a playground, and a beach are the basic attractions.

78. Machias: The payoff for the long trip east from Ellsworth on U.S. Route 1 is arriving in Machias, particularly if the Maine Wild Blueberry Festival is under way. For nearly 40 years the town has turned blue and white during the middle week or so of August, which is also the middle of the local blueberry harvest. Contests, parades, and blueberries served up in every imaginable form in a family-friendly atmosphere shape the event. If you miss it, the next best bet is viewing the spectacularly colorful blueberry barrens during the autumn foliage season. Excellent blueberry pie can be had at Helen's Restaurant almost any time of the year.

79. Cutler: Worth the very long trip on U.S. Route 1 to reach it from points south and west, Cutler requires a right-hand turn onto State Route 191 when you reach East Machias. Another ten miles or so will put you in the village, which is devoted almost exclusively to fishing for lobsters. Stay on 191 to reach the parking lot and trailhead for the Reserved Lands. Picnic tables and restrooms are near the parking lot, but the ocean views are only available to hikers.

80. Machias Seal Island: Boat excursions to Machias Seal Island can be booked from Cutler or from Grand Manan Island, New Brunswick. In the midcoast region, you can take a tour boat from New Harbor to see puffins on Eastern Egg Rock in Muscongus Bay.

81. Whiting: Careful observation will be necessary for anyone interested in visiting Whiting, population about

480. An hour east of Machias on U.S. Route 1, the town's village is easily missed. There are no commercial enterprises in the village, and the nearest point of interest is Cobscook Bay State Park, in next-door Edmunds township.

82. Edmunds: Dedicated travelers will find the trip to Edmunds fairly straightforward. After leaving Ellsworth on U.S. Route 1 north (you'll really be headed east), just stay with it for a few hours until you reach Whiting, where signs for Cobscook Bay State Park and Moosehorn National Wildlife Refuge start to dot the roadside. Both park entrances are right on the highway, so they will be hard to miss. Rangers at either park can help you find nearby Tide Mill Farm.

83. Pembroke: At the easternmost end of U.S. Route 1 lies the town of Pembroke, which once counted itself fortunate to have America's "First Road" running through its downtown. These days, Route 1 is still a benefit, although the "downtown" is a just a faint reminder of the town's halcyon days in the late nineteenth century. Reversing Falls Park is on Mahar Point at the end of Leighton Neck. Mahar Point juts into the narrow, shallow bottleneck through which Cobscook Bay fills and empties Dennys and Whiting bays twice each day.

84. Pleasant Point and Eastport: To reach Pleasant Point and Eastport, follow U.S. Route 1 through Pembroke, and begin looking for the right-hand turnoff for State Route 190 about five miles east of town. Route 190 will take you through the Pleasant Point Reservation, which is on the northeast shore of Bar Harbor Cove. The reservation, known locally as "Sipayik," has recently created the Waponahki Museum & Resource Center for visitors. Farther on is Eastport, a once-decaying town that is now experiencing a renaissance and is well worth visiting.

85. Lubec: The long trip to the international border at Lubec offers rewards for visitors on both sides of the turbulent channel known as Lubec Narrows. At the end of State Route 189 (off U.S. Route 1), diminutive Lubec was once purely a fishing town but has now decided that tourism is part of its future. Across the bridge is Campobello Island, on which stands the one-time summer home of President Franklin Delano Roosevelt. Both draw modest crowds each summer. In addition to the Roosevelt museum and park, you can visit the Head Harbor Lighthouse at Campobello's East Quoddy Head.

86. West Quoddy Head: To reach Quoddy Head State Park and West Quoddy Head Lighthouse, take State Route 189 toward Lubec. About eight miles from U.S. Route 1, signs will direct you to South Lubec Road and the park, where there is plenty of parking and rarely a crowd.

Acknowledgments

Joe

I want to thank our editor, Jon Eaton, for sharing his vision for this book and then making it a reality; Ken, for the unique and wonderful essays that lend a dimension to the photos in this book I never saw in them before; Janet Robbins, of North Wind Design & Production, for this lovely book design and for bearing with us through revision after revision; and the staff at Tilbury House for their belief in this book and their unstinting support for it. Also, I extend my gratitude to the editors, writers, and art directors who gave me so many photo assignments on the coast of Maine, and to the people I've met along the way who made those assignments delightful and memorable.

Ken

I mostly want to thank the terrific editor and photographer I worked with these last six months. Others deserving mention are too numerous to count: past editors, sailing teachers, boating partners, family, friends, and supporters. The staff of Tilbury House deserve special mention, too.

About the Photographer

Joe Devenney has been photographing Maine since 1976 and has been a professional outdoor/location photographer since 1983, shooting on assignment for *The New York Times, Offshore, American Profile, Shape, Audubon, Consumer Reports, Yankee, Down East, Travel Life,* McGraw-Hill, *The Sacramento Bee, Congressional Quarterly, Professional Boatbuilder, WoodenBoat,* and many other clients. His photographs have appeared on the covers of *Down East; Yankee; Maine Boats, Homes & Harbors; Northeast Boating; Points East;* and other magazines, and have been published by the National Geographic Society, The Sierra Club, *Reader's Digest, Outdoor Photographer,* and *Popular Photography,* among others. His prints are shown in galleries, juried shows, and festivals throughout the eastern U.S. and are included in many private collections. His work has been published worldwide and is featured in the collections of Getty Images, The Image Pro Shop, and Alamy. He maintains several galleries on Photoshelter and is a member of Canon Professional Services and a lifetime member of the American Society of Media Photographers. Joe lives in Jefferson, Maine.

About the Essayist

Ken Textor has ranged the Maine coast by land and sea since the late 1970s. He is a contributing editor for *Down East* magazine and has been boating columnist for the *Maine Sunday Telegram,* contributing editor for *Maine Boats, Homes & Harbors* and *Country Journal,* columnist for *Popular Woodworker,* and managing editor for *Boating Digest.* His writing has appeared in *WoodenBoat, Cruising World, SAIL, Northeast Boating, Fine Woodworking, Fine Homebuilding, Fine Gardening, New England Boating, This Old House, Smart Homeowner, Points East, Boating World, Trailer Boats, Sailing, Yachting, Professional Boatbuilder,* and other publications. Ken began his writing career as a general assignment reporter for the *Concord* (NH) *Monitor* and was bureau chief for the *Claremont* (NH) *Eagle-Times.* He is the author of two previous books, *Innocents Afloat* (Sheridan House, 1993) and *The New Book of SAIL Trim* (Sheridan House, 1995). Ken lives on Arrowsic Island, Maine.